Accidental Activist

Changing the world one small step at a time

Mary Allen Jolley

Praise for *Accidental Activist*

"Meet Mary Jolley, age 16, school bus driver from rural Alabama, an apt metaphor for this book. She will pick you up where you are living. Meet all the riders: ordinary people; mayors, governors, senators, and representatives; presidents of PTA's, universities, and of the United States. A LOVE story. Enjoy the journey and learn as you go."

—Hubertien Helen Scott, Ph.D.,
NDEA 3-year graduate fellowship beneficiary,
Professor Emerita, Appalachian State University, NC.

"Few women have lived a life as courageous and consequential as Mary Jolley's. From the impoverished Alabama farm where she was raised during the Depression and where her parents taught her the value of education and the virtues of making a difference in the lives of others, she worked her way into the halls of the U.S. Congress, where she arrived in the mid-1950s as a legislative aide to Alabama Congressman Carl Elliott, becoming his right-hand woman (almost always the only woman in the room). Her tireless behind-the-scenes efforts helped pass the National Defense Education Act, which has provided millions of deserving students across the nation the opportunity of a college education. With wit, wisdom, and riveting detail, Jolley shares a behind-the-scenes look at the most fiery decade in the history of Alabama and of the nation—the 1960s—working with Elliott and others to push back against the forces of racism, intolerance and ignorance, not just in her own state but across the nation. Here, she details her lifelong journey, with a cast of characters ranging from John F. Kennedy to George Wallace, and shares how her efforts to make other lives better have continued over the ensuing half century, right up until today, as she closes in on her 100th birthday. This is a story that will enrich and inspire all Americans, and certainly all Alabamians."

—Michael D'Orso, co-author (with Representative John Lewis) of
Walking With the Wind: A Memoir of the Movement
and (with Representative Carl Elliott) *The Cost of Courage:
The Journey of an American Congressman.*

"Readers will find valuable life lessons in this lively and personal behind-the-scenes account from an unsung heroine of the fight for human rights and equal education in America."
—Ellen Griffith Spears, Ph.D.
author of *Baptized in PCBs: Race, Pollution, and Justice in an All-American Town*

"As the saying goes, many people frantically struggle for fame while a handful forget themselves into immortality. Mary Jolley never sought Alabama's spotlight, but she was seldom beyond its refractive beam when matters of greatest importance were at stake. *Accidental Activist* is a primer for all who wish to know what was best about the state's history, politics, and society in the Twentieth Century."
—James Wayne Flynt, University Professor Emeritus of History, Auburn University, author of 13 books on the historical, economic and social fabric of Alabama, including *Poor But Proud: Alabama's Poor Whites*; co-author of *Alabama: A History of a Deep South State*, both nominated for the Pulitzer Prize.

"*Accidental Activist* describes a remarkable journey through the years of a life so well lived by a woman of strong faith richly endowed with several of the spiritual gifts, not the least of which is that of administration. Her journey is marked by an unceasing persistence in improving opportunities for those whose circumstances prevent full development of their talents. Her story describes the voyage of a woman from rural Alabama who would ultimately walk with the highest officials of our government in her successful quest to promote vital change. It includes valuable boldface texts setting forth lessons she learned from these varied challenges and the accompanying joys and heartaches she has faced throughout her full life. It should be required reading for anyone interested in making the world a better place through involvement in civil service, non-profit entities, or educational institutions.

"I was a minor participant in some of the events she describes. I continue to be amazed by her remarkable life. The Lord has truly blessed us with the gift of her presence."
—Champ Lyons, Jr., Retired Justice, Alabama Supreme Court

"Not many people know the name Mary Jolley. But her story, beginning in Alabama's Black Belt more than 90 years ago, proves that the

world can be made better by one woman's quiet, but effective, work. In the brash bluster of our present political discourse, Mary Jolley's life is testament to the impact of one solitary life."
—Doug Jones, United States Senator, 2018-21

"*Accidental Activist* is a stirring history, stated factually and modestly. But the story that keeps peeking out of the layers of fact is the story of a woman's growth, using the paltry tools offered by the poor rural South, into a sound Christian character with a smooth genius of drawing cooperation from people and guiding them into the creation of successful programs and systems.

"Mary Jolley honestly never paid much attention to the glass ceiling smothering feminine achievement. She just saw what needed doing and invented a way of doing it, often as the only woman at a table surrounded by men. While the smart people around her often saw and attacked the problems, Mary Jolley never saw just *problems*. She always saw *people* with problems. That's her genius. It is nourished by her solid Christian character—sensitive, responsive to the realities in each particular context, confident of God's divine providence. Mary Jolley is a fountain of initiative, and majestically creative. Her book tells us—no, *shows* us—how we Americans can lift ourselves out of the morass we are in. Any of us who live as she has lived will discover that we have become richly fulfilled human beings. And also, by the way, ACCIDENTAL ACTIVISTS."
—Fr. Joseph A. Tetlow, S.J. Ph.D.
Former dean of Loyola University in New Orleans, President of the Jesuit School of Theology at Berkeley, director of Montserrat Jesuit Retreat House at Lake Dallas, Texas, and author of numerous articles and books, including *Ignatius Loyola: Spiritual Exercises, Choosing Christ in the World*, and *Making Choices in Christ*.

"Mary leads us on a nearly five-score journey from Ward, Alabama, to Washington, D.C., and a universe surrounding. Fired by great capability, the courage of her faith, and a commitment to all God's children, she moves from classroom to congressional hearing room to a dozen other seats of service where the hopeful power of possibility can be plied and realized. Along the way, she exudes both idealism and pragmatism, held in a healthy and productive tension. The power of the stories she tells, the ongoing magnetism of her spirit and wit and eternal optimism—these set an expectation for all of us not just toward the immediacy of a job well done, but rather the "what's next"

attitude anticipating a life well lived. Activist may, indeed, be accidental. But her active life seems to be as intentioned and inspiring as the daily sunrise. 'Let there be light!'"

<div style="text-align: right">—MART GRAY, wandering minister and founding board chairperson of Sowing Seeds of Hope, Perry County, Alabama</div>

"Thank you Mary Allen Jolley showing the world what being a true daughter of the South means! The first time I visited the North, a young African American man I met, realizing I was from Alabama, said, "Are you ok? I've heard it's really racist down there." Like many out-of-staters, his assumptions were informed by defiant segregationist rhetoric, stands in schoolhouse doors, and state-sponsored violence against peaceful protesters. In response, I quizzically replied, "That's not my experience." Unbeknownst to a lot of people, most whites in Alabama are decent, fair-minded people trying to do what's right. It is from this cloth that Mary Allen Jolley was cut. Among many other things, *Accidental Activist* readers will come away knowing that there are way more Mary Jolleys in Alabama than George Corley Wallaces. "Who's Mary Allen Jolley?" you may ask. Within the pages of *Accidental Activist,* you will meet a remarkable trailblazer who overcame personal tragedy, defied Jim Crow, sidestepped sexism, and "accidentally" changed the world through commitment, intelligence, and empathy. Mary Allen Jolley's parting gift to us is more than just a touching love letter that recounts her greatest achievements. The *Accidental Activist* is an essential "how-to" guide for anyone who has dared, even for a moment, to ask, "What can I do to make the world a better place?"

<div style="text-align: right">—LTC (Ret) Kenneth Crawford, Founding Member, Carl Elliot Society, University of Alabama, member of the extended cohort of "Mary's Kids"</div>

Accidental Activist
Changing the world one small step at a time

Mary Allen Jolley

Livingston Press
Livingston, Alabama

Copyright © 2024 Estate of Mary Allen Jolley
All rights reserved, including electronic text
ISBN 13: trade paper 978-1-60489-381-6
ISBN 13: e-book 978-1-60489-382-3

Library of Congress Control Number: 2024935494
Printed on acid-free paper
Printed in the United States of America by
Publishers Graphics

Typesetting and page layout: Joe Taylor & Jan Pruitt
Proofreading: Brooke Barger, Savannah Beams, Kelly Scott, Kelly West, Trey L, D. Anthony Lang, Arange Clemons, Tricia Taylor, Caitlin Dial, Jojo Young, Jarion Rogers, Madelyn Brasher, Mary Haysley Gillespie, Saide Rodriguez, Christin Loehr, K. Sohta, Jan Pruitt

Cover Photo: *Front cover, left to right: President John F. Kennedy, Dr. Benjamin Willis, Superintendent of City Schools, Chicago, IL; The Honorable Anthony Celebrezze, Secretary of U.S. Dept. of HEW; Dr. Chester Swanson, Professor of Education, UC Berkeley; Mary Allen Jolley. Rose Garden presentation of Vocational Education Report. Photographer: Abbie Rowe. White House Photographs. John F. Kennedy Presidential Library and Museum, Boston.*

Livingston Press is part of The University of West Alabama,
and thereby has non-profit status.
Donations are tax-deductible.

6 5 4 3 2 1

This book is dedicated to all the people who shaped and encouraged me—most dearly to the memories of my parents and family, of my caregivers and teachers, of Carl Elliott, and of Dick Jolley—and to all the friends of the long road.

I also dedicate this book to the late Andrew Elliott Carpenter, and to all the young people like him, and their generations to come, who carry forward the work for opportunity, justice, and peace.

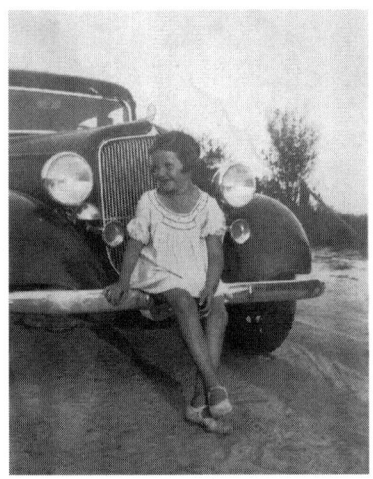

Above: Mary Allen, age 6. Below: Mary Allen Jolley in 2010 (Portrait by Alice Wilson)

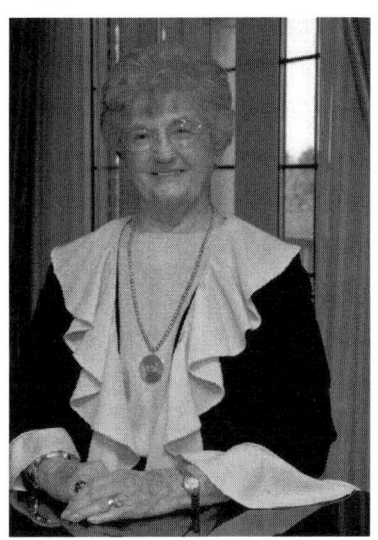

Table of Contents

"She's not a household name in Alabama, but Mary Allen Jolley changed the world"..1

Why I finally wrote this book ...3

Learning from my family and neighbors5

Learning from a devastating loss..16

Learning from illness and prejudice20

Learning from new opportunities (even though it took
 nudges from Mama and Dr. Russakoff)29

Learning from the politics of the possible............................33

Learning the hardest lesson of functional politics...............38

Learning to focus on the goal, and not myself.....................50

Learning from a congressman for the nation
—and for his district ...62

Learning to endure defeat with integrity and courage75

Learning the power of collaboration and innovation..........85

Learning the power of publicity—and of listening89

Learning from life's delightful surprises...............................92

Learning from pioneers of the past—and
 responding to life's changes..99

Learning to work through opposition105

Learning to leverage partnerships for mutual benefit......110

Coming home to Alabama and joining a progressive team.............115

Learning from failure, and going for the win....................121

Honoring a legacy of service: the Profile in Courage Award...........127

Establishing Family Resource Centers...131

Retirement and learning to cope with a loss like no other136

Striving for racial reconciliation..149

Finding what sustains you—my spiritual journey157

In the end, gratitude..161

End notes..166

Photographs ...166

Appendices
 Honors and Awards..175
 Seven Life Lessons I Learned from Mary Jolley.......................178
 "I Stand Outside" ...181

Acknowledgments...182

"She's not a household name in Alabama, but Mary Allen Jolley changed the world"

This is how *The Birmingham News*[1] described Mary Allen Jolley in August 2018, when over 250 people gathered in Tuscaloosa to pay homage to this daughter of Alabama on her 90th birthday. Black and white folks mingled with local dignitaries. Affluent citizens of power and position were there, along with hardworking farmers who had driven many hours to salute her. Young movers and shakers, millennial activists, church officials and people from all parts of the state dedicated their Sunday afternoon to celebrate her work on behalf of the people of her county, her state, and the country.

Over the course of nine decades, she has broken down barriers in education, government, and the economy. Mary Jolley achieved a long, notable career by translating her optimism and hard work into programs that help millions of Americans have a better life.

This book is her story.

—Marjorie Buckholz

Why I Finally Wrote This Book

> "You get old and you realize that there are no answers: just stories."
> *Garrison Keillor*

> "Stories can change the world."
> *Rick Bragg*

When I reached my 90s, some friends and colleagues told me I should tell about my life and some things I helped to get accomplished. I've resisted doing that, but now, though I know my story is not going to change the world by itself, I've decided to tell it because it might help somebody else see that they can help change things for the better.

"No answers: just stories." That statement by Keillor[2] really struck a chord with me. I believe stories can help us live fuller, better lives. They can help us understand ourselves and other people, and they can lead us to stretch our imaginations and expand our aspirations. They can show us role models and horrible examples; they can help us to feel what is right, and to know what we want to stand up for. Stories are powerful teachers.

Rick Bragg's "Last Lecture" at The University of Alabama was one such story for me. Rick is a former newspaperman, now teaching journalism at the University of Alabama. In the "Last Lecture" program, professors say to their students what they would say if they knew it was the last lecture they were ever going to be able to give.

Rick told the story[3] of working in New Orleans as a correspondent for *The New York Times*. There had been a murder in the community, and he was tasked to find the mother and write a story about her feelings about what had happened to her son. He went to her home and as she opened the door to let him come in, he began to apologize to her. He explained that one of the hardest things a reporter has to do is have people relive these horrible experiences. He was saying how sorry he was to have to ask those questions and she interrupted him and said, "Don't worry about it. If it ain't written down, people forget."

That hit home, and stuck with him. Stories do have the power to change the world.

I didn't start out wanting to make changes in the world. But as I come up on my hundredth year on this planet, I realize that a few key things that happened to me helped me see where change was needed and how I could be part of making it come about. So I invite you to listen to my story—and to know that you can be part of making the changes that you see need to happen.

Learning from My Family and Neighbors

I was born on August 30, 1928, and despite the Great Depression, my childhood was a happy one. I remember above all else that I always felt deeply loved by my parents, and safe and secure with them. Though I couldn't have said it in these words at the time, I knew that they loved me unconditionally, even when I did wrong and was punished. I think it's so important for children to have that feeling. I think it set me on the path that I have been on. When you've been freely given that, not made to feel that you have to earn your parents' love, you want to give to others. In my 90+ years, I've seen the kinds of problems that people have to overcome to make a good life, and so many of those problems stem from not feeling loved by their parents. I know I was fortunate in this regard, and I hope you are, too. **But: if you didn't receive that love as a child—if you didn't have parents who could instill confidence in you and show you how to treat yourself and other people with love and care—then I encourage you to look closely at the people in your larger world, and to learn from the example of those who do model courage and compassion. Maybe a relative, or a teacher, or a boss can be your role model. And if role models are thin on the ground, then learn what you can from the flawed examples in your life; if nothing else, you can see how NOT to behave, and make a better path for yourself and your children—and anyone whose life you touch.**

I also encourage you to learn as much as you can about the larger world in general. The wider your perspective, the more possibilities you can see. I was fortunate in that my mother, Henrietta Pearson, began seeing the world from a broader perspective when she was a girl. She instilled that openness to possibilities in me, though, as I'll tell you later, sometimes she had to nudge me to take the next step.

Mama was born in Duncanville in Tuscaloosa County in 1891. When she was 12 years old, her mother died, leaving four girls and two boys to be raised by their father. At age 18, she left her home and came into Tuscaloosa to go to nursing school, and right after graduation, boarded a train to New York City to take a postgraduate course in obstetrical nursing at Columbia University Hospital. That completed, she

returned to Alabama and went to work at the McAdory Infirmary in Birmingham. When World War I began, she volunteered as an Army nurse. After the war, she came to Tuscaloosa to work in what became Druid City Hospital, where she served as superintendent of nurses. The hospital included a residence for nurses where she lived. When my mother visited the hospital's construction site, the mason invited her to lay a couple of bricks in the foundation. She did, and years later showed them to me with affection and pride. As I write this, the residence still stands on the University of Alabama campus, and I always think of Mama when I pass by it.

After serving as superintendent, Henrietta decided to use her skills in a very different direction and moved to Atlanta to care for individual patients in private duty nursing. She enjoyed the work and the city, but a visit to her sister in Ward, Alabama, led to a big change in her life. On that visit she met the man who would become my father, Charlie Neal Allen. It may have been love at first sight, but marriage was a serious commitment that she didn't enter into lightly.

My father, a widower with three young children whose wife had died of breast cancer, was a farmer in south Sumter County, a land of rolling hills crisscrossed by clay roads and kudzu. After two years of long-distance courtship by mail and occasional visits, my parents wed in 1925, and Henrietta came to live on the 300-acre farm with Charlie and his children: Ruth, Willard, and Charles, aged 6 to 12. In 1927 my brother Walter was born, and I followed him eighteen months later. Within a year of my arrival, the Great Depression got underway with the crash of the stock market in l929.

The world I was born into

Our family of seven lived in a two-story home, without electricity, refrigeration, a central water system, or indoor plumbing. In rural Alabama our home was not all that unusual—most families lived in houses with the same lack of amenities. Only with the fruition of President Franklin D. Roosevelt's New Deal in the early 1940s did we get electricity.

Our home was flanked by outbuildings, each with a different function—a barn for our milk cows, horses, and hogs; coops for young chickens and laying hens; a smokehouse to cure and preserve meat; a storehouse for feed and seed; and sheds for farming equipment and

for an automobile. My father also had a blacksmith's shop for sharpening plows and shoeing horses. A covered well provided a water supply for our barn, and our screened back porch held the second well for water used in the house. Near the well at our barn was a black iron pot and several washtubs where we laundered our clothes and linens. At hog-killing time (the coldest part of the winter), we used the pot to render lard, and in the fall for cooking lye soap and making hominy of shelled corn. An extensive vegetable garden; an orchard of apple, peach, and pear trees; a scuppernong arbor; two large pecan trees; two fig trees; and two huge oaks filled out the landscape surrounding our home.

At the back of the house stood a big stack of wood split for our kitchen stove, as well as logs for the fireplaces we used in winter to heat our home. One of my earliest chores was to bring in the stove wood every evening for cooking our food. As a small child, I could stack 10 to 12 pieces of wood into my arms to deposit in the wood bin in our kitchen. I was proud of being part of the work of the household: it gave me confidence that what I did mattered.

I also had the benefit of being part of a multi-generational household. When my Grandfather Allen passed away in 1930, my Grandmother Allen made her home with us for most of the year, but she would stay with each of her other four children for extended visits. I greatly admired her, for she always had time for me, especially to talk about growing up and helping me learn about our Allen relatives, present and past. She gave me a great sense of family, and she was also an example of strong religious faith and practice. I can still picture her after breakfast going to her room where for an hour or more she would read the Bible. We understood this to be her sacred space and would not intrude. I carried into my later life the importance of having some time every day, however brief, for prayer and reflection.

Forces that shaped our lives

The Depression years (1929–1939) no doubt affected others of my family more than it did me, especially the older children: I was too young to realize how dire were the times in which we lived. We had home-grown food in abundance. We heated our house and cooked and heated water with a wood-burning kitchen stove. We were years away from access to air-conditioning, but doors and windows were screened and we kept them open for the breeze on hot summer

nights. Kerosene lamps lit the house, and handmade quilts kept us warm while we slept in winter. We raised and preserved our own pork and beef and chicken, and our cows provided an ample supply of fresh milk, some of which we churned into butter. I do recall that we placed blocks under the wheels of our car, and it remained parked and idle in the shed for more than a year because we had no money for oil and gasoline. We rode the three miles to church in a wagon pulled by mules, and as a small child I considered it to be quite exciting and a lot of fun.

I am sure my parents had many concerns about the state of the economy. I recall seeing papers in my father's desk showing a loss of funds deposited in the Bank of Cuba (Cuba, Alabama). I have no doubt we lost all the money our family possessed. There was little hope for acquiring more cash: even if a farmer could succeed in making a crop, the market was so depressed that cotton sold for three cents a pound. When my brothers graduated high school in the middle of the Depression, going to college was not an option for them, and they had to take a harder path to success.

Models of civic involvement

In good times and bad, my mother and father were both active members of our community, and I learned from their example the importance of civic service. My father was a leader of our Cokes Chapel Methodist Church; Sunday School Superintendent and teacher; Chairman of the Board of Stewards; and Moderator at the Methodist Quarterly Conferences. He served as Chairman of the Trustees of Ward High School and was elected to the Sumter County Board of Education. He was appointed by the Governor of Alabama to be a Justice of the Peace. He served on more farm committees than I can remember, including being President of the Board of Directors of the Black Warrior Electric Co-op which brought electricity to our community when I was a young teenager. Then, for the first time, we had year-round refrigeration, a washing machine, and electric lights. Our first radio could get WWL, the clear channel radio station operated by the Jesuits at Loyola University of New Orleans. At the time, I had no idea how important Jesuit theology and some of its practitioners would become to me in later life.

When anyone in our community was sick, my mother was called upon to help. She was present for many of the births and most of the

deaths in our community, and gave skilled nursing care to numerous members of our family and friends. In addition she was active along with my father in promoting the PTA, the Red Cross, and the war effort in World War II. We planted and harvested food for ourselves and for others; my mother led the effort to collect scrap iron and aluminum. We bought war bonds as often as we could. Many years later, when she was in her 70s, my mother was opposed to the war in Vietnam. She told me once, "I did all I could to end war during the two World Wars. And if it were not for my rheumatic knees I'd be out there marching against this war."

Our farm was in Kinterbish, a little community in south Sumter County, Alabama, about 70 miles southwest of Tuscaloosa. Many of our neighbors were African-American families. Three tenant farmers and their families lived on our land, and the children of those families were my playmates. Later in this book I'll say more about how I came to think about these relationships as I grew older, but here I'm describing the world as I knew it when I was a child.

Kinterbish was a small community of limited resources. My uncle, Earl Allen, was the only doctor in south Sumter County, and my mother was the only registered nurse in the area. When she was called away to help someone, I was cared for by our housekeeper. From my earliest memories until I was twelve, an African-American lady came to our house to cook breakfast and lunch and take care of me and my brother.

Learning through love and discipline

The women who worked in that role were another great influence on my life. In the way of that place and time—in the middle of the Jim Crow South— I called them "Aunt." But my parents taught me to respect all adults, and I also knew that I was to obey without question whomever my parents left in charge. The first housekeeper I remember, Mrs. Connie Thomas, gave me the nickname "the baby" because I was the youngest in the family. Aunt Connie was very loving and kind to me, as were the women who followed her: Mrs. Amy Glover and Mrs. Melley Duncan. But loving-kindness didn't mean that discipline was not enforced.

Though I was an obedient toddler, when I was six or seven years old I began to get, as the saying went, "too big for my britches." My knowledge of how I was to behave didn't always translate to perfect

action. One day I told our housekeeper that I didn't have to do what my mother had said when my mother wasn't there. Aunt Amy took a long look at me and said, "Well, she ain't ever told me that." When my mother got home, Aunt Amy let her know I needed instructions in how to behave, saying, "Miss Henrietta, you need to side talk the baby."

That was the first time I'd ever heard the expression "side talk", and it was a perfect description of the way my mother disciplined us. She always took us into a private room and talked to us one-on-one in a very kind and soft voice. That day I promptly received the "side talk" recommended by Aunt Amy! Mama reminded me that when she was away I was to cheerfully do whatever the person in charge told me to do, and if I did not, she would have to take other measures.

I knew what those "other measures" would be, because a few times in my life I was physically punished by my mother, who used a small switch that she had me fetch for her. She would sting my legs with a few swipes. Even as a small child, I was free within limits to roam our farm and community, and my punishment generally came about because I had failed to keep those limits and come home by the established time. I sometimes found it hard to be obedient; there were always so many interesting things to do!

Aunt Melley was our last housekeeper. She taught me to cook, and by the time I was 10 years old I could cut up a chicken for frying. By the time I was 12, I could get up and cook Sunday lunch, with fried chicken and, in the summertime, fresh butter beans and corn and sliced tomatoes from our garden, and still have time for church. **I learned so much from each of the women who worked with our family: not only love and discipline, but how to do things and be useful. I treasure that. This, along with my stove wood chore, was my first experience of one of the truths I've seen proven over and over again in my life: that work that allows a person to take care of themselves and their families is crucially important both to individual confidence and to community building.**

How my parents interacted with our neighbors and tenants was another lesson to me, especially later in life when I realized that the respect and honesty of their relationships was far from universal. Robert Foster was one of the African-American tenant farmers who lived on our farm. He was a hard-working farmer and a man of great

character. As a young man he had to have one leg amputated right below the knee. But he was creative and wanted to work, so he made himself a wooden peg leg with a padded top and adjustable straps. Every day he would put it on and get to work plowing and whatever else needed to be done, working alongside my father. My father liked him so much and thought Mr. Foster had such good habits and good ideas that he shared everything he knew about farming with him. Eventually, Mr. Foster bought his own farm and moved there with his family, but when I was a child, the Foster children and another Black child, Mary Ella Williams, were my closest playmates, along with my brother and cousins. We played back and forth between our houses and the woods and fields of the farm.

A child's paradise

Looking back, this rural setting was a child's paradise. Even as a young child, I felt very at home in my community, and knew that I was part of something larger than just our family and farm. I could wander up and down the road because there was no traffic to speak of. I would go to a neighbor's house and just walk in and start talking to whomever was there. In retrospect, I see that may have horrified the neighbors, but they always made me feel welcome.

There were adults in our community who were not family but whom I remember being especially kind to me before I started school, including the lady who cut our hair. When my mother sent me to get all my curls cut short, Mrs. Lerona Garrison, who thought I had beautiful hair, cried and sent home with me a beribboned curl that I found decades later with my mother's letters after her death.

Miss Lerona was also my reason for getting one of my mother's infrequent little switchings. Because I loved being with her so much, I simply didn't go home by the time my mother had specified. It wasn't that I lost track of time—I just wasn't ready to go when the time came. When I did get home, my mother felt that I needed to have my priorities clarified, and I paid the consequences.

Another neighbor, Mrs. Adah Grimes, one day taught me a lifelong lesson about kindness and hospitality—and baking. Mrs. Grimes was an older lady who loved spending time with children, and I loved to spend time with her. On the day I best remember, I had dropped in and after we talked for a while about the weather and whatever was

going on in the neighborhood, she asked me if I would like to have something to eat. I answered that, well, since she had asked, I would like to have a piece of cake.

"Hmm," she said. "I don't have a cake now."

I was undeterred. "Well, can we make one?"

She led me into her kitchen and built up the fire in her wood-burning stove. Then we made the cake. And by "we," I mean that I carefully watched everything she did and listened to every word she said while she measured the ingredients, broke the eggs, and stirred the batter. At every step, she told me what she was doing and why she was doing it, and I learned how to make a cake. I have never forgotten it, or her.

My mother almost gave me another little switching when I got home and told her about my afternoon. She was mortified that I might have imposed on Mrs. Grimes. She said, "I can't believe you told her that you wanted a cake and she made you a cake!" But that was the kind of community we lived in. Neighbors were friends, and you helped others when they were sick, and you cared when something happened in another family, and when a child wanted to spend time with you and maybe have some cake, you took time for that when you could. **Over the decades of my life, I've seen that such willingness to be present and involved with neighbors is one of the hallmarks of healthy and caring communities, whatever their level of affluence.**

When I was a child one of my most earnest wishes was to be grown up: I wanted to be treated like an adult. The relationship I had with one of my mother's sisters was another key point in my life, broadening my perspective on the world. Emma Mitchell (at whose home my parents met), was the postmistress at Ward, Alabama. When we no longer had a housekeeper and my mother was called to a sickbed, she often would leave me with her sister. Emma allowed me to call her by her first name and to help—under her strict supervision—sort and postmark the mail. I felt so grown up. I learned geography as we prepared the mail to go to its destination: items bound for the south and west went on the train to Mobile; those for the north and east went on the train to Memphis. I began to have an idea of where we were in the world, and of how much world there was beyond us.

Making music and learning to add—or not

When I was very young, my Sunday school teacher taught me how to play "Jesus Loves Me" on our piano, and I discovered I had a talent for picking out tunes I'd heard. Miss Rebecca Hybart made me feel really grown-up by giving me attention and then praising me when I demonstrated that I could play, especially doing it "by ear." Miss Hybart taught at Ward School and urged my parents to send me for music lessons with the teacher there even before I was old enough to enroll in school. (Under Alabama law, a child had to be six years of age by July 31 to start school in September; my birthday was a month too late.) They agreed, and two days a week, after I finished my music lesson, I went to the first-grade class to wait until I could be picked up or ride the school bus home.

By sitting in the classroom with the first grade, I actually learned to read before starting formal schooling. I made even better progress in music lessons once I learned how to read. After my actual first grade year, when time came for me to enter second grade, the teachers conferred with my parents and agreed that I would skip the second grade and begin third grade instead.

Skipping that grade was not without trauma. Ward School, even though it had all 12 grades, had such a small enrollment that, at the elementary level, each teacher taught two grades in the same room. When I was moved up to the third grade, this meant that I was in the same room as my brother who was almost two years older than I.

I shall never forget the day I was moved to the third grade. When I entered the room, everyone was seated at their desks. I was properly introduced and invited to join the math class in progress. The lesson for the day was to "add and carry"—operations that I knew nothing about. The teacher asked if I wanted to go to the blackboard and add two numbers: 23 plus 17. I could write the numbers, but I could not do the addition! I immediately wished I was back in the second grade, and so did my brother. When we got home that afternoon, he couldn't wait to tell my parents how dumb I was and how I had embarrassed our family because I couldn't add.

The end result was my lifelong aversion for mathematics. I took the courses I had to take to graduate from high school and college, but I never ever enjoyed math classes. I thought then, and now, that I am

not good at math. Otherwise, I made good grades all my life, and continued to enjoy music and play in public gatherings throughout adulthood. **Later in life, the contrast between what I was able to understand and enjoy when encouraged rather than ridiculed was a lasting lesson for me in how to help anyone learn, whether in a school or community setting.**

In 1943, the year I started high school, Ward High School was consolidated with Sumter County High in York, 15 dirt-road miles away. My brother Walter drove the school bus from our home every morning to pick up twenty-some students for Ward School. First- through ninth-graders would go to class there, and high school students transferred to another bus bound for Sumter County High School.

My very untypical first occupation

Before my senior year, World War II was still raging in the Pacific, and my brother volunteered for the Navy. With Walter gone, there was no one to drive his bus route. After much thought, my parents agreed that I could take the job if I could qualify. I went to the county seat to take a driving course and examination, which I passed with flying colors—even the part of the test where I had to back the bus through a series of stanchions. Imagine my excitement! First of all, no female had ever driven that route. In fact, I think at that time I was the only female bus driver in the entire county—which turned out to be the beginning of a series of "firsts" in my life.

I was thrilled to be employed at the rate of $35.00 per month. My first purchase with money I had earned was an RCA radio for my bedroom. I listened to WWL broadcasting from the Blue Room at the Roosevelt Hotel in New Orleans, and to the syndicated broadcasts of the *Grand Old Opry* and *The Hit Parade*, hearing the new songs that I could then play on the piano for my friends.

Sumter County High introduced me to many new names and faces. The curriculum was more diverse. For example, we were exposed to a foreign language; we had a better library. But extracurricular activities were non-existent as far as I was concerned. I was in the band, but we performed only during school hours. The minute school was over, we headed straight for the bus to return to Ward, and then I had to make the bus route to deliver students in my own community. I usually got home around 4:30 or 5:00 p.m. But despite my tight schedule, there

was time for fun with my classmates, including returning to York for football games played at night.

One enduring lesson I learned in high school came from the state supervisor of the home economics curriculum, Miss Ruth Stovall. When she visited our school, our home economics teacher had each of us display our current sewing project: dresses. Mine was awful—and also unfinished. I had had to rip out the seams again and again, and my seersucker frock was a mangled mess. But Miss Stovall found something good to say about each girl's project. About mine she said: "What beautiful colors you've chosen! When you finish this you'll be the prettiest girl in class." **That was a teachable moment for me: I learned afresh the power of kindness over ridicule and that I didn't have to be perfect to still succeed. In later life, this translated into realizing the fundamental necessity of focusing on the strengths that exist in a community or group striving for change: finding what is working and building on that.**

I graduated high school in 1946. My classmate Tut Altman and I were tied for the honor of being valedictorian of our class, so we both made speeches. I felt ready for the next chapter of my life. If I had known all that was going to happen, I might have felt differently.

Learning from a Devastating Loss

After graduation I immediately enrolled as a freshman at Livingston State Teachers College, located 25 miles from my home. Livingston State was established in 1835 as a Normal School—its primary mission was to prepare students to teach by educating them in the norms of pedagogy and curriculum. Two of Father's brothers had studied there and then spent time teaching in small rural schools in Sumter and Choctaw counties before moving on to other venues and/or careers. Two of my cousins had already graduated from Livingston, and I anticipated college as a grand adventure. I packed all my belongings into two small suitcases and arrived ready to take charge of the world. To my surprise, by mid-week I was homesick and more than ready to go home. I began to wonder if I had not made a terrible mistake.

Fortunately, some friends gave me a ride home that first weekend, and when I learned that I could actually get home again (yes, all of 25 miles away) I was completely satisfied. I loved going to class, and liked making new friends, and joined in just about every extracurricular activity available to me. I was elected Secretary of the Freshman Class, and at the end of the first year was voted "Most Versatile Girl."

My family was able to pay tuition for the first quarter ($45.00), but I was expected to find work to pay for all other expenses. Throughout my college career at Livingston and later at the University of Alabama, I was fortunate to find those jobs—and they ran the gamut. I could type 90 words a minute, so I did secretarial work. I could play piano, so I accompanied the Glee Club and the Modern Dance class. I served food on the cafeteria line twice a day, and walked all over campus as a messenger for the Office of Dean of Women. One summer I had a full-time job at the new Trinity Methodist Church in Tuscaloosa, helping organize and plan for the North Alabama Conference, figuring out logistics and placing representatives in host homes throughout Tuscaloosa. My favorite job while I was in Livingston was playing in The STC Hot Shots, a dance band that three of my classmates and I formed to play *Hit Parade* songs for dances on cam-

pus and off. I was able to find jobs and make my own way through my four years of college education. But those years didn't follow the path originally planned.

"Just get the wagon loaded and start moving"

Although colleges were experiencing an enormous increase in enrollment as the soldiers returned from WWII and took advantage of the GI Bill, there was an acute shortage of teachers for public schools, and school systems were hiring teachers who had not yet completed college. After we had completed our first academic year and one summer session at Livingston State, several of my friends were leaving to take teaching positions. I wanted to be with my friends, and I needed to earn money to keep working toward my degree, so I decided I would apply, too.

To my amazement, I was hired— by mail, without even a telephone interview—to teach in the very rural community of Cold Springs, halfway between Cullman and Jasper, the two largest towns in Cullman and Walker Counties, Alabama. I had never been to Cullman County. My job was to teach high school girls' physical education, music for elementary students, and a seventh-grade introduction to the world of work called Occupations.

Feeling that I was setting out on another great adventure, I boarded a train in York and headed for Cullman to catch the single daily bus from Cullman to Cold Springs. The train and bus schedules didn't allow that to be a single day's journey, so I had booked a room in the Eureka Hotel: the first time I had traveled by myself and stayed in a hotel. By mid-afternoon on the second day I was on my way to my first big-time job!

While the pay was not that wonderful—$1,200 for the nine-month term—my living situation was ideal. To attract teachers, the County had built a large home called "The Teacherage" where 18 of us lived in community, paying $50 a month for room and board. Two housekeepers cooked and cleaned the common areas for us, but we also had responsibilities for other tasks of daily living.

When I set out to teach, it never occurred to me to have doubts about my ability to manage a classroom. I took to heart the words of a good friend who said, "Don't worry about the mule being blind, just get the wagon loaded and start moving." In most cases, the students and I got

along really well and lessons proceeded smoothly. In general, what student doesn't like to sing and play games? But there was one boy in the Occupations class, named J.R., that I just couldn't get to cooperate.

In my opinion, Occupations wasn't much of a class. We had a textbook that described different kinds of jobs and told the qualifications required to do them. But the students in our rural area had little opportunity to observe the occupations we covered. When I asked a student to answer one of the questions at the end of a chapter—"name the industrial fields"—his sincere response was, "Corn fields, cotton fields, pea fields..." J.R. was a natural comedian, and with material like that for inspiration, he could get everyone in the class to laugh, even me, sometimes. But he was a constant disruption, so I finally banned him from my class. When I told my father about the situation, he told me very seriously that I had a responsibility to teach J.R. He told me that I had to bring him back into the class and find a way to reach him. I did let him back in, but I'm not sure I ever really reached him.

Looking back, I have frequently asked forgiveness for all the things I didn't know to do to be a really good teacher. On the plus side, I at least was able to let students know that I cared about them as individuals, and that I believed they could succeed. My hope is that doing this helped build a foundation for more learning.

During my school year at Cold Springs, I was able to save enough to pay the cost of going back to college for the 1948 summer term at Livingston. And so I left my first year of teaching to return to summer school, but with the understanding that I would be returning to my classroom in late August.

A loss I could not imagine

My life, however, was about to change in a way I had never anticipated. My father continued to have an active civic life, serving on boards and participating in the governance of the County, in the course of which he made frequent trips to Livingston and Demopolis. He had told me that on June 24th he would come by the dormitory to see me and take my laundry home for me to do over the following weekend.

Expecting to see him about mid-afternoon, I stationed myself in a rocking chair on the porch of my dorm so I could see my father

as soon as he arrived. The afternoon wore on and he didn't come. Finally, it was dinner time and I left my vigil believing that he simply forgot to stop. My feelings were a little hurt, but I wasn't worried, knowing that my dad could look after himself. It did not dawn on me that anything could happen to him. About 8 o'clock that night, my sister's oldest son, Charles Baskin, found me in my dorm. His face told me that he had terrible news. He said, "Your daddy is dead and I've come to take you home."

Charles told me that my father had come home earlier than expected, telling my mother he was having chest pains and felt that he couldn't stop to see me, that he should just come home. She insisted that he lie down immediately, then sent for my brother to come help her get him to the hospital in York. As they lifted him from the car onto the gurney to enter the emergency room, he told my mother to remember their talks about death and to do the best she could. With that, he took his last breath.

My father's death affected me profoundly, in ways that I only came to understand years later. He was the first person in my family to die; he was the oldest of five siblings who always consulted with him when making important decisions. He was the manager of our farm that provided our livelihood and the respected head of our family. He was a strong pillar of the community. Most of all, I knew that I was very special to him and now he was gone from my life forever. I simply could not believe it had happened, but reality took over and I had to face the future without his guiding hand and his loving arms giving me a hug when I would leave home, always reminding me to "be careful."

When I saw my father for the last time, he was standing by the door on our front porch. Friends had come by to give me a ride back to college, and I was a bit late and rushed out the door without stopping to embrace him and give him a good-bye kiss. I looked back and waved to him as I entered the car with my friends. **That omission is one of the regrets of my lifetime, and this is the lesson I learned: take the time to show people that you love and appreciate them. You never know how much a hug or a word of affection or admiration may mean to someone. Or what it may mean to you to have neglected to give it.**

Learning from Illness and Prejudice

After my father's funeral, I continued through the summer session in college, and when September rolled around I was back at Cold Springs for another school year. I enjoyed every day that I spent in that community. Outside of work, the 18 of us living in The Teacherage entertained ourselves in talk sessions, card games, taking walks, and doing exercises. We participated in community events, including church every Sunday. We made an occasional trip to Cullman to eat at the All Steak restaurant (a landmark still in business). We also journeyed into Jasper for an occasional movie. Those were the days before cell phones, televisions, and computers!

I did love teaching, and got along very well with all my students (even, ultimately, J.R.). I visited in their homes and got to know many of the parents. I managed the cheerleaders and attended all the basketball games. There were no restaurants in the community, so I always prepared the pre-game meals for the basketball team. To this day, I still use an engraved silver tray the basketball team gave me when I left in 1949.

After my father's death, my mother and I both knew that we were going to have to make changes in our lives. A nursing school classmate and long-time friend of Mama's was working in Tuscaloosa and encouraged my mother to return there and resume her nursing career. Mama took that step on a trial basis, and soon decided to make the move permanent. Our family all agreed that our older brother would buy the farm from the rest of us, relieving my mother of the very difficult task of keeping it going.

Since I needed to finish my degree, I decided to transfer to the University of Alabama to be near my mother. For a short time she lived in a small apartment in the hospital, while I lived in a dormitory on campus. In my last year at the University, Mama and I shared an apartment near the campus. After I graduated, she moved back into the hospital apartment, expecting that I would only be home for short visits as I began my full-fledged teaching career.

The day of my graduation dawned with bright blue skies. As I walked

across the stage to receive my diploma, with my mother and brother Walter witnessing the event and the sure belief that my father was watching from heaven, I remember thinking: Life can't get much better than this. I had successfully completed all degree requirements with reasonably good grades; I had managed to find jobs to pay all my college expenses and had no debts; I had paying jobs on the horizon just waiting for me. Life was good and the future was promising to be all that I had imagined.

The day after graduation, I headed to Girl Scout Camp with the Montgomery Girl Scouts, to serve as Program Director for the summer before moving to Frisco City, Alabama, to teach high school girl's physical education and music in the elementary school. I enjoyed the work of the camp and the camaraderie with my fellow counselors.

But after the first month there I began to have chest pains and congestion. My colleagues assumed I needed a round of antibiotics and encouraged me to see a doctor. I did, but after two weeks I was no better, so back I went. The doctor made a chest x-ray, agreed there were still signs of congestion, and prescribed a different antibiotic. I was able to complete my commitment to the camp, and on August 1 returned to Tuscaloosa to have some time with my family before the teaching year began.

Prelude to an ordeal

When I arrived, my mother took one look at me and insisted that I see a doctor in Tuscaloosa. That doctor decided that I had pleurisy and strapped my chest, which did help relieve the pain. After a few days I was feeling much better and decided to visit my brother Charles and his family who lived in Cuba, Alabama.

August is the month of summer's "dog days"—hot, dry weather and not enough wind to move the leaves on a tree. To get relief from the heat we decided to go swimming. There were no public swimming pools in Sumter County, but my brother Charles and I had learned to swim in the local creek, and so we went back to our swimming hole. After plunging in headfirst, I came up coughing blood. We immediately returned to his home, but an hour later, I started coughing up blood again. Charles took me to the doctor in York, who took an x-ray, saw the congestion in my lungs, prescribed another antibiotic, and told me if the bleeding happened again to go immediately to

Rush Hospital in Meridian, Mississippi.

Back at my brother's home, the bleeding returned, and we made the 25-mile trip to Meridian. I had a major hemorrhage while I was being admitted, and was placed immediately in a room and sedated. My mother was called, and the next day I was wheeled into surgery for an endoscopic examination. After another day, hemorrhaging had not re-occurred so I was sent back to my brother's home, with still another antibiotic, and told to rest in bed until my fever subsided.

With those instructions, I was soon feeling much better and toward the end of August made plans for my new job. I arrived in Frisco City with great plans for the future and with enthusiasm for a new beginning as a public school teacher. However, by the time Thanksgiving arrived I was very sick. I had been seeing doctors for two months, frequently calling my mother, who was very worried. While a student at the University, I had worked at the Student Health Center transcribing Dr. Albert G. Lewis's dictation. My mother had spoken with him about my condition, and he told her that he would see me and make a diagnosis if I could get to Tuscaloosa on Thanksgiving Day.

A stunning diagnosis

I left Frisco City early Thanksgiving morning, driving 110 miles to reach Tuscaloosa by noontime. Dr. Lewis spent more than an hour taking my medical history. He had asked my mother to assemble all the X-rays and records of the current illness. After completing my history, he asked me to accompany him down the hall to the x-ray lab. When he displayed the first film he exclaimed, "My God, Mary. You have tuberculosis."

Not content with seeing all five x-rays showing a large cavity on my lung, Dr. Lewis had me do a sputum test to further confirm his diagnosis. I still remember seeing little red and blue squiggly tubercular germs swimming underneath the microscope.

At that point, my mind just froze. I could not begin to think about what to do next. I knew that tuberculosis was considered to be fatal; there were no cures; years of bed rest were primary in treating the disease. To my knowledge, I had never been exposed to anyone who had the disease. I had no idea where I would go next. Mama lived in the hospital where she worked and I had no home. Quite suddenly my blue skies of graduation day had turned to gray skies of disease

and despair. For the first time in my life, I experienced utter fear and uncertainty.

But I was in good hands. Dr. Lewis quickly outlined a plan: the next day I would see a lung specialist in Birmingham; then the two of them would make arrangements for me to be admitted to a sanatorium owned and operated by the State of Alabama. At that time all known tubercular patients became wards of the State: that was the only place I could receive medical care was in a sanatorium. There was no bed immediately available in Birmingham, so my mother arranged for me to stay with my Aunt Emma at her home in Ward until I could be admitted to Oak Mountain Sanatorium.

After the first night with Aunt Emma, I began to hemorrhage again. Dr. Lewis once again intervened and told the sanatorium authorities that I had to be admitted on an emergency basis, available bed or not. My brother drove our mother and me to Birmingham and I was placed in a room about mid-afternoon. Mama was told that she could not stay with me and could only visit on weekends—and that she must leave immediately. That separation was heartbreaking for both of us.

All alone and in the dark

As I told my mother goodbye, I closed my eyes and tried my best to forget about my plight; I just did not want to think. There were no nurses or technicians in and out of my room; no doctor had appeared on the scene. I was left totally alone in the dark.

Suddenly I remembered how comforting it was as a child to go to sleep in my father's arms while he held me at church. I could picture him as he knelt to pray for us at Sunday School. Surrounded by the deep silence of that dark room, I had my own encounter with God. I was able to pray and say to God: "I don't know why I am here, but I accept the reality of what has happened to me. Any return to health is now out of my hands, but You have the power to heal. I want to be healed, but I leave that in Your hands. If my health is restored, I believe You have work for me to do, and I will do it to the best of my ability. I will not be angry about having tuberculosis, but with Your help I will do what I can to be cured. It is all in Your hands." And then I went to sleep.

I awoke a few hours later to sounds of people coming and going. The

room was partitioned by a curtain and I could not see the person in the bed next to mine. I became aware that the patient was being attended to, and that shortly thereafter, she passed away. I began to wonder if I might be next. My mind raced to the worst possible conclusion. Had I been placed in the room for hopeless cases?

My thoughts turned to my mother whose unconditional love for me had always provided the security and safety that all children need. How awful she must have felt to leave her only daughter in an institution so far away from Tuscaloosa, forbidden to see me except for a brief period on weekends. She couldn't drive, and I didn't know how she could get to Birmingham to visit. She was fighting her own battles, working long hours and taking care of herself on her own. She was making enormous sacrifices in her own life, and my illness only added to her burden. I couldn't avoid my own dark thoughts. Even if I didn't die that night, how could we cope?

Remembering my roots and finding strength

I survived the night and began the dull routine of inactive life in the sanatorium. And whether by Greyhound bus and cab or driven by relatives or friends, Mama did not miss many weekend visits. In between, she sent me letters, because patients did not have access to phones. I admit that there were some bad moments for me. But her love and devotion comforted and encouraged me, giving me a strong dose of the strength and optimism that brightened my mood.

I had always thought that my parents were somehow different from many of the families who lived in our small community. Over the years, I had come to appreciate what it meant that my mother saw the world from a broader horizon. She was a leader, and could show the rest of us what she was seeing and what needed to be done. She was a forerunner, open to new ideas, and throughout her lifetime rose to new challenges. She could quickly and accurately analyze a situation, and had the mental and emotional flexibility to adapt to adversity and move forward. Even in my lowest moment, I felt Mama would somehow get both of us through my ordeal. She had always smoothed the pathway for our family, and I knew I could count on her.

In the early l950's, experimental treatment of tuberculosis (TB) included the use of streptomycin, a drug already on the market but never before used extensively to treat TB. I received a massive dose, and

within three weeks I had no apparent symptoms of the disease. I was moved to a dormitory-like pavilion where I met other women, some of whom had been there for as long as three years. The ticket to being released from the sanatorium was an x-ray showing acceptable status of the cavity on the lung. I told my fellow patients that I believed I would be going home in three months, after the results of my scheduled X-ray were evaluated. They laughed at me.

But I made friends with my fellow patients: some twelve women all brought together by a fate that none of us wanted or sought. **With great hopes that God would answer my prayer for healing, I was determined to portray a positive outlook for those around me every day, and particularly for my family who came to visit. I could not imagine spending my future being miserable about my life and rehashing what had happened to me. Instead of asking "why?", my hope was simply to find joy with the belief that a happy outlook could help to transform me.** I enjoyed reading books and answering letters from friends and family. My soul was nourished and my resolve to fully recover strengthened by the many loving visitors who made the journey to Oak Mountain for the brief visits allowed.

My outlook was also made more positive by the many former students from Cold Springs and Frisco City who sent me cards and letters, and also paid short visits. One former student from Cold Springs wrote to me from Germany while serving in the Air Force; the students at Frisco City dedicated the school's Annual to me, devoting a full page to my picture and a citation! I can never adequately express how much these gestures meant to me. At moments when I thought I might not make it, these mementos let me think that perhaps I had done a little good in this world, and my better nature would take hold of the moment and return me to optimism.

An ordeal becomes a blessing

In March, 1952, three months after I had been admitted, my time in Oak Mountain did indeed end. After the scheduled x-ray, I was told that I would be discharged. The doctors could not find any active TB agents: I was free of the disease. After I was released, I paid a visit to Dr. A.H. Russakoff, the specialist who had confirmed Dr. Lewis's diagnosis and helped admit me to the sanatorium. He recommended another six months of limited activity, with lots of bed rest, as well as six more months of streptomycin, which proved to be a good call.

Dr. Russakoff continued to check my lungs over the next two to three years and found that the scar tissue had completely disappeared. He told me that nine out of ten radiologists could not detect that I had ever had tuberculosis. Over the years I have had many chest x-rays and not one question has ever been asked of me regarding abnormalities of any kind.

While I was in the sanatorium, Mama decided to buy a house in Tuscaloosa so the two of us would have a place to be together. I am sure she was thinking of the fact that, even though my recovery so far had gone spectacularly better than expected, neither of us could know when I could return to productive employment. It took a few weeks to make final arrangements on a house, and I spent that time in Monroe County with my brother Walter and his wife Mollie. I then returned to Tuscaloosa and joined my mother at our new home to complete the prescribed six months of rest. Mama was working at the University Student Health Center, and would continue there until her retirement in the late 1960s.

In retrospect I learned some important life lessons during my prolonged illness. I learned how important my Christian faith had been, and the complete trust in God that had helped my healing. This experience affected me deeply, so much so that I could put aside any fears about the future. I had come through an ordeal, and I knew it was not because of anything I did, or could have done. I was determined that I would not live in fear of the future; instead, I trusted in God that my life could be joyful, and I intended to embrace it fully. I thought it unlikely that I would be married and have a family, but I wanted to do some work that had meaning, and I wanted to help make a better world.

Over time I have come to learn that this major illness was a blessing, and looking back I now understand how it was a major force in shaping my future. As I approach 100, I often reflect on the wisdom of words written by Anne Lamott: "I do not understand the mystery of grace—only that it meets us where we are and does not leave us where it found us."[4]

Preparing for an unknown future

In the summer of 1952, college degree in hand and health restored, I began the search for a new life for myself. For women of today, it is difficult to comprehend how limited opportunities were for women in

that era. Professional jobs were primarily teaching and nursing; other "pink collar" jobs open to women were secretarial or clerical work, retail sales, and industrial sewing.

I was not sure I could teach again, although I still had hopes of returning to that work, which I had enjoyed. While I did not want to be a secretary, I realized that to re-enter the workforce, I might well have to go in that direction. Through the Vocational Rehabilitation Service I was given an opportunity to enroll in a class in Speedwriting, a new approach to taking dictation that was different from the more traditional Gregg shorthand taught in business schools of the day. By mastering this skill, I thought I might be eligible for a respectable job in Tuscaloosa—not very much pay, but neither was teaching school a highly paid job.

So I became a student once again. For six weeks, I spent the morning hours learning to take dictation.

Thus far I had made no applications for jobs. The teaching job in Frisco City had been filled. Hoping against hope, I called my former principal at Cold Springs. To my surprise and delight, he asked if I would like to teach again. "Of course," I replied with enthusiasm. So we agreed that I would begin in September, right back in the same community where I first taught, returning to The Teacherage and the living situation that had been so agreeable and so much fun.

The ugly punch of ignorant fear

But at the end of July, I had a telephone call from the principal. He told me that the residents of The Teacherage did not want me to return to live with them. They had all sorts of objections related to my illness, and expressed fear that they would all contract tuberculosis. Although he reminded them that he had clearance from my doctor, they still would not consent to my coming back. He offered me a room with his family, and said that he supported me and the job offer still stood. "Mary, I know this will be hard," he said. "But I sincerely hope you will take the job."

I was stunned! It had never crossed my mind that I would be confronted with anything of this nature as a result of my illness. That educated people would refuse to accept scientific facts about the disease in question and give no credence to the evidence presented by my doctor floored me. This was personally devastating.

After three days of trying to think through the circumstances of the moment, I called the principal and told him that I thought it best that I not return to teaching.

I felt then that hard times for me were not nearly over, that perhaps there was much more bad news ahead. However, I told myself that I would not give in to prejudice and ignorance, and that I would press on until something better came my way.

The lessons I learned from this part of my life—the importance of faith and perseverance, the corrosiveness of ignorance, the necessity of changing course to your ultimate goal when one pathway is blocked—have helped me to this day.

Learning from New Opportunities (Even Though It Took Nudges from Mama and Dr. Russakoff)

A few days after I received the unexpected news from Cold Springs, Mama came home from work and told me that the Job Placement Office at the University would like me to register with them. She was friends with the director, so I was certain Mama had arranged this. And so to please her, I did go to the campus and had a conversation with the Director, then filled out the necessary forms to be placed in the active file.

Shortly afterward, Mama called with a message that the Placement Office wanted to schedule an interview for me for a job with the new Congressman who had just been elected from the Tuscaloosa district. Armistead Selden was a native of Greensboro in the heart of the Black Belt of Alabama, so called for the soil that enslaved people had plowed into plantations. I told her that I was not interested in going to Washington, I didn't want to go that far from home, I didn't even know the man, and so I didn't think I should go for the interview. She insisted in no uncertain terms that for me to refuse to even talk with his representative would be nothing short of rude. "Just go for the interview, Mary. It's very nice of them to be concerned about helping you. They want to talk to you, and you owe it to them to at least have the conversation."

And so I agreed to the interview. I listed my scant work experience, and told the interviewer that I was learning to take dictation and was already very good at typing. He told me that the job entailed answering Congressional mail; that I would work with three other people; that the Congressman was a freshman who would be running for re-election in two years. He told me when I would have to arrive in Washington. He said I would need to find a place to live and promised to send information. He told me that the salary was $4,080.

With that, he offered me the job.

Shocked, I thanked him and explained my health issue. I said that I would need to think about it for a few days and also go to Birmingham to confer with my doctor. He seemed to understand and said to

call him when I could make my decision. "But," he said, "I'll need to know within a week."

Mama was elated. She said this was a grand opportunity for me and that I should accept the offer right off. I said I wasn't sure it was the best thing for me, and I certainly did not want to commit until I talked with Dr. Russakoff. I arranged to see him in Birmingham the next day. He did his usual thorough exam and said I was doing splendidly.

I doubtfully told him about the job offer, reminding him how important my health was and emphasizing that I did not want to jeopardize it in any way. I cited the weather in D.C.: "They often have snow and ice; I won't have a car and I'll have to use public transportation." He looked at me and smiled, and with words I'll never forget, said: "My dear, they are still making umbrellas and raincoats. I suggest you get one of each, and catch the next train to Washington, D.C."

In early January of 1953, I arrived in Washington after an overnight train ride. By telephone and mail, I had managed to find a room near Lafayette Park. I could see the White House when I walked out the door of the rooming house going to work every morning. I had a small bedroom, with a bath down the hall. From my bedroom window, looking out on 16th Street, I often saw famous people (including President Eisenhower) arriving at the Statler Hilton for newsworthy events.

Exploring the city and realizing a childhood dream

I quickly picked up on the office routine. I was the most productive "letter writer" in our office. Sometimes I took dictation, but more often than not, we were given a stack of letters and expected to frame appropriate answers. Sometimes we even wrote letters in which we thanked people for thanking us! Occasionally I called government agencies to get the information I needed to answer constituent requests. After all the writing, then came the filing of correspondence.

Congress usually adjourned by the end of July. We would then come home to Tuscaloosa where we opened our office in the Post Office Building, now the City Hall for Tuscaloosa. There was less work to do then since Congress was not in session, but people would come by to visit and sometimes needed help that we could provide. When January came, we were once again off to Washington.

Learning to navigate the city was an intriguing opportunity for me, and I made the most of it. Sightseeing every minute when not at work occupied me almost full time. I made friends with other women who worked in Alabama Congressional offices and who knew the town. They led me to experiences that I might otherwise have overlooked. I went to the theatre; heard the Washington Symphony at Constitution Hall; saw the 4th of July celebration at the U. S. Capitol. On weekends I would take trips into the countryside visiting Gettysburg, Manassas, Charlottesville, and the historic homes in the area. I quickly learned to be the staff person who could take visitors from Alabama to tour the Capitol, usually ending with a lunch that of course had to include the famous bean soup in the House Restaurant.

I also joined the Congressional Secretaries Club and through one of their planned excursions realized my childhood dream of going to New York City like my mother had. We saw Broadway shows; had a boat ride around the Island; took in a performance at Radio City Music Hall; and were feted at a fancy reception, courtesy of Schenley Liquor Company. I felt rather strange being hosted by a liquor company: my family were teetotalers, but I could still see the potential for influence peddling. At that point in my career, I could be happy that I really had no influence on matters pertaining to liquor interests, or any other special interest for that matter. I just typed the letters!

Deciding to do work that mattered

In all candor, making new friends and learning my way around the city was exciting, but I was bored to death with what I did in the 8-to-5 work week. I did not feel I was accomplishing anything worthwhile, and I had some cultural differences with some of the Black Belt aristocracy. Sitting at a desk with an Underwood manual typewriter preparing the same letter over and over was not something I wanted to do the rest of my life. It was not my job to learn about legislative issues, but occasionally the Congressman would come back from the House floor and tell us something about happenings there. While I often took visitors to the House Gallery, I knew just enough to answer their questions. I wanted to get out of the secretarial side and into the legislative side where the real work was going on, but I didn't see any way of doing that from where I was.

In April 1955, the beginning of my third year in Washington, I had had enough. **I knew I had exhausted the possibilities of that situa-**

tion, and if I couldn't be doing work in Washington that I believed mattered, I would go elsewhere to find work that could make a difference in people's lives.

I decided that I was going back to Tuscaloosa and find a teaching job. I had saved some money, and could cash in my retirement withholdings, so, with my mother's blessing, I finished my commitments in D.C. and made the big move. I was thrilled to be back with Mama in Alabama and immediately started making contacts to help me get back into teaching.

When tuberculosis forced me to resign from my teaching job in Frisco City, I had given the principal complete information about my condition and encouraged him to ask the Alabama Department of Public Health to send a mobile unit to check everyone in the school for TB so that treatment could begin immediately if needed. (I was relieved to learn then that I had not infected anyone.) Mr. Lee kept in touch with me while I was in the hospital—even visited once. When I wrote to him from Tuscaloosa in the early spring of 1955 he was ready to offer me a job. He said he was sure he would be needing teachers for the September opening of school, and he assured me that he would do all in his power to bring me back to Frisco City.

During the intervening weeks I tried to make myself useful to Mama and renewed my ties to Trinity Methodist Church. I organized and reviewed instructional resources to prepare myself for a September job. I was getting ready to take the next step, and that step was firmly away from Washington, D.C.

Until the telephone rang.

Learning from the Politics of the Possible

When I answered the telephone that afternoon in July 1955, I was surprised to hear Congressman Carl Elliott asking me to come to Jasper, Alabama, the next day to talk with him about a job as his legislative assistant. I knew him from Washington: he was part of the Alabama delegation, representing the Congressional District contiguous to that of Congressman Selden. I had visited with him and his wife and children at the annual Alabama State Society picnics, and a good many evenings he and I chatted as we rode the same streetcar on our ways home from Capitol Hill. One evening, I shared some photographs I had from my years of teaching in Cold Springs, which was in the district he represented. I was deeply impressed by his interest in the ordinary people who lived in that rural mountain-top community.

Mr. Elliott remembered meeting me years earlier, in 1948, at Cold Springs Baptist Church, where I was playing the piano for an all-night singing when he was campaigning. In those days, when members of the community came together to enjoy gospel music, "all night" really meant all night. His drop-in visit provided respite for me from playing the piano, so I remembered him as well! That night the minister introduced Carl Elliott as a candidate for Congress, and reminded everyone that he was running in the upcoming primary election and that he was a man we could trust and be proud of.

Mr. Elliott then spoke for a few minutes, telling us why he was running for Congress. He wanted to help people, especially those who wanted an education and had no resources to pay for it. After his speech he took time to shake hands with everyone, including me, and we chatted for a few minutes while I told him about teaching, and where my family lived. He was elected by a large majority in the Democratic primary which, in those days in Alabama, was tantamount to election, although the November general election was still on the horizon. Minimum voting age was 21 at the time, so I was too young to vote for him, but I would have. He impressed me then as a man with integrity and good ideas.

Now meeting at his home in Jasper in 1955, Congressman Elliott

talked to me about what he hoped to achieve in the coming years. He was deeply interested in education, and told me that he thought I was someone who could help him achieve success in legislating for education. He also told me that he thought it vital to regularly schedule visits throughout his district to meet with people, to explain to them what he was doing and how he voted on bills during each session. Based on our streetcar conversations, he hoped I would be interested in becoming his legislative assistant to work on these matters. (Judging by the variety of challenging tasks he ultimately gave me, he may also have been thinking of the job description boilerplate "and all other duties as assigned.") His concern for the economic stability of his district, where there were many unemployed coal miners and small farmers, was obviously sincere. He wanted me to come to work immediately, and then return with him and his staff to Washington in early January.

Recognizing the opportunity and deciding to take the risk

Decision time! I had no contract for a teaching position, but I was reasonably certain that one was forthcoming. I had worked on Capitol Hill and had been bored by my responsibilities, but the opportunity to leave the rote letter-writing behind and become a legislative assistant was very attractive to me. I knew that if the Congressman was successful in what he wanted to do, then it would be an opportunity to help effect change on a scale that I couldn't do as an individual teacher. In contrast to my previous stint as a Congressional secretary, I felt Mr. Elliott really was interested in my capabilities, and that he saw strengths in me that before had been overlooked. I began to feel that this job could be the opportunity of my lifetime. I left the Congressman's house telling him that I needed a little time to think about his offer, and that I would discuss it with my mother, and get back to him in no more than two days.

Mama had never met Mr. Elliott but was willing to trust my judgment. Principal Lee in Frisco City, who was expecting to hire me to teach, told me to make my best judgment and that if I decided to return to Washington, I would go with his blessings. By this time I didn't feel the need to check with Dr. Russakoff: I was excited by the prospect of returning to Cullman County, where I had friends, and getting to know people throughout the Northwest Alabama District. By far the most tantalizing part of the offer was to be the legislative assistant. I knew it would be a challenge, and that I had a lot to learn,

but I felt confident that I could do a good job. In the end, I called Mr. Elliott and told him I was ready to report for work. He wanted to know if I could come that day!

In August 1955, I started on a ten-year journey of working for Congressman Carl Elliott, and another 35 years of enjoying a close friendship after he left Congress. In my eulogy at his funeral, I described him as "my mentor, my friend, and my hero." He sought to develop all the talents I possessed and gave me every opportunity to use my abilities to help achieve his goals for the nation, and for Alabama. The work I did with him uniquely prepared me for the career steps that followed until my own retirement in 1994—and for the work I've done in the almost thirty years since then.

In the late 50's and 60's, regular order prevailed in Congress: appropriations bills to run the government were generally approved on time. Authorizing committees had time and resources to explore new legislation and provide oversight on existing programs; appropriations committee work did not make use of "continuing resolutions" as is now the case. In short, Congress actually dealt with the nation's ongoing business, and tried to find solutions to the nation's problems. The bipartisan polarization that has paralyzed our government for the past many years did not exist. Congress worked five days a week. If the House was in session only three days, the other two days were spent in committee hearings. This steady work made it possible for Congress to adjourn every year no later than September; but the goal always was to adjourn at the end of July. That gave members time to spend in their districts and to travel overseas when responsibilities called for such travel. Mr. Elliott did not return to Jasper and his district every weekend. He and his family—wife Jane and their four children, Carl Jr., Martha, John, and Lenora—lived in Washington while Congress was in session, and in Jasper the remainder of the year, so that the children were in school in Jasper in the fall, and in D.C. in the spring.

Democracy demands communication—both speaking and listening

In my first months on the job, from August through December, I traveled throughout the 7th Congressional District, sometimes alone and other times with Congressman Elliott. My first journey was to accompany him to Cullman where each week while at home he would make a radio program called *Report to the People*. He did the same in

Washington at a recording studio: we mailed the tapes to Cullman for distribution throughout the district. Part of my job each week was to suggest timely legislative topics that would be of interest to the people at home. I also scheduled town hall meetings to offer his constituents opportunities to hear reports directly from him and to ask questions and make comments. These meetings were always conducted with civility and without rancor. If people wanted to register complaints, they would ask him to step aside for private conversation. I took dictation of the Congressman's letters to colleagues about legislative matters, and he would brief me on issues he wanted to pursue in the next session.

Mr. Elliott was a very principled man and was always very clear with his staff about those principles. He told me when I started work with him that there were "some things I won't do just to keep this job. However, there are some things I don't ever want to do that would cause me to lose my job." Among them was what he called petty stealing. He cautioned that we were to be very careful about filling out paperwork for reimbursement of expenses. For example, he would say, "it costs $1.25 for a cab ride to National Airport. [A true statement back then!] Please do not ask for $1.50: be sure to put down the actual cost." With that admonition he trusted me to sign his travel reimbursement requests. **I remembered the Bible verse I learned as a child (Luke 16:10) and made it a personal rule, in that and every other job I held, and throughout my life. I strove to be "faithful in little things" so that it would follow naturally to be trustworthy in the big ones as well.**

Mr. Elliott, his family, and his staff all returned to Washington when Congress convened in early January 1956. President Eisenhower gave his State of the Union address in mid-January—that event signaled Congress to start work immediately. My first task every day was to summarize the previous day's Congressional Record and brief Mr. Elliott on any committee meetings or votes scheduled for the day. He had other reminders: Whip notices, Majority Leader's schedule, and discussions with his Congressional colleagues. I always tried to make sure he knew about any mail that we had received on the issue at hand; any discussions I had with other committee staff; and any other details that I thought would interest him. Every day I also scanned the Congressional Record for items that should be called to his attention. He served on the Committee on Veterans' Affairs, so I

paid special attention to the work of that Committee.

I had my share of Congressional mail to answer and took turns with the telephone calls to our office. I was expected to read a dozen or more weekly newspapers to keep up with events in our District and, when appropriate, write letters of congratulations and/or appreciation.

Learning the Hardest Lesson of Functional Politics

The Congressman would assign me to attend committee hearings on topics of interest to him. I made many phone calls and attended hearings of the Subcommittee on Cotton of the Agriculture Committee. Many small farmers in our District planted cotton and depended on acreage allotments and price supports. I had to gain an understanding of how the system worked and be able to respond to their letters and phone calls. In addition, there were hearings when Mr. Elliott wanted to testify on their behalf.

At one of our morning briefings, Mr. Elliott told me that he was going to vote against the Civil Rights Bill of that year, and he asked me to prepare a statement for him to include in the hearings of the Committee. He also suggested that I attend a hearing at the Judiciary Committee chaired by Congressman Emanuel Celler of New York to learn more about the legislation that was being proposed. At the hearing the primary witness was the Attorney General of the State of New York, a famous lawyer named Louis Lefkowitz.

Attorney Lefkowitz told the Committee that he made a study in Alabama of the number of African-Americans registered to vote. He had gathered statistics from several counties, but the county he chose to highlight was Sumter County, Alabama, the place where I was born and raised. He reported that African-Americans who lived in the county were being totally suppressed and unable to register to vote. I left the hearing with no doubt in my mind that there was wrong-doing in my home county, and I just knew that when I informed Mr. Elliott of the facts he would change his plans and instead support the voting rights bill.

I returned with this big news and walked in the Congressman's office to let him know what I had just discovered. When I finished my story, he asked me to have a seat. He said, "Mary, I have to tell you what you may not want to hear, but I cannot vote for that bill. I wish I could, but if I do I cannot be re-elected from Alabama. My seat would be taken by someone who not only will not vote for civil rights, but he won't vote for education, for health care and hospitals, for housing,

for farm programs, and a host of other measures that people of our District, both black and white, desperately need. You must understand that the practice of politics is an art of the possible, and what is possible is not always perfect. So you go over to the Library of Congress, do some reading, and then write a statement."

So I did. I didn't like it, but I had to accept that was what was necessary at the time. In the real world of politics, Mr. Elliott often had to take a position that was not the perfect one, but which could make possible the next step in the right direction. **The real strength of an elected official is the ability to create consensus through give and take to make progress and move our nation forward with legislation that both provides opportunity and preserves freedom.**

But there are limits to accepting incremental change, to "going along to get along"—or even going along to get something done rather than nothing. In 2022, we saw sacrificial statesmanship by Republican members of the House select committee investigating the January 6, 2022, attack on the U.S. Capitol, particularly Representative Liz Cheney of Wyoming. Because she had the courage to stand on her principles of government and of right and wrong, she lost her seat in Congress. My hope is that the example of principled people throughout our history—like Carl Elliott in his time and Ms. Cheney recently—will inspire support for the rule of law. Without this, our democracy cannot survive.

Serving with an honest man who got things done

During the years I worked with him, Mr. Elliott more often than not voted his conscience, although on the questions of civil rights, his survival in Congress continued to require him to oppose voting rights bills. On other issues, however, he cast votes on matters pertaining to labor unions and public housing that were controversial with some of his wealthier constituents. He was a constant friend of the Tennessee Valley Authority, the federal corporation whose dams continue to supply electricity for much of North Alabama, which played a significant role in the development of the economy.

As a rule, Mr. Elliott represented with integrity what his conscience demanded, yet balanced that with how the people he represented wanted him to vote. He was always sensitive to their needs, but he also considered himself to be a Congressman for the nation. The key

was to find balance between the two. He would say to me on occasion that if a Congressman stays in office long enough he eventually casts enough votes that he makes every group in his district angry; consequently, he would add, "You need to help me find new people every year. We need a constant stream of new supporters if we expect to survive at the voting booth every two years."

What I learned about Carl Elliott's background and character from working with him only increased my respect for him. Carl grew up without many comforts other than his family's love. His parents were tenant farmers in Vina, Alabama. He loved to read, but his home had no books beyond a Bible and neither his school nor community had a library. But he was known as trustworthy, so neighbors and an uncle loaned him everything they had and he read it all. Carl was the eldest of nine children and from the time he was a child, in addition to going to school, he worked doing whatever he could to help his family make ends meet, including the hard physical labor of farming and, later, hauling lumber. He was the janitor at the high school from which he graduated as valedictorian in 1930.

While he was in high school, his parents took him to hear Dr. George Denny, the president of the University of Alabama, speak at a public meeting in Russellville. Dr. Denny said that the purpose of the University was to educate the sons and daughters of Alabama, and it was "in easy reach of every youth of Alabama." Carl took Dr. Denny at his word, and after graduation and a summer of working to help support the family, took his meager savings to Tuscaloosa. He planned to ask for part of his tuition and fees to be deferred, and then to do what he had always done: immediately find work to start paying his way.

He and a friend began walking the hundred miles to Tuscaloosa to the University. A neighbor saw them en route and arranged a ride for them, so they arrived the same day they began. They presented themselves to Dr. Denny, expecting to be advised about next steps for enrollment. But what they heard instead made Mr. Elliott realize that when Denny had said "the sons and daughters of Alabama" he had apparently meant the sons and daughters of privilege and wealth.

Instead of encouragement, President Denny told them what they already knew: times were hard. They needed some support from home in order to attend the University, he suggested—but neither of their families could offer financial support. He brusquely advised them to

return to Franklin County, find work, save money, and come back in a year or two and enroll. His opinion was that they hadn't tried hard enough to be prepared. And beside all that, President Denny said, "You don't have the kind of clothes you should wear at this University." And with that he sent them out of his office.

But Carl hadn't come that far to give up. I encourage you to read his own account of his time at the University in his 1992 book *The Cost of Courage*. In summary: six years later, after living in some primitive conditions and working five jobs at a time while maintaining an A average in full-time coursework and consistently sending money home to help his family, he had earned a master's degree in history and graduated from the UA School of Law. He also ran for President of the Student Government Association and was the first non-fraternity-affiliated student to beat the campus machine and win. In years to come he would often say, "I learned more politics in that campaign than I have been able to use since."

Mr. Elliott came to Congress in 1948 knowing he wanted to pass legislation to help poor students go to college, a commitment born out of his own student experience. He said the greatest and most difficult achievement of his life was earning his two degrees from the University. He told me he was grateful that he had possessed the physical strength, and not just the mental determination, to work his way through those six years. He saw others who didn't have his constitution fall by the wayside, and he felt there had to be a better way. He felt that America needed to find a way to help young people develop their talents, not just for their good but also for the good of the nation. He succeeded in reaching that goal—he was a guiding force in the creation and successful passage of two key pieces of legislation that opened to people across the nation unprecedented opportunities for education: The Library Services Act of 1956 (LSA) and the National Defense Education Act of 1958 (NDEA).

Seeing how "across the aisle" works

Mr. Elliott's ultimate success in getting legislation passed came in part from his years of earning the respect of both his Republican and Democratic colleagues through hard work, fairness, and consideration. He did more than his share of the housekeeping chores necessary to help the House of Representatives function well. He served on the House Administration Committee and was responsible for assign-

ing parking spaces, a thankless task but one in which he gave up his own parking space for someone he thought deserved a better spot. He helped with oversight of the Government Printing Office. From time to time he also participated in controversial election re-counts that were conducted in several states to determine which candidate would be seated in the House. These were chores that many members tried to avoid at all cost.

In his committee work, Mr. Elliott accommodated other members by traveling to their districts to hold hearings. He extended every courtesy possible to schedule hearings that did not conflict with other responsibilities of members. He invited Republicans to submit names of witnesses whom they thought could make contributions to the hearings he conducted. He respected all points of view and treated everyone, including witnesses before the committees, with utmost respect. He was generally viewed as bi-partisan, accommodating, respectful of others' opinions, and a competent legislator. He could inspire others to join in his efforts, recognizing that legislation is never a one-person achievement.

Working on laws to make life better for all

In his first committee assignment, as a member of the Committee on Veteran's Affairs, Mr. Elliott supported legislation to extend the time period when World War II veterans could receive readjustment benefits to tide them over until they could find work. His was a crucial vote in favor of President Truman's National Housing Act. He cast votes for Social Security, rural telephone services, and overtime pay for minimum wage employees. He demonstrated his independence by breaking with his Alabama colleagues to vote for statehood for both Alaska and Hawaii.

In his early years of service, he was deeply disappointed when legislation to provide funds for libraries and education failed. However, in a short time to come he would experience success with these issues to which he had been committed throughout his lifetime.

To achieve success in any legislative endeavor, it is important to be in the right place at the right time, serving on the right committee. Those factors began to come together in 1951 when he was able to move from the Veteran's Affairs Committee to the Committee on Education and Labor. It was here he wanted to use the seniority he was

gaining to play a major role in our national life. He developed a close working relationship with Alabama's senior senator, Lister Hill. Their partnership was a significant factor passing landmark legislation for libraries and education. Both were authors of the LSA and the NDEA.

When Mr. Elliott began his first term in the House in 1948, Senator Hill had been serving in Congress for 25 years, first as a member of the House of Representatives and, starting in 1938, in the Senate. As a senator, he had created for himself a unique role. He was Chairman of the Senate Committee on Labor and Public Welfare and was also Chairman of the Senate Subcommittee on Appropriations for Labor and Public Welfare. Leading both components of this two-step process of authorizing and appropriating gave him a powerful voice on the fate of legislation regarding libraries and education over which his Committee had jurisdiction.

The Library Services Act of 1956

In 1946, two years before Carl Elliott was first elected to Congress, Senator Hill had been introducing bills to fund establishment and/or improvement of libraries in rural areas. None of the bills had passed, but each had gained significant support in both houses. Over the years, Senator Hill continued to champion this cause, and knowing of Congressman Elliott's intense interest in libraries and education, persuaded him to become one of the prime sponsors of the 1956 library bill in the House of Representatives. This time they would be seeking $37.5 million to be allocated over a period of five years at the rate of $7.5 million a year. The money could be used for buildings, bookmobiles, book acquisition, and scholarships to educate librarians. They saw the federal funds as seed money to leverage more funding from state, county, and city governments.

Mr. Elliott used stories from his district to illustrate the deep need for libraries in rural districts like his. Mr. Elliott's 7th Congressional District had fewer libraries than any other part of Alabama. The district was primarily rural, characterized by poverty, and by a declining population. The area's traditional occupations of coal mining and small farming were no longer sustainable ways to make a living. Many children living in those counties had never had access to a library, in school or in the public square. Books were a luxury, and many families could not afford to purchase them. In the context of that time, Mr. Elliott would often say of the legislation for libraries, "we are plowing

new ground." Federal funds for libraries had never before been appropriated. Moreover, Mr. Elliott was legislating in an era when Congress worked from balanced budgets. Raising the nation's debt limit was not even considered a possibility. Today's national debt, measured in the tens of trillions of dollars, would have been unimaginable! In l956, some conservatives viewed library funding at $7.5 million per year for five years as leading straight to an unbalanced budget and the fiscal ruin of the nation.

Gathering evidence of the hunger for knowledge

While he was home in the district in summer 1955, Mr. Elliott rode through Winston County on a bookmobile sponsored by a group of women's clubs in the area. To enliven the hearings and supplement the statistics substantiating the need for the funding, Mr. Elliott brought first-hand stories of the people who would benefit from expanded services, people who came out of the hills and hollows to tap into the intellectual world brought to them through books. He told about a lady who returned and refilled with new selections a wheelbarrow full of books for her own family and several neighbors. He described an 80-year-old gentleman who came to the bookmobile and asked the librarian for a book on the outer reaches of the universe. "I find," he told the librarian, "I need to know about space."

Senator Hill and Representative Elliott were surprised, but pleased, when President Eisenhower openly supported the library bill and sent representatives of the Department of Health, Education, and Welfare to lobby for it. There was fierce opposition from Congressional members of the conservative coalition as well as members from urban areas who were disappointed that the cities had been left out. But thanks to the work of Mr. Elliott and the other supporting legislators and with the efforts of librarians and educators from all over the United States, the Library Services Act won passage in l956.[5]

Getting books into Alabamians' hands

With the funding from the act, at the end of four years Alabama had established or expanded seven multi-county regional libraries, and had put six new bookmobiles in operation. More than 700,000 Alabama residents had been provided with new or improved library services, and state and local appropriations for libraries had increased by nearly $600,000.

In 1960 Mr. Elliott moved to fully fund the library program for another five years, working in concert with Lister Hill in the Senate and colleagues in the House. By this time, he had gained strong support from representatives of other states who had seen first-hand the positive impact of the legislation in their districts. They bypassed the conservative opposition holding up the approved bill in the House Rules Committee. By shrewdly using parliamentary procedures, Mr. Elliott and other supporters got the entire House to agree to bring up the Senate bill for a vote. Under a move to suspend the rules, the Senate bill was passed overwhelmingly by the House. Thus the Library Services Act was fully funded for another five years. The Act was later enlarged to authorize $40 million annually for library services located in both rural and urban areas. This was a tremendous victory for all who had labored to provide library services for people living in rural America.

The impact of the Library Services Act was felt far beyond the borders of Alabama. By the end of l969, the number of counties in America without adequate library services had been reduced by two-thirds. Hundreds of new libraries and thousands of new librarians were serving the public. People in the country's poorest areas, mostly in the South, could either walk to fully stocked libraries or be reached by bookmobiles.

As a legislative assistant, I treasured the thrill of helping to improve the lives of people who lived in rural America by bringing sources of knowledge they could freely access in books. I was 27 when the original LSA passed, and I thought, "This is really BIG TIME for a girl from Ward, Alabama." I did not imagine the future about to beckon me.

Legislating for education

Mr. Elliott waited patiently to push forward on education legislation. He took a major step toward his goal when, in 1957, he became chair of the Committee on Labor and Education's Subcommittee on Special Education. The Committee chairman, Representative Graham Barden of North Carolina, was a very conservative Democrat who believed that maintaining the status quo was his primary mission. To counter Barden's influence, the leadership of the Democrats began to add to the Committee fresh faces on their side of the aisle. In 1955, Edith Green of Oregon, Frank Thompson of New Jersey, and Stewart Udall of Arizona joined Mr. Elliott and Lee Metcalf of Montana on

the committee and began to cooperate to make changes, becoming known as the "Fearless Five."

They took on Chairman Barden and forced a committee vote to create five Subcommittees so the work of legislation could be achieved. Next they forced the appointment of subcommittee chairs. At that time, seniority prevailed in the Congress as a tool of organizing. Mr. Elliott was number six in seniority, thus not in line to become a subcommittee chairman. However, number five was an African-American Congressman from New York, Representative Adam Clayton Powell. He was well known for always offering the "Powell Amendment" to major legislation to make it illegal for Federal funds to be used for programs that discriminated against persons on the basis of race.

Consequently, he was an anathema to many members, particularly those from the South because so much "legal" discrimination already existed there. Maintaining the status quo was a successful strategy that had been used time and again by Southern Congressmen (there were no women members from the South then) with the result that progressive measures all died somewhere along the way, if not in the authorizing committees, then in the Rules Committee.

I can only imagine the turmoil in Congressman Barden's mind when faced with the dilemma of appointing Powell, the radical, who wanted to integrate institutions and programs, or Elliott, the progressive, who wanted to spend money on education. I'm sure that Barden felt he was caught between the Devil and the deep blue sea, and in the end he chose Mr. Elliott. In his mind, I imagine, that choice represented the lesser of two evils.

After the committee session when the names of the subcommittee chairs were announced, Mr. Elliott returned to the office and called me in to meet with him. He told me what had just happened, and he said, "I want you to be the Clerk of the Subcommittee on Special Education. I've been thinking about this for the past several weeks, and I think you can do the job. It doesn't mean a great pay raise, but this is something I need you to do."

I was shocked beyond words, reminding him that I had never before had a job like that and was not sure it would be best for him, or for me. He replied that he had never been a subcommittee chairman but

the two of us would learn how together and get the job done. With that, I had a new job title, and job description.

An Alabama girl in the Congressional whirl

My work assignments were very different, but I still worked at the same desk in Mr. Elliott's office that I had occupied as his legislative assistant. There was no office space available for all the new subcommittee clerks. I was the only female among those clerks: all the other women attached to the committees were secretaries. At the time, I was glad to be in proximity to Mr. Elliott since his primary legislative responsibility was now running the subcommittee. He immediately began the process for developing his agenda for education.

Legislation to provide federal aid for education was not an ordinary everyday event in the halls of Congress; in fact, it had only occurred on rare occasions throughout our nation's history. Opponents always argued that education was not included in the Constitution as a responsibility of the federal government; supporters would counter by pointing to the General Welfare clause of the Constitution and to the history of federal aid given to higher education through the Land Grant College Act of 1862. Issues of aid to parochial schools, and to "separate but equal" schools in the South, were reasons to avoid the subject, especially if you represented a district in the South.

Those issues did not deter Carl Elliott. He was passionate about making college affordable and accessible. He believed that poor students should not have to do what he endured in order to get an education. He felt that the economic future of the nation depended on all its citizens having an opportunity for education. In his mind, America's future needed everyone's talents, and he was determined to find a way to nurture them.

His first instruction to me was to get ready to hold hearings. We planned to begin with a series of hearings in Washington, then to go across the country to the states and districts whose representatives served on the Education and Labor Committee. In all these hearings, we were to look at the question of need; demographics of who entered college; the cost of getting a college degree. We were also to consider the merits of scholarships versus loans, and to assess manpower shortages which were evident in the fields of science, engineering, and foreign languages.

Going to the places where Emma and I had sent the mail

I had to kick into high gear to climb the learning curve that faced me. I had never traveled extensively: I had mostly gone back and forth between Alabama and Washington. Planning logistics for a hearing, organizing travel, surveying the hearing site, organizing a local support group, meeting the local press, preparing a briefing for the Chairman and Subcommittee members, instructing potential witnesses, and making everything happen without a hitch at first seemed to me the equivalent to performing miracles. I certainly approached the job with as much prayer as hard work, which I could fortunately do at the same time!

Early on, Mr. Elliott taught me that it was important to be flexible, and he demonstrated that ability many times. Before moving into hearings in the field, he decided that we should concentrate on legislation asked for by the administration of President Eisenhower. The President's bill provided for a small pilot demonstration program to address a growing problem of juvenile delinquency. Experts believed that such projects would reveal best practices for countering delinquency, particularly in the large urban areas of the country. The first day of hearings placed our Subcommittee on the front page of *The New York Times*,[6] featuring a picture of Congressman Elliott with two of the witnesses and a write-up about the legislation. That first day taught me that a front-page article in the *Times* was an omen of importance and significance. People appeared out of the woodwork, wanting to testify, asking questions, writing letters, all of which vastly increased my work hours.

After an auspicious beginning in Washington, officials in Pennsylvania invited Mr. Elliott to hold a hearing in Philadelphia. Their State Department of Human Resources wanted to highlight some of their needs and raise awareness of possibilities under Eisenhower's proposed legislation. I went to Philadelphia to see the hearing site, to gather information on local resources such as stenographers to record the hearing, to develop plans for press coverage, and to plan logistics for the Committee members coming from Washington. Those logistics included meeting the trains of arriving representatives, briefing them about the witnesses they would hear, arranging lodging and meals—every detail I could think of.

As the old sayings go, both the Devil and God "are in the details"—which means that things can go very wrong or very right depending on how well you have thought through what is needed to make an event or project go smoothly, and considered what could go wrong and planned contingencies. Some time invested in this at the beginning of any enterprise will pay dividends in peace of mind and smooth performance—no matter what may go haywire.

The host officials who helped me with planning suggested a late evening ride through the streets near our hotel might be revealing to members of the subcommittee. They could see for themselves the gangs gathering on street corners and perhaps witness drug exchanges or other crimes in progress. I told them I wanted to see first-hand what might be in store before suggesting it to the Committee members. The officials agreed to pick me up from the hotel near midnight. I rode in an unmarked police car with two armed policemen. We cruised the streets for an hour and did, indeed, witness large numbers of youngsters congregated on the streets. I decided the same tour would be instructive for our subcommittee members and made arrangements for an informed person to accompany the Congressmen in each of three cars.

Learning To Focus on the Goal, and Not Myself

On the day of the hearing, the trains had arrived on time and everyone was accounted for except one Republican member, Congressman Stuyvesant Wainwright III of New York. Shortly before the hearing was set to begin, he entered the hearing room and in a loud voice said, "This is the worst hearing I've ever been to" and demanded to see the Chairman. I replied that Mr. Elliott was on his way to the hearing, but he continued to tell me (and many others within the sound of his voice) all the things that had gone wrong.

First, he said, he had no information on the location of the hearing. Second, he had been told he would be met at the train station. Third, he had no idea who the witnesses would be. The list continued until Mr. Elliott walked into the room, took charge, and the hearing got under way.

Everything came off as planned for the afternoon, except that I sat through the three-hour hearing simmering with anger at what I felt was an undeserved tongue-lashing by the New York Congressman. I thought he was brash, rude, and disrespectful; and I knew I had provided his office with all the information he said he did not have. When I made mistakes as a child, I was accustomed to getting a "side talk" from my mother. I had never before been so humiliated in public. During the three hours of the hearing, I decided I was going to side-talk Congressman Wainwright, whether he wanted to hear it or not.

As I wrapped up the details of the hearing, I confronted the Congressman. I said to him: "Never in my life has anyone spoken to me as you did earlier this afternoon. I am just a young girl from small town Alabama—not the world's capitol of New York City—but I do not appreciate such behavior. Don't you EVER again talk like that to me!" I didn't wait for his response but turned and left the room in tears. I found privacy in a small adjoining room, and tears proceeded to fall washing away my frustrations. I had yet to have private words with Mr. Elliott, but had decided that he probably was going to ship me home to Alabama. At the moment I would have been happy to take

the next airplane going south!

Instead, he told me to dry my tears and forget it. But he added, "I guess we just lost Wainwright's vote on the bill."

That was an ah-ha moment for me! I had never entertained the thought that Wainwright had a vote and that his vote was something the Chairman needed. I was just concerned that he was personally offensive to me and I was going to set him straight. I had lost focus on the larger issue of getting the bill passed. In general, I had batted a thousand in preparing the hearing, but had made a major error that might prevent the legislation from going forward. Fortunately, I was able to learn the lesson of keeping focus without that dire result, because Congressman Wainwright's ultimate actions were much more mature than mine had been. In the end, he supported the Chairman and the legislation.

The lesson I learned from this situation was, whatever unfair thing might be said to me, to keep my focus on what I was trying to accomplish, and not on my feelings.

In addition to the juvenile delinquency legislation, the Subcommittee on Special Education also had jurisdiction over bills related to the physically handicapped. At the time, groups representing people with various handicapping conditions organized their respective constituents into their own silo organizations, and were not known for working collaboratively with one another. For example, pressures were mounting from our constituents for services for the blind. Mr. Elliott had me look into the best way to proceed with creating legislation to fund the provision of those services.

Fortunately, we determined that relevant bills had already been referred to the Subcommittee, so we moved to hold hearings on those bills, and to develop the needed legislation based on what we discovered in those hearings. This process kept us engaged for more than a year, but it was far from the only thing we were working on. Our most concentrated effort was going to be the engagement of the nation in a crucial and controversial undertaking: making federal policy in the field of education.

The National Education Defense Act

The Tenth Amendment to the U.S. Constitution leaves to the states

the responsibility for establishing schools and systems for education as one of the powers not delegated to the federal government. Early acts of the Continental Congress (the Land Ordinance of 1785 and the 1787 Northwest Ordinance) required land to be reserved in townships for schools to be built, and recognized the provision of schools as an essential element of good government. The Morrill Land-Grant Acts of 1862 and 1890 helped provide funding for establishing a national system of land-grant colleges and universities. The Smith-Hughes Act of 1917 and the George-Barden Act of 1946 provided funds to the states to establish vocational education for high school students and adults. But federal legislation regarding education was rare and usually controversial. This was the background against which we began to prepare for achieving Mr. Elliott's goal of making college financially accessible for all students.

Defining the problem you are trying to solve is the crucial first step in any complex process. Discovering what resources are available to you and using them strategically is the second. We began by holding hearings on education legislation in Washington. We were working to identify programmatic needs; explore administrative structures; create a statistical picture on the status of education, particularly higher education. Those hearings also provided an opportunity to assess the political climate.

Carl Elliott never attempted to legislate out of ignorance. In every endeavor he began by gathering as much information as he could, and gathering it first-hand whenever possible. As we considered what all kinds of resources would improve public education in the nation, we went to Fort Benning, Georgia, to see the state-of-the-art audio-visual equipment and techniques the Army was using to train soldiers, envisioning how that could enrich learning in America's classrooms.

An important tool of participatory democracy available to us was the Legislative Reference Service of the Library of Congress. Upon the request of a legislator, the service would produce an authoritative report, called a "white paper," that could help us understand an issue, solve a problem, or make a decision. We asked the Service to prepare a white paper on the history of Federal aid to education and the issues surrounding the legislation as it was being enacted, or if it had failed to be enacted. As Chairman, Mr. Elliott was most interested in providing funds for scholarships for college students. To support his

position, we also provided a set of assumptions on a specified number of Federal scholarships and asked them to use those to give us an idea of the financial implications for the Federal budget.

So, when hearings started, we did not have a specific bill to consider; that step would come later.

Setting up hearings, gathering demands and opinions

As Clerk of the Subcommittee, I had to learn that my responsibilities reached beyond Mr. Elliott and his immediate office. I had to be responsive to many Congressional inquiries about legislation referred to the Subcommittee. Correspondence came in from all over the United States for which I was expected to provide answers. I was responsible as well for keeping accurate records of hearings and especially any roll call votes that were taken. The full Committee on Education and Labor had a staff to assist once a bill had cleared the Subcommittee. The House of Representatives had an Office of Legislative Counsel with a large staff of lawyers to assist in drafting bills. During the course of many months I spent time, almost daily, with the two lawyers who were assigned to our project. I felt that I was working on a very large project that was important to the nation, and I was committed to giving my all to help it be successful.

While Congress was proceeding to work on higher education legislation, President Eisenhower had a stated policy of "No New Starts" in many areas of our national life. While he did not explicitly include education as one of those areas, we knew that it would be important to have his blessing on any bill that survived both the House and Senate.

By late September 1957, our Subcommittee had held hearings in Washington, D.C. and were traveling out west to hold hearings in Oregon, South Dakota, Minnesota, and Utah. We were in Utah on October 4, 1957, when we saw the headlines that the Soviet Union had launched Sputnik, the first man-made satellite to orbit the earth. Frankly, this couldn't have happened at a better time for our work.

Russia's Sputnik makes our case

This stunning news made the USA come alive to the fact that we were falling behind in the development of technology; in educating scientists, engineers, and highly skilled technicians. The widespread realization gave new life to our cause.

Shortly after Christmas 1957, Senator Hill, Jack Forsythe from the Senate Committee staff, Congressman Elliott, and I spent several work days at the Bankhead Hotel in Birmingham outlining the components of a bill for the Senator and Congressman to introduce and champion in their respective legislative bodies.

The title for the legislation became obvious. It had to be the National Defense Education Act (NDEA) because the defense of our nation demanded that we not permit Russia to get ahead of us in the fields of science and technology. With that decided, our discussions centered on what we could do that was practical: what could we propose, how much would it cost, and how could it be paid for?

One of the things we talked through were the many good past proposals that had failed to be enacted for lack of broad support. We decided to resurrect some of those ideas and put them in the bill. We spent a lot of time discussing not only what to propose to meet the needs we had identified, but thinking purposefully about how to garner votes. We knew we had to make a conscious effort to attract stakeholders in education to our cause.

That the legislation ultimately succeeded can be credited, I believe, to the careful strategic thinking the two legislators engaged in at that Birmingham hotel. The Birmingham meeting concluded with the Congressman and Senator sending instructions to the Legislative Counsels of the House and Senate to begin the work of drafting a major piece of legislation. When we arrived back in Washington on the first of January, we spent many hours with the lawyers making sure that every provision of the bill was worded correctly—that is, it actually would result in what was intended. Our strategy included the introduction of identical bills by Congressman Elliott and Senator Hill.

The bill is introduced in the House

After several weeks of intensive scrutiny, the Hill-Elliott Bill (NDEA) was ready for introduction. H.R. 32417, the bill introduced in the House of Representatives, was very detailed and contained nine sections (called "titles"). The enacting clause stated the bill's purpose: "to strengthen the national defense and to encourage and assist in the expansion and improvement of educational programs to meet critical national needs."

Sen. Hill and Representative Elliott held a joint press conference to announce the introduction of their bill. It made news all across America and it became our nation's answer to Sputnik. There was a sense of anticipation that this would be a time when our nation would strengthen education to meet the challenges of the day, but we could not take for granted that the bill would pass.

The legislative process intensified with more hearings featuring famous names—Edward Teller, father of the hydrogen bomb; Werner von Braun, the rocket scientist who eventually got us to the moon; Lee DuBridge, President of Cal Tech, one of the nation's premier colleges of engineering; Admiral Hyman Rickover, engineer and father of the nuclear submarine; and many well-known educational leaders. Representatives of professional associations including the American Association for the Advancement of Science, the American Council on Education, the American Vocational Association, and many others were invited to testify.

Of these, I remember best the relationship that I developed with Admiral Rickover. The Admiral had turned a very large building on Constitution Avenue into a laboratory for building the first nuclear-powered submarine. He had had a lot to say publicly about problems in U.S. education: he made the point that even when graduates of the U.S. Naval Academy came to work for him he had to re-educate them, teaching them some physics and math that had not been covered in their college educations.

When I called him to let him know that the Subcommittee wished to have him come testify, he exploded on the phone, telling me, "I have work to do that is important; I don't have time to waste by talking to Congressional committees. Additionally, I don't know anything about the legislation you are considering. The only time I have to work on that will be Saturday morning, and I am sure you don't work on Saturday!" He continued in that vein for a couple more minutes.

When he finally let me speak, I said, "As a matter of fact, I do indeed work on Saturday mornings. I will be glad to come to your office with a copy of the bill, and I will stay as long as you need me to answer your questions and explain why the Congressman thinks your testimony will be so important."

The Saturday session with the Admiral went well, and he agreed to

come before the Subcommittee. He let me know that he was not going to be complimentary of the current state of affairs in our public schools and colleges. Of course, that kind of unvarnished truth-telling was exactly what was needed to convince legislators to pass the NDEA.

Unexpected help from the Eisenhower administration

Back in Congress, the Hill-Elliott Bill hearings proceeded with witnesses asked to address specific issues. Part of the strategy was to include in the bill educational programs that could attract support from all aspects of the educational community. We wanted every school district in America, and every college and university, to find something in the bill that would assist them in the fields of math, science, languages, and technology.

Eventually, we also had support and assistance from the Eisenhower Administration despite the "No New Starts" policy. The Assistant Secretary of Health, Education, and Welfare, Elliott Richardson, was personally involved in working with the Republicans and the White House. He was diligent in keeping them informed and made valuable suggestions to us as the weeks and months passed. He even went out of his way to see me one day to say he was leaving town on vacation, but left his private phone number in the event Mr. Elliott needed him.

Congressman Elliott and Senator Hill agreed that the House of Representatives should go first in passing the bill. They believed that passage by the House was the steepest hill we had to climb, and that if we were successful in getting the bill through the House, Senator Hill would have relatively smooth sailing in the Senate. He, too, had held hearings in the Senate and was prepared to move once the House acted.

Stuck in the Rules Committee, then unexpected help

So, we had a strategy in place, and the process of law-making began. First, the Subcommittee approved a bi-partisan bill on a unanimous vote; this was followed by the full Committee on Education and Labor with a favorable vote of 23 to 3. The bill then lingered for several weeks in the Rules Committee chaired by Representative Howard Smith, a very conservative Congressman from Virginia. He refused to call a hearing and the bill could not be debated and voted on until he set the rules under which it would be considered. For a time, the bill was dead in the water.

I was in my office on a Saturday morning when a lobbyist for the American Parents Committee stopped by to chat. She asked what was happening with the NDEA legislation. In giving her the discouraging news that it was stuck in the Rules Committee, I said "I wish more people were as interested in the NDEA as the woman who calls me every day to check on it. She is on the *Queen Mary* going to Europe on vacation. I don't know her, but she said her name was Mary Lasker." When I said that name, my friend jumped up with joyful surprise and said, "I'm going to make some phone calls, and we're going to get some help in lobbying for this bill."

Only later did I learn that Mary Lasker was the owner of the Chrysler Building in New York City. She was willing to use some of her ample resources to help the nation, and she had a special interest in health and education.[7] That chance conversation with my friend led to Mrs. Lasker and other prominent people from New York contributing to a fund that enabled friends of the bill to open an office to do the lobbying needed to pass the NDEA, sharing information in mailings, meetings, and press conferences. **The lesson I learned from this serendipitous support was to always be curious: if someone is interested in what you are doing, find out who they are, and see if they can become an ally.**

Pressure from the lobbying effort began to build, and by early August Representative Smith relented and moved the bill from the House Rules Committee to the floor of the U.S. House of Representatives. For the first time, I was permitted to be on the floor and at the table used by the Chairman of the Subcommittee as the bill was debated. My role was to be available to answer questions for any member and particularly to assist Mr. Elliott who was designated to lead the debate. We had tried to anticipate the flow of the debate (difficult to do!) and thought of answers to what we expected to be controversial issues. Otherwise I sat and listened to every word of the debate. As floor leader, Mr. Elliott controlled the time for the Democrats. Some really good things occurred during the debate—some of which are hard to remember were possible in today's hyper-partisan political atmosphere.

First, the passage of the bill was completely bi-partisan. Republicans supported the bill, and spoke in favor of it. Much of the discussion centered on the provisions of scholarships and loans.

Second, when a Republican member moved to "strike all after the

enacting clause"—which, in effect, was a motion to kill the bill—Republican after Republican stood up to defend the bill as presented. As floor leader, Mr. Elliott was in position to speak against the motion, but he didn't have to. The Republicans speaking on behalf of the bill pointed out that Mr. Elliott had been fair to their side of the aisle every step of the way; he had been accommodating and had accepted some of their amendments in Committee. They urged a "No" vote on the amendment, and their position prevailed.

Third, a Powell Amendment was offered and adopted. The wording of the amendment amounted to a statement of assurance that there would be no discrimination based on the race of individuals applying for student loans.

Passing the NDEA—despite opposition to the very end

Finally, on August 8, 1958, the National Defense Education Act passed the U.S. House of Representatives, but not without an attempt by opponents to scuttle it. The key vote occurred after a motion to recommit the bill (a parliamentary procedure used by representatives who oppose a bill) failed by a vote of 239 – 140. If the motion to recommit had passed, it would have in effect killed the bill. Of the nine members of the Alabama Congressional Delegation, only four (including Mr. Elliott) voted against the motion to recommit. The other three Alabama congressmen supporting the bill were Albert Rains of Gadsden, Bob Jones of Scottsboro, and Kenneth Roberts of Piedmont. Frank Smith was the lone supporter of the NDEA from the State of Mississippi: few representatives from the Deep South states were willing to vote against the motion to recommit. On the next motion to pass the bill, there was no recorded vote, which meant that the controversies had all been addressed and there was consensus that the bill should become law.[8]

Senator Hill took charge in the Senate and his bill was approved in late August. We had the necessary conference committee to iron out differences and President Eisenhower signed the bill on September 2, 1958, making it Public Law 864. *The New York Times* led the press coverage. All over America, colleges and universities, state departments of education, and local school districts suddenly had access to resources that they had never anticipated. It was the first major legislation for education to pass Congress since the Land-Grant Act of 1862. It has been called the first billion-dollar act to aid education.

Opening the doors of education

The NDEA has also been characterized as "opening the doors of colleges and universities to all who wanted an education." As Mr. Elliott noted in *The Cost of Courage*, by 1991 more than 20,000,000 students had applied for and received NDEA loans.

Briefly, the NDEA funded:
- student loans – the first federal program for the nation.
- graduate fellowships.
- audio-visual equipment/programs, including expansion of public television.
- equipment for science labs in high schools.
- summer training programs for teachers of math, science, and foreign languages, and for guidance counselors.
- cultural and foreign language studies at colleges and universities.
- technical education programs for community colleges.
- better data collection by state departments of education.

Graduate fellowships educated a new generation of scholars and educational leaders, including many who served the University of Alabama (UA). Ironically, UA failed to receive any graduate fellowships in the first year of NDEA implementation, which Mr. Elliott sought to remedy. UA higher education professor Dr. Wayne Urban's 2010 history of the NDEA, *More Than Science and Sputnik—The National Defense Education Act of 1958*, included a review of the papers of Representative Elliott and Senator Hill in the UA Libraries' Special Collections. Dr. Urban's research revealed that Mr. Elliott advised the University to invite the program officer from the U.S. Department of Education to come to Tuscaloosa and visit with faculty and staff. In addition, he offered to seek the appointment of Dr. Alex Pow, UA Vice President, to serve on the advisory panel that approved applications from universities throughout the nation. While Dr. Pow would have to recuse himself from considering an application from UA, he would have an opportunity to see the process at work and learn how to help his colleagues shape a viable application.

Urban summarized the initial impact of the NDEA on the University of Alabama: "Graduate Fellowships, of course, were not the only federal funds received by The University of Alabama. Alex Pow regularly apprised Mr. Elliott of the total federal funding that came to the university from NDEA titles. In May of 1960, for example, Pow told Mr. Elliott the University to that point received over $800,000 from various NDEA provisions. While graduate fellowships made up the largest portion of that amount—almost one half—student loans were responsible for almost as much as graduate fellowships, with counseling and guidance, foreign language, and educational television's programs accounting for the rest of the funds received."[9]

A national impact of the NDEA was the access to higher education for women provided by its financial aid and from subsequent programs including Perkins Loans, Pell Grants, and Stafford Loans. More women than men attend college today, where they are more likely to complete their degrees and to go on to graduate school. Dr. Deondra Rose, a political historian at Duke University, says Carl Elliott's determination to pass legislation supporting education "offers a really powerful case of how important it is to have people from all walks of life in political institutions. If somehow Carl Elliott had not experienced what it was like to go to college and not have financial support, if he didn't have the insight into what inequality means for average Americans, we never would have had that policy. And so, I think it really speaks to the significance of diversity in American governing institutions."[10] It has been very rewarding for me to find occasional articles, or books, that contain positive comments about the National Defense Education Act of 1958. At the retirement center where I have lived for theses past few years, I became friends with Dr. Hubertien Scott, an English Professor who retired from Appalachian State University in North Carolina. She was an NDEA Fellow who received a very generous fellowship to earn her doctorate that made possible her distinguished career.

In *The New York Times* of November 18, 2018, Michael Bloomberg wrote an opinion piece titled, "Why I'm Giving $1.8 Billion For College Financial Aid." He explained: "America is at its best when we reward people based on the quality of their work, not on the size of their pocketbook. Denying students entry to a college based on their ability to pay undermines equal opportunity. It perpetuates intergenerational poverty. And it strikes at the very heart of the American

dream: the idea that every person, from every community, has the chance to rise based on merit.

"I was lucky. My father was a bookkeeper who never made more than $6,000 a year. But I was able to afford Johns Hopkins University through a National Defense student loan, and by holding down a job on campus. My Hopkins diploma opened up doors that otherwise would have closed, and allowed me to live the American dream."[11]

When I read this article I heard echoes from my past. These are some of the same words of Carl Elliott, who devoted his public life to making the American dream possible for millions of Americans.

In a lengthy report on passage of the bill published on August 21, 1958, read into the Congressional Record by Lyndon Johnson the next day, a *New York Times* reporter referred frequently to problems that Mr. Elliott had to overcome in getting the bill passed. "These problems," he wrote, "were prickly – religious, racial, economic, educational. In his Alabama district they were also highly political."[12]

Those words were prophetic, as we were to find out later.

Learning from a Congressman for the Nation— and for His Distrct

Passage of the National Defense Education Act vaulted Mr. Elliott onto the national scene. He was invited to speak on many college campuses. He was awarded an Honorary Degree from Tufts University. His visibility inside Congress signaled that he was on track for a leadership role. The conservative leaders of the Education and Labor Committee for so long had neglected to give serious attention to vital areas of our national life, and Mr. Elliott was determined to address those areas. For example, the field of special education (education for people with disabilities) had never been explored, and Mr. Elliott's Subcommittee turned its attention to that need. Bills to support the arts were also referred to our Subcommittee and we devoted time for hearings on that subject.

Mr. Elliott was also concerned with labor issues, and joined Senator John F. Kennedy to sponsor labor reform legislation. Mr. Elliott was author of the House bill; Kennedy was the Senate sponsor. The floor debate was in Mr. Elliott's hands, but at midnight the night before the bill was to be debated in the House, he was carried to Bethesda Naval Hospital for emergency surgery to remove his gallbladder. Without his leadership, the bill went down to defeat.

In 1960, Senator Kennedy announced his campaign for President of the United States. Mr. Elliott was among his early supporters and worked diligently to get him elected. In the face of stiff opposition from churches in our district that were against electing a Catholic as President of the United States, Mr. Elliott nevertheless was determined to give his full support to Kennedy because of their shared commitment to pass laws and create programs to offer more opportunities for Americans to succeed and to build strong communities.

Organizing our district for voter education

We began by studying the situation to see what our challenges and strengths might be. We surveyed our district, talked with political leaders, and as a result decided to target women voters. Our method was to find women who would agree to hold a "Koffee for Kennedy."

The hostess would invite her friends and neighbors to meet in her living room or kitchen. She would serve coffee and all who attended would be asked to contribute $1 to the campaign.

We quickly organized these "Koffees" throughout the nine counties of our district. To my surprise, it really was easy to do, as a natural result of Mr. Elliott's unstinting efforts to represent his constituents and to be attentive to their needs and concerns. He knew the people of his district, and they knew him. We were responsible for finding the hostess and scheduling a speaker. All the other work was done by our volunteers, multiplying what could be accomplished. At the end of the first two weeks, the idea was in full bloom and men began to want to come. Before it ended, the men were heavily involved and, indeed, one man I remember—in Blount County—had personally visited the 92 people who voted in his precinct to invite them to a "Koffee" at his home: 87 of them showed up.

At each event, Mr. Elliott spoke about his personal friendship with Kennedy and reminded them of Kennedy's assurance that he, not the Catholic Church, would be President of the United States. He told how the Kennedy brothers had served honorably in World War II and how John Kennedy nearly lost his life and became a hero by saving the lives of his shipmates. This personal touch helped voters see Kennedy from a broader perspective. At first, questions were raised about his Catholicism, but as the weeks wore on, the people became really excited about John Kennedy, the war hero, and his potential as our young President.

By the end of the campaign, we counted over 5,000 people who had attended these gatherings.

Knowing the people you represent and serve is the foundation for community organizing. By earning people's trust through integrity in your dealings with them over time, you earn the right to present to them new facts and ideas for their consideration.

Enlisting respected friends and dedicated families

We organized rallies in our nine-county area which required finding influential speakers who were willing to speak out on behalf of John Kennedy. For one of these rallies I had recruited Judge Roy Mayhall, a Circuit Judge in Walker County. He was also Chairman of the Democratic Executive Committee for the State of Alabama and a loyal and

dedicated Democrat. In addition, he was a deacon and Sunday School teacher at First Baptist Church of Jasper. His minister, on more than one occasion, had taken the pulpit to say that we should not elect a Catholic to be President of our nation, repeating all the "reasons" that bigots were spouting via the media. (I was always relieved that the minister didn't try to prove his point by citing the Scriptures—not that the Scriptures would have supported him!). As we were driving to Blount County for the rally, I reminded Judge Mayhall that perhaps he should go easy on the local preachers: "If you were to die, your family would need at least one minister to perform your funeral."

Judge Mayhall gave one of his most moving speeches that night, and in doing so, he told the audience what I had said to him on the way over from Jasper. As we drove away, the Judge said, "Did you see that man on the front row with the red face? He cornered me after the speech, and he said, 'By God, I'll be glad to bury you.'" We had a good laugh, and drove on to the next meeting.

I was always impressed when families brought their young children to our political rallies. More often than not, I would approach the parents and ask if I might "appoint" their children to be campaign workers for Kennedy while at the event. With their permission, I then got the children to go through the audience to hand out campaign literature.

Two families I remember especially were the Henry Box family from Locust Fork and the Vincent Lavanna family from Jasper.

Mr. Henry Box was the grandfather of three youngsters in elementary school who I "appointed" as Kennedy campaign workers. They were such enthusiastic workers that I sent their names and addresses to Senator Kennedy's office, requesting his secretary to write letters thanking them. A few days later, three letters arrived —one for each youngster. When Mr. Box saw the return address on the letters, he decided to deliver them right away to the boys at their school. I was told that the entire school celebrated the event, and the young men were thrilled beyond words to have a letter signed "John F. Kennedy."

Vincent Lavanna's daughters were "Kennedy volunteers" who worked several campaign rallies handing out literature and competently answering questions. Many years later, my path once again would intersect with the Lavanna family when their oldest daughter, Dr. Betsy Lavanna, and I worked together on several community projects in Jasper.

I thought it was good for our democracy when I saw an entire family engaged in the politics of progress. Having prominent citizens who believe in and are willing to speak for your initiative is another invaluable asset in community development.

A Congressman for the nation—and for his district

Mr. Elliott believed it was his responsibility as a congressman to work both for the good of the nation and for the benefit of the people he represented in his district. He and Congressman Bob Jones, who represented Alabama's 8th District, saw the potential for developing dams and lakes in Marion and Franklin Counties where Bear Creek and its tributaries flowed through. They felt the Tennessee Valley Authority (TVA) was the logical agency to help with the development of the watershed.

The Washington office of the TVA had been led for almost 30 years by a woman (unusual for that day and time) named Marguerite Owen. Miss Owen was devoted to the improvement in people's lives made possible by the services and resources created by the TVA.

Mr. Elliott decided that we needed to learn what we could do to get TVA to come on board with help, including funding, to develop the two-county area. He decided that the two of us would have dinner with Miss Owen at least once a month to learn what we could do to get the project developed.

She was willing to meet with us, and shared crucial lessons in community development, including the non-negotiable need for all stakeholders to be represented. She explained to us that the community must embrace its own role in development, and recommended forming a not-for-profit agency involving citizens at every level. Before TVA would be interested in investing, the community itself would have to make an investment. If there was no money, then time and sweat equity could be substituted.

We returned to the district and organized the non-profit agency and named it The Bear Creek Watershed Association. Our purpose was overall community development, with an emphasis on greater utilization of its water resources. The Association elected officers, with Mayor David Morrow of Red Bay elected as first president. Rankin Fite, a prominent lawyer and Speaker of the House in the Alabama Legislature, was the lawyer who structured the non-profit and was

a founding member. The Association recruited members (who paid a small membership fee) and held meetings throughout the affected communities to assess community needs. In the end, they concluded that one thing they could all work on was a clean-up campaign of the roads and streets of small towns by collecting and disposing of trash. This generated new volunteers, new friendships, and enthusiasm for their area. The next year, the Association concentrated on a project to keep high school students from dropping out of school.

With these two successful ventures in place, the TVA was ready to help secure funding for building dams in the watershed to create a series of lakes. With assistance from Congressman Jones, who then chaired the Committee on Public Works, funding was secured and the project built. **This project demonstrated the power of people to change their communities by working together toward common goals: a lesson that Miss Owen taught us.**

Congressman Elliott is tapped for higher service

In addition to mounting a major campaign in Alabama, Mr. Elliott made speeches for Kennedy in other States. On one such venture into Tennessee he met Speaker of the House, Sam Rayburn, who was also campaigning for Kennedy. After the rally, Speaker Rayburn asked Mr. Elliott to step aside for a private talk. The Speaker said he felt Kennedy was going to be elected and he wanted to do all he could as leader in the House of Representatives to see his program enacted by Congress. Representative Howard Smith, the conservative Virginian and Chairman of the House Rules Committee, posed a threat to achieving that goal. To end Smith's power to obstruct, the Speaker had decided that when Congress re-convened after the election, he would move to enlarge the membership of the Rules Committee. He told Mr. Elliott that he wanted to appoint him to serve in that pivotal group.

I was elated when Mr. Elliott relayed this information to me. Of course, it was not yet public knowledge, and we had to await results of the Presidential election. Nevertheless, this was a clear signal that Mr. Elliott had earned the trust of the Speaker and many other House members. Membership on the Rules Committee would elevate him to a more prominent role in all legislation to come before the House and would perhaps place him in line for Majority Leader and even Speaker of the House.

When the votes were reported on election night, John Kennedy had won Alabama by 87,069 votes.

Carl Elliott joins a powerful team

Shortly after President Kennedy was inaugurated in January 1960, Congress met to organize. First up: Rayburn's campaign to enlarge the Rules Committee by three members. Two would be Democrats—who were the majority party—and one would come from the Republican side of the aisle. Speaker Rayburn led the effort, and eventually called in the Kennedy Administration to help round up the necessary votes to change the House rules. In a highly charged atmosphere, the motion for change won by five votes. Congressman Elliott and his Alabama colleagues Congressmen Jones, Rains, and Roberts supported the bill; the other five Alabama members voted against it.

Shortly after the vote, Mr. Elliott returned to the office and began to answer the phone calls that were flooding in. I interrupted him to take a call from Speaker Rayburn asking Mr. Elliott to come immediately to meet with him in the Capitol. "Is he going to keep his promise to appoint you to the Rules Committee now?" I asked. His reply reminded me of the ever-shifting balance of practical politics: "Mary," he said, "this has been such a bitter fight. It is possible that the Speaker has had to promise the seat to a half dozen others. I'll know something when I return from the meeting."

Speaker Rayburn was true to his word: Mr. Elliott was one of three new members appointed to the House Rules Committee. For me, this was a case of good news, bad news. The good news: a congressman who placed the good of the nation above all else was now part of a very prestigious committee that was a training ground for leaders of the House. The bad news for me: Mr. Elliott's elevation to Rules meant that he had to give up his membership on the Committee on Education and Labor. He would no longer be Chairman of a Subcommittee, so I no longer had a job as Subcommittee Clerk.

At that juncture, Mr. Elliott told me that he was placing me in the role of administrative assistant with a considerable increase in salary. I was not at all sure that I wanted the position, but I had no intention of retreating from the promising future opened by the election of a Democratic President. John Kennedy truly was opening a new frontier.

A few months after President Kennedy took office, I decided to reach out for his help in solving a very basic problem for our constituents. The office for the Congressman for the 7th District was in the Federal Building in Jasper, on the second floor. Many of the people who came to Mr. Elliott's office for help and advice were disabled coal miners whose lungs had been all but destroyed by black-lung disease developed while working in the mines. There was no elevator in the Jasper Federal Building, so those men had to climb stairs, arriving in the office so out of breath and racked with coughing that I sometimes thought their lives might end right in front of my eyes. Legislation providing benefits for black-lung sufferers and even beginning to address the conditions that cause the disease didn't pass until 1969. But after our particular problem was brought to the President's attention, within three months there was an elevator in the building, installed as part of the General Services Administration's mandate to provide adequate facilities for government business. While the installation of this elevator did nothing to address the systemic problem, I felt that it was at least a step in the right direction, and a tangible help to the miners and others. **It was a lesson to me in using every connection I had to advocate for the needs and rights of the people we represented.**

A show of support from the 7th District

The service of the three new Rules Committee members began with a slight to them from the chairman. At the first meeting, Chairman Smith had the staff move three straight-backed chairs to one end of the large conference table in the Committee's meeting room for the new members to sit in. The chairs were such a contrast to the luxurious leather swivel chairs that the continuing members used that one could not help noticing the difference. An enterprising newspaper reporter cornered Smith after the meeting and asked: "Are you not going to get better chairs for these new members…more comfortable chairs like those of the other members?" In a very offhand remark Smith replied, "No, they can use these chairs…I predict that after the next election these new members may not be around here anymore and there is no need to waste money buying new chairs."

This incident occurred before the days of cell phones and the Internet; nevertheless, in today's world one would say the Chairman's words "went viral" all over America, including of course the news-

papers of Alabama. When our friends back home in the 7th District read the account, several of them organized a campaign to purchase an elegant chair for their Congressman. We had no knowledge of this until I had a phone call from the Clerk of the Rules Committee telling me that a chair from Alabama had been delivered for Mr. Elliott and was at the Rules Committee office. A small plaque attached to the back of the chair read:

> To Congressman Carl Elliott
>
> 7th Congressional District of Alabama
>
> From his friends, citizens, and taxpayers of the
>
> 7th District who believe that their Congressman
>
> Who has risen from a tenant farmer's son
>
> to the House Rules Committee
>
> is entitled to this Chair.

The Rules Committee staffer called me to ask what to do with the chair. I suggested that, considering Chairman Smith's comments, perhaps he should place it in the hearing room for Mr. Elliott's use. That ended the conversation for the moment.

In the meantime, Smith arrived at the Committee room. According to accounts from friends who witnessed the scene, he had several people bringing in chairs from storage in the Capitol and trying them out around the table to see how they looked. One newspaper reported that "Judge Smith seemed to be supervising a spring cleaning job…." In the end, the new members all had chairs exactly like those of the veteran members, and we gladly placed the Chair from our constituents in our office in the Cannon Building. For days on end, people stopped in to see "The Chair" and reporters wrote stories and photographers made pictures.[13]

This situation, in which the chairman's lack of courtesy backfired on him so publicly, impressed a couple of lessons upon me: first, the crucial importance of dealing with colleagues and opponents alike with equal respect and fairness, and, second, the power of a humorous and dignified response to affirm the truth of a situation. These ideas may seem outdated in today's political climate, but I believe they are the very foundation of civility in discourse, which we must

reestablish as the norm in the United States if we are to survive as a democracy.

A change in duties, then a new opportunity

Membership on the Rules Committee meant a change in Mr. Elliott's duties. He now was a major part of the Democratic leadership of the Congress to help structure debates, setting priorities for every piece of legislation that moved to the floor of the House of Representatives. Witnesses appearing before the Committee were, by and large, members of Congress and no others. The task of the Committee was to survey the existing climate and move strategically in the direction that the Congress and President Kennedy felt we should be going. There was very little work that a legislative assistant could do—the work to be done concerned relationships, promises of mutual support, and communications between members of the House. All of this was work in the arts of diplomacy and negotiation that had to be done by the Congressman himself.

So I undertook my duties as administrative assistant. I supervised the operation of our office; read mail and delegated it for answers; kept Mr. Elliott's calendar; returned phone calls for him; and performed other duties as requested. We always had projects going in our District that needed tending, and a large part of my work was concerned with those issues. I also kept in close touch with the U.S. Office of Education as it implemented the provisions of the National Defense Education Act. We rejoiced with the Office with every success story that emerged, especially when it came from Alabama.

While I knew my work was important, I began to miss the excitement of travel, of meeting new people, and listening to new ideas for problem-solving that had been so engaging with issues before our Subcommittee on Special Education. I wanted to be part of the direct action of making a difference. In a few months, a new opportunity presented itself.

From administrative assistant in the congressman's office to assistant director in the Office of Education

After our months in the district during the 1960 Congressional Recess, in January 1961 we returned to Washington to start the new leg-

islative session. Shortly after we returned, the U.S. Office of Education asked me to come over for a visit. "We'd like you to meet some people here," the staff member said. Of course I went, and learned that President Kennedy had asked the Department of Health, Education and Welfare and the U.S. Office of Education to conduct a study reviewing the effectiveness of the Vocational Education Acts from 1917 through l946. I was told, "We're looking for staff that can help do this review, and we want to propose legislation at the end of the process. We think you could be very helpful to us, because we saw what you did when we worked with the Office of Education on the NDEA."

They invited me to join the staff as an assistant director. My primary responsibilities would be providing information to the Advisory Panel that President Kennedy would appoint and working with them to design the final recommendations for legislation that the Kennedy Administration hoped to initiate.

I felt this was right down my alley: organize people to listen and learn, discover needs and discern possible helps, define and propose legislation. Mr. Elliott agreed this was a good thing for me to do, so I accepted the new position. I felt some sadness at leaving Mr. Elliott's team and some reluctance to depart Capitol Hill, but I knew it was another opportunity to do work I felt was vitally important: to help shape education programs to strengthen the nation and all its people for the future.

Mutual learning among powerful people

President Kennedy named an Advisory Panel for the study. The panel members were leaders from the business world, government, labor, education, and the news media—we had prominent scientists, economists, labor experts, business leaders, newspaper owners, teachers, college presidents, and high-level government officials from Labor, Commerce, and Education—some of whom had never had much interaction with vocational education or visited a vocational education program. The staff's first job was to educate these 26 people to the breadth and possibilities of vocational education while they were educating us about what future workforce needs were going to be.

With the charge from President Kennedy to "review and evaluate the current National Vocational Education Acts, and [make] recommendations for improving and redirecting the program," we began

the process with a series of meetings with members of the Panel, chaired by Dr. Benjamin Willis, Superintendent of Chicago's City Schools. Our Staff Director was Dr. Chester Swanson, on leave for a year from the University of California at Berkeley. We organized visits to schools from California to the East Coast, and the Midwest in between. We had witnesses come to Washington to appear before the Panel, and utilized the knowledge and skills of the outstanding educators who supervised the vocational education program from their Washington setting. We also learned about youth groups that existed to encourage extra-curricular activities such as Future Farmers of America, Future Homemakers of America (to which I belonged in high school), Vocational Industrial Clubs of America (VICA) and the Distributive Education Clubs of America (DECA).

Vocational education was not only for preparing high school students for good jobs upon graduation, but also for retraining adults already in the workforce so they could keep their jobs amid changing needs and technologies. The system had performed dramatically during World War II, training thousands of adult workers to support industries essential for winning the war, symbolized by Rosie the Riveter.

Throughout the study, we sought to find ways to strengthen the Federal-State-Local government framework that so successfully delivered vocational education and training. Our summary report stated, "a major concern of the Panel has been to study the strengths and limitations of the local State-Federal programs, including the implications of automation, technological advance, population mobility, discrimination, urbanization, and the administration of the program."

Our report on the work-world and on workers' needs

At the completion of our work, the Panel issued its report with a summary of its recommendations for a changing world of work:

1. Offer training opportunities to the 21 million non-college graduates who will enter the labor market in the 1960's.

2. Provide training or retraining for the millions of workers whose skills and technical knowledge must be updated, as well as those whose jobs will disappear due to increasing efficiency, automation, or economic change.

3. Meet the critical need for highly skilled craftsmen and tech-

nicians through education during and after the high school years.

4. Expand vocational and technical training programs consistent with employment possibilities and national economic needs.
5. Make educational opportunities equally available to all, regardless of race, sex, scholastic aptitude, or place of residence.

To carry out the recommendations under the existing Acts, the Panel asked for legislation to authorize the appropriation of $400 million to strengthen our nation's vocational education and training system.[14]

Sharing the findings and seeing the act signed into law—but not by President Kennedy

In addition to a formal report, we prepared a popular version for easy reading.[15] We targeted the 26 million young workers who would be entering the labor market in the decade of the 60's. Our statistics revealed that 8 out of 10 of the students then in elementary school would not complete four years of college, but could gain occupational competence by pursuing many different paths, such as apprenticeships, technical institutes, vocational high schools, and armed services. Especially important to non-college-bound high school students were the federally funded programs in industrial training, vocational agriculture, marketing, and home economics.

The Panel also recognized the dramatic shift taking place with 8 million wives, mothers, and widows who were moving from full time housework to paying jobs. Vocational education could serve their needs as well. Retraining for adults would be needed as technology changed and jobs began to disappear.

The Panel's work ended on a high note with a meeting at the White House. On a bright sunny day in November 1962 President Kennedy greeted the Panel members and staff in the Rose Garden where he thanked Dr. Ben Willis for his leadership. Tongue in cheek, he commented that every time he saw a report from Dr. Willis it always involved a need for money. He said that he would review the report and decide on a plan of action. He thanked the Panel and greeted each of us personally.

Sadly, President Kennedy did not live to see the fruits of our labor, which culminated in passage of the Vocational Education Act of 1963.

Twenty-one days after Kennedy's assassination, President Lyndon B. Johnson signed into law the Vocational Education Act of 1963. Along with staff members of the Department of Health, Education, and Welfare, I was invited to the East Room of the White House to see the legislation the panel had developed become law. It was a bittersweet occasion with about 100 people present.

Witnessing the signing was deeply significant to me. Although I knew the history and the process of education legislation, actually engaging in this policy development had been in itself a further education for me. The panel members and consultants were steeped in the dynamics of the labor market; in the demographic needs for education and training; in the strengths of the Federal-State partnership for providing training; and in the unrelenting pace of technological change and automation with implications for the future. The depth of the knowledge that informed our work enabled us to make policy recommendations that could bring about needed change. Fortunately, there was wide acceptance of our report and Congress took action. Vocational Education by and large enjoyed bipartisan support.

An opportunity for further work in policy development

With the work of the Panel completed, I began to think about what would be next for me. Soon, I was invited by the Commissioner of Vocational Education to remain to assist him and others in following up as the report of the Panel moved to new related legislation and implementation. This came as a gratifying vote of confidence, since in the beginning Office of Education personnel were anxious that we might not be very friendly or understanding of their work. The addition of this job to my resumé, plus the experience itself, was invaluable to me in the jobs that I would hold in the future.

Perhaps the most important lesson I can share with you from this period of my life is this: take what you know and build on it. When you have a chance to take a challenging next step, take it.

Learning To Endure Defeat with Integrity and Courage

My appointment to the U.S. Office of Education had been in place for a few months when Mr. Elliott called to ask if I could meet him for dinner at a restaurant on Capitol Hill. I told him that I would be glad to see him, and he told me that Julian Butler would also be there.

I first met Julian while he was a student at the University of Alabama. As part of recruiting the constant stream of new supporters that every representative needs, Mr. Elliott had suggested I go to the University and find some young people who would believe in our cause and be willing to help in campaigns. Julian, who came from a line of staunch Democrats in northeast Alabama, was one of the young men who signed on with us and who then proceeded to recruit his friends. At the time Mr. Elliott asked us to meet for dinner, Julian was working in the office of Senator Lister Hill.

Over our meal, Mr. Elliott explained that in the 1964 Democratic primary for his House seat he was going to be facing Tom Bevill, a Jasper attorney who served as floor leader for Governor George Wallace in the Alabama Legislature. Bevill would have the support of the Wallace movement that was strengthening day by day.

Making the election even more challenging was the fact that the decrease in Alabama's population documented in the 1960 U.S. Census meant the state had lost one seat in the House of Representatives. This meant that the congressional district lines had to be redrawn into eight districts rather than nine. However, the Alabama Legislature, mesmerized by the racism and anti-federalism of George Wallace, had not reapportioned those districts, even though it was required by federal law.

Because of this failure, in the congressional elections of 1962 and 1964, Democratic candidates faced a two-tier primary. First came the in-district primaries, which yielded nine congressional candidates, one from each of the outdated districts. Those nine candidates then ran in a state-at-large primary in which the candidate with the fewest votes was eliminated.

Even though his 7th District had the smallest population of all the Alabama congressional districts, Mr. Elliott had survived in the two-tier primary in 1962 election and had continued as a member of Congress. But the growing influence and spending power of the Wallace machine presented formidable obstacles to victory in 1964, particularly in the state-wide contest, because he was less known by voters outside of his district.

Mr. Elliott told Julian and me that everything he had worked for over the years was now at risk, but he was determined to campaign throughout the nine counties in his district. He was optimistic that he would prevail in the end. He then asked us if we could find a way to leave our jobs and help him win the race.

Out of the executive branch and into politics—with a purpose

What a decision! We would be living in the Holiday Inn at Jasper; our headquarters would be in a previously abandoned house at the entrance to the town; recruitment and training of volunteers was high on the to-do list; followed by plotting a schedule to carry out our yet-to-be-developed campaign strategy—all in the space of five months.

I thought of all the good that Mr. Elliott and our team had accomplished, especially for the district he represented, but for the nation as well. I thought of our grassroots campaign for President Kennedy, and of the network of hardworking volunteers in the district who made that effort successful. I believed with all my heart that the good people of our district would not withhold their support for Carl Elliott.

With all that turning around in my mind, I felt assured that we could win. I looked at Julian and he looked at me. He said, "I'll go if you will." I nodded and said, "I'll go."

After dinner I started thinking about how to break this news to my mother, who had moved to Washington to live with me. One of my colleagues and I had purchased a house in suburban Maryland, and Mama had accepted my invitation to make her home with me for the rest of her life. While she was in good health and independent, I was not sure how she might feel about my going back to Alabama and leaving her in Maryland with my friend, Mary Ellis. I knew that I would be working day and night and probably could not return to Washington during the five months until the election was over. But

understanding what was at stake, Mama encouraged me to go and assured me that she would be just fine where she was. I was granted leave from my job, packed my bag, and was in Alabama within the week.

Looking for voters in Alabama again

My first tasks were to establish our headquarters, acquire volunteers to help with every conceivable chore, and plan for printing campaign materials and acquiring other necessities.

We determined that we would make Mr. Elliott's record for the past 14 years of representing the 7th Congressional District of Alabama the centerpiece of our campaign. We emphasized the importance of his seat on the House Rules Committee and of the passage of the National Defense Education Act, which had greatly benefited education at many levels throughout our district, including the first major student loan program for college students. We reminded voters of his support for rural libraries, rural electrification, rural telephones, loans to farmers, and of his vote to include farmers in the Social Security system for the first time.

We did not have polling to guide what we did, we did not have money for television and advertising, and we did not have a large staff but depended on volunteers. It would be a bare-bones campaign, largely fueled by the good will and deep friendships we had cultivated over the years.

I had a working knowledge of where most of these supporters lived and what we could depend upon them to do. I felt very comfortable in re-activating the network we had built to campaign for JFK for a vigorous campaign for Mr. Elliott. As a result of our grass roots work for that presidential campaign, we had in place an organization of Democratic Women of Northwest Alabama, who had proven themselves by turning out our voters.

Remembering the success we had experienced with our "Koffees for Kennedy," we decided that strategy of person-to-person would also work in our favor once more. And so we organized. Julian or I would go in advance to have our audio-visual set up working, and one of us would arrive with Mr. Elliott who made the speeches—oftentimes 8 or 10 gatherings a day in the homes of supporters. We organized these meetings throughout the nine counties, and on election night

the returns gave us a solid victory. We carried all nine counties by a substantial margin.

We were happy with our district primary victory: it was abundantly clear that George Wallace had hoped to unseat Carl in the district primary, and he had failed in that effort.

Up against the Wallace machine

We knew the state-at-large contest would be a fight to the finish. Our supporters in the 7th District continued to work throughout the second campaign. One of our campaign brochures stated "Alabama is at the Crossroad. Let's travel the road to reality and progress. Elect Carl Elliott." There was no "opponent" as such; it was a matter of garnering votes throughout Alabama. Mr. Elliott was well known throughout North Alabama, but not so in extreme southern parts of the state.

Always looming in the background was George Wallace and his constant race-baiting and his determination to completely dominate the politics of Alabama. Wallace had mastered the politics of fear by relentlessly playing the race card.

Several days before the election, a group called the United Conservative Coalition met in Montgomery for the purpose of deciding whom they wished to eliminate from Congress in the November general election. Apparently Congressmen Bob Jones and Carl Elliott were the targets, but in the end, they turned on Mr. Elliott. Their decision signaled the Wallace machine to get busy. They had ballots printed, with the George Wallace slogan, "Stand Up For Alabama – Vote for Eight," followed by the list of eight names which did not include the name of Carl Elliott. In other words, eliminate him.

More than a million of these ballots flooded the state three days before the election. The Ku Klux Klan, the John Birchers, and most significantly the Alabama Highway Patrol, were all at work making sure that people in every voting precinct had one of these instructive ballots to "stand up for Wallace" and eliminate Mr. Elliott.

And Carl Elliott was eliminated. Even so we lost by a relatively small number of votes.

Alabama takes a wrong turn

With that election we witnessed the beginning of many years of lost opportunity in our state that continue today. Alabama lost its collective

progressive political voice during and since the Wallace years.

As the years have gone by, I have always been glad that I was part of the effort that Carl Elliott made to give voice to a better way for our democracy to function. I joined with him in believing that the citizens of Alabama should have a choice, and we wanted to be that progressive voice that moved us along into the 21st century. The fact that the voters did not choose us was a disappointment to say the least, but we did give them a choice, at great personal cost for Mr. Elliott.

In the midst of this profound disappointment I was comforted by an editorial by John Siegenthaler of *The Nashville Tennessean* that spoke the truth about Carl Elliott's character and what had been done to him: "...a conscientious public servant has been shamefully wronged, and the people of Alabama have been deprived of the services of a good congressman..."[16]

After the election, I returned to Washington and spent the first two weeks catching up on lost sleep. It was good to be back with my mother and have some time for reflection and thinking about the future. Mr. Elliott was also in Washington to finish his work there and close out the Congressional office.

Continuing work with my mentor—and eying the Governor's Office

Mr. Elliott decided that he would open a law practice with offices in Washington and in Birmingham, Alabama. He asked me to stay on and help him get organized for his future, and I agreed to remain. He also indicated that he might still have an interest in a further political career and would want me to be a part of that effort.

For the next two years I spent time between Washington and Alabama, helping Mr. Elliott with clients who employed him and doing the groundwork to help him campaign for Governor of Alabama. We believed that a progressive voice expressing the best hopes and aspirations of the people of Alabama still had a chance to be heard and elected. We operated primarily out of Mr. Elliott's Birmingham law office. To keep expenses as low as possible, we used space in the offices of one of our Washington clients to do the firm's work in D.C.

In the meantime, the Alabama Legislature had a major fight with George Wallace over a succession bill that would permit Wallace to run for a third term (at that time, and now, third terms are forbidden

by the Alabama Constitution). The Legislature did not pass the bill, and for a time it appeared that Wallace would not be a major factor in the governor's primary election. Nevertheless, there were plenty of candidates – including former Governor Jim Folsom, Former Governor John Patterson, State Legislator Ryan deGraffenried, Attorney General Richmond Flowers, Former Commissioner of Agriculture A.W. Todd, Charles Woods, a multimillionaire businessman from Dothan; Sherman Powell, a coon hunter, lay preacher, and lawyer from Decatur; and Eunice Gore, a man who carried his Bible claiming he had "the backing of the Lord."

To this group, most of them well-known statewide, Carl Elliott added his name. We made our initial announcement and supporters filled the City Auditorium in Birmingham for our campaign kick-off. We felt that we had made a good beginning. But then came the Wallace intervention. Standing together, George Wallace and his wife Lurleen announced that Lurleen would be a candidate for governor. Tacitly they were announcing that when Lurleen was elected, George would actually be governor again. Those were not the exact words they used, but the picture of the two standing together was worth a thousand words. Nothing needed to be said.

Nonetheless, we carried on. We decided on five issues to stress as our platform, and our campaign literature spelled them out:

Carl Elliott Pledges 5-Point Platform

1. Press ahead on Alabama's educational system until it is the best in the Southeast.
2. Speed up Alabama's program of economic and industrial development by utilizing the State's great natural resources.
3. Strive for racial peace in Alabama. We will make clear that our goals are goals for all citizens.
4. Tackle with diligence and determination the pressing problems of the aged, the sick, and the poor. We will pay our old age pension people $25 every Friday.
5. Speed up construction on our highways and push for more rapid development of our waterway system.

Canvassing every corner of Alabama

We campaigned all over the state. Major newspapers—*The Anniston Star, The Montgomery Advertiser-Journal, The Birmingham News, The*

Decatur Daily—had favorable comments about Mr. Elliott. The editorial that I thought best portrayed our effort came from the *Lee County Bulletin*, January 27, 1966:

> "Carl Elliott evidently is banking heavily on the idea that a majority of the voters of Alabama are fed up with political double-talk, deception, and hum-buggery. In opening his campaign for governor in Birmingham last Friday night, the former congressman faced the issues – especially the race issue – frankly and without equivocation.
>
> "He made it clear that he intends to talk about racial problems honestly and constructively. Most Alabamians yearn for racial peace, Mr. Elliott believes, and he indicated he will make that the cornerstone of his program.
>
> "If the frank-talking Elliott is mistaken in his judgment of the political temper, he will not be a front-runner. On the other hand, if Alabama warms to a candidate who will talk straight, reject easy solutions to complicated problems, and have no part of demagoguery, he will have to be counted a leading contender."

In the beginning our campaign stops drew very good crowds, but the further south we traveled, and as election day came nearer, it was apparent that we would not receive the support we had hoped for from the Black voters newly enfranchised by the Civil Rights Act of 1964, who were responding to a direct appeal from Richmond Flowers. The majority white vote was still in the Wallace corner. Our progressive message could not be heard above the din of "segregation now, segregation tomorrow, and segregation forever!" Even so, we came in third. Richmond Flowers came in second. The Lurleen/George ticket won without a run-off.

Choosing a new battle

Within a year, Lurleen Wallace was dead from cancer, and Lt. Gov. Albert Brewer succeeded her as governor. George Wallace continued to campaign for President of the United States. And in 1969 Richmond Flowers was sentenced to eight years in prison for conspiring to extort payments from companies seeking licenses to do business in Alabama while he held the office of Attorney General. Mr. Elliott continued to practice law and struggled to pay the debt he had taken on to pay for the campaign.

As deeply disappointing as it was for those of us who had supported Carl Elliott, I was glad I had made the effort because I believed that Alabama needed a government that was progressive and that could move us toward a better future. I believed there was a role for government to level the playing field for improving the education and health of all our citizens; to regulate the institutions that made our economy grow and businesses succeed; to build strong communities and to develop our natural resources for the good of all the people. I felt I had given my best effort and was ready to move on and let someone else find a way to change Alabama politics — it was no longer a priority of mine.

And here is the lesson I learned at this juncture of my life: when you have given absolutely all you have to give, tried everything you know to try, and find yourself up against a force over which you cannot prevail, it is no disgrace to cede the field, and find a new place to give your best.

Mr. Elliott shows his appreciation

Two months after the primary I was on my way back to Washington for what I thought would be my final move. I was convinced there was no place for me in Alabama, and I wanted to be as far from the Wallace reign as I could be. I had not burned any bridges in Washington and had found a new job that would not involve Alabama politics.

Just before I left for Washington, Carl invited several close friends to a dinner in Birmingham to say goodbye. To my surprise, he took that occasion to make remarks, and then gave me a copy. For the rest of my life, I have treasured what he said, because the fact that he took the time and went to the expense to wish me Godspeed says more about him than about me.

> *I chose Mary Allen to work for me ten years ago. I admired her good brain then, and now, I'd like to make the public testimony that I have met few women, and almost no men at all, who are as smart as Mary Allen.*
>
> *I also recognized when I hired her that she had the ability to land on her feet, and that is a great ability. Take it from one who has always had another landing place on his anatomy.*
>
> *Mary Allen was a sensitive person when I hired her. But, I knew the fact that nearly all of earth's achievers are sensitive. That is true*

whether the achievements are in the field of art, education, music or politics. When I hired Mary Allen I was interested in education and politics.

At the beginning I realized that Mary Allen believed that the promise of America was—"To every man the right to live, to work, to be himself and to become whatever things his manhood and his vision can combine to make him." (Thomas Wolfe).

Mary has the moral courage to fight for what she thinks is right. Now I think it is fair to Mary to say that she and I didn't always see eye to eye 100%. Sometimes this worked to Mary's immediate disadvantage. But, then later, in the long pull it sometimes worked to my disadvantage, too. Confidentially, I sometimes suspected that she saw to that.

I want to make it clear, however, that there was never any disagreement between us where the well-being of the disadvantaged, the diseased, the distraught and the distressed was concerned. She fought their battles with me for a decade.

She fought alongside me to ensure the live birth of the National Defense Education Act in 1958.

She fought alongside me in 1960 to help eradicate the blight of religious intolerance that up to that time had said that only a Protestant could be President of the United States.

She fought the battle of the House Rules Committee with me in 1961 when we sought to give Alabama a larger voice in the affairs of our nation. Mary Allen stood with me in my statewide campaigns of 1964 and 1966.

Then we fought to stop the hate, and malice and ill-will that has enveloped our State. While we were not successful in these efforts the important thing is that Mary Allen did her part.

I believe it takes more courage to fight these uphill—yea, even hopeless—battles than it does to fight those where the odds are even. But the odds are never even for the poor, the ignorant, the oppressed and those who are heavily handicapped with the hardships of physical infirmity and mental weakness. I chose to fight for that group all my public life. Mary Allen fought with me. She fought with her fine brain, with her magnificent enthusiasm, with her great ideals.

One hundred and one years ago, when Jefferson Davis was told that there was no more food in Richmond, the beleaguered capital of the Confederacy, he said simply, "then, we'll eat the rats that infest the city."

Twenty-five years ago, Winston Churchill said if the German hordes invaded England that the English would fight them on the beaches, in the streets, and on the roof tops. I have had occasion this past year to think on these things.

When my resources were gone, Mary Allen turned everything she had into cash—her insurance, her borrowing power, her automobile—all for the cause for which we fought.

I love Mary Allen for all these things, and I didn't want her to leave without at least a few of her many friends having this opportunity to say goodbye.

We knew we had fought the good fight

Carl Elliott was a voice for the powerless, for fairness, and for opportunity. But his words also had a huge impact on me because they gave me insight into the person I had hoped to become. For the first time I began to fully understand what our hard work had truly been about: that we were seeking decisions that reflected the moral values that should inform national policy insofar as "the least of these" were concerned. That we did not always succeed did not diminish the fact that we staked out a pathway that in biblical terms admonished us to "feed the hungry and thirsty; clothe the naked; visit the sick and those in prison" (Matthew 25).

And so I returned to Washington with a deeper understanding of who I was as a person, knowing that somehow my life should continue on the trajectory I was on. As I think about that long ago event and remember its impact on my life, I am astonished to recall that I was 38 years old when this insight came to me. It seems that I had lived a long time before making such a life-changing discovery, but I am now confirmed in my belief that no matter the length of our lives, we can continue to learn and discover new truths throughout our time on earth.

And if we live long enough, we may see some degree of justice come from our efforts.

Learning the Power of Collaboration and Innovation

I returned to Washington to serve as Associate Director of Governmental Affairs for the American Vocational Association, a professional organization of 35,000 educators in 50 affiliated state organizations. I had met the AVA director through President Kennedy's vocational education task force, and our work in that arena let him know I was a good fit for the AVA.

Before I had really gotten started in the job, however, I found myself being granted a leave of absence to respond to an opportunity linked to another part of my past work: the preparation and passage of the Library Services Act. I was asked to consult with President Lyndon Johnson's National Advisory Commission on Libraries, which was charged to "make a comprehensive study and appraisal of the role of libraries as resources for scholarly pursuits, as centers for the dissemination of knowledge, and as components of the evolving national information systems." My role was to organize hearings across the country to inform this study, and I did, including locations as far-flung as Nome, Alaska. One of the great benefits of this service was the opportunity to work alongside Bessie Boehm Moore, an Arkansas educator and national advocate of libraries.

Hearings complete, I went back to the AVA and continued my job monitoring Federal legislation, informing our members of pertinent upcoming events, and engaging members in support of the legislative positions of the association. The AVA did its work through many committees that came together each year at an annual convention, and through the Board of Directors that met every six months.

Each state organization also held an annual convention. Those meetings took place throughout the year, and my job involved extensive travel to meet with them. I conducted legislative workshops for state groups, doing my best to bring a sense of reality to how we could work toward achieving our legislative goals. I also attended Washington strategy sessions with other education and professional groups, as well as sitting in on Congressional committee hearings and visiting representatives' offices. Preparing testimony for the AVA staff and members designated to testify at Congressional hearings was also part

of my work. In addition to fulfilling the established responsibilities of my position, I also had the opportunity to bring to fruition new ideas for improving our work, including joining forces with other organizations to increase our impact on important issues.

A new strategy: working *together*

The AVA was not the only association representing educational interests in Washington at that time: more than 50 organizations worked on behalf of various kinds and levels of education, promoting legislation to help fund their particular niche.

In Congress, authorizing funding and appropriating the money to fund that authorization are two separate steps. In strategy sessions with key staff on the Appropriations Committees of Congress, we had discussed the fact that Congress had never appropriated the full amount authorized to assist education at any level. Congressional staff were very much aware that witness after witness at hearings would make their case for funding their niche of education, but no group ever stepped forward to recommend that every level of education should receive more adequate funding. It appeared that each group was seeking its own good without regard to other educational programs, all of which were important to the success of our national education initiatives. To the extent education groups failed to support each other, we all suffered from lost potential.

One day in a strategy discussion with staff from some other educational organizations, we decided we could change that approach. The idea came up: "Well, when each of us testifies, why don't we all say that we all want all the funding for every aspect of education? Then we aren't pitting ourselves against each other. Instead we're making a key point: "Everybody in the country is in this boat and all kinds and levels of education are important to the nation. Let's make the boat rise for everybody with all the funding Congress has authorized."

Creating *collective action* from scratch

The idea of presenting a united appeal for full funding of education was attractive to almost every group, and so we gave birth to a new venture: the Committee for Full Funding of Education. Altogether the Committee grew to a membership of 40 or more organizations, with each appointing a representative to work with the Committee. We met weekly when Congress was in session, shared information that

became critical to our success, and found genuine cooperation among the members.

I think it surprised members of Congress who were appropriating funds that this could happen and as a result all of us got increased appropriations. We all experienced a vast increase in federal funds going into education. We achieved this just by learning how to cooperate for the good of everyone and to lean on each other for help. That was a good lesson on the power of collaboration. The practice is often referred to today as "collective action." **From the standpoint of my age, it seems to me that we have to keep relearning that we do more good for more people when we work together. It's not new, and it's not necessarily easy, but it can be done if you make your mind up to do it.**

Collaboration in understanding and communication is also crucial to working effectively toward a goal. An innovative venture I undertook for AVA was establishing an internship program for people already working in education. Over the time I worked for Carl Elliott, we had three interns, all of whom had earned doctor's degrees and were Fellows of the American Political Science Association. They were very helpful to our work and contributed substantially to our capacity for policymaking, and I believed interns could be similarly valuable for the AVA.

Good programs produce good leaders

We wanted AVA interns to truly be our partners, knowing that we and they both stood to profit from working together. They provided vital perspective for those of us inside Washington who needed to keep in touch with the grass roots; conversely, those beyond the Beltway stood to profit from a better understanding of how education policy was made and implemented. At the same time interns could further develop the leadership skills that would enable them to play a more significant role in education.

Our first intern at AVA was Carroll Bennett of Des Moines Community College in Iowa. I met him on a visit to the Iowa Vocational Education Association, and I was immediately struck by his leadership skills in guiding the work of the State Association and by his openness to new ideas. When I mentioned the possibility of an internship in Washington, D. C. at the AVA headquarters, he immediately consulted with the

two most important people in his life: his wife, Mary Jo, and his President at Des Moines Community College. With approval from all three, I went back to Washington to work out the details.

We negotiated the internship through an organization known as Washington Interns in Education (WIE). The one-year assignment included a work experience in education policy; in Carroll's case, it involved an organizational study of the American Vocational Association. The year also included interacting with 25 other interns on a weekly basis to learn about education policy development at the national level. Interns also had an opportunity to meet and hear from leaders in education from throughout the United States. Funded by the Ford Foundation and conducted by George Washington University, the interns attended seminars, met with cabinet officials and other government leaders; spent time on Capitol Hill; and traveled to sites throughout the United States to observe and learn from innovative projects and practices. I was successful in working out the negotiations with this group, and after an interview with AVA staff, Carroll brought his wife and four young sons, then ages 5 to 11, to live in Washington, D. C. for a year.

We have kept in touch throughout the years: Carroll and Mary Jo's sons are now holding responsible positions in Iowa in law, finance, and education. Carroll says that his year as an intern was hugely important to him in his career, and that it was life-changing for his children, for in their new schools in the Washington area they came in contact with students from countries throughout the world representing a range of ethnic origins. He believes the year in which the children lived, learned, and played with children from cultures different from their own enabled them to accept others without prejudice or fear, and encouraged them to become self-confident leaders in their respective communities.

The effect on our intern's children was to me a wonderful and unanticipated fruit of our program—and one very much in keeping with the purposes of education in democracy.

Learning the Power of Publicity—and of Listening

During the 1960s, vocational technical education was very visible and came under scrutiny of policy makers as well as practitioners. The Vocational Education Act of 1963 had provided new funding for research through a competitive grant-making process. The National Center for Vocational Technical Education Research at The Ohio State University had made vocational technical education more visible than ever before. In this atmosphere of heightened awareness, the National Academy of Sciences called for a national study to be conducted by its National Research Council.

The National Academy of Sciences was chartered by Congress in 1863 as a private, nonprofit, self-perpetuating society of distinguished scholars engaged in scientific and engineering research dedicated to the general welfare of the nation. The Academy has a mandate to advise the federal government, and in that role the Academy formed a committee to study vocational technical education research. I was fortunate to be one of the twelve members to engage in the process. Now as then, I consider it an honor to have been given the opportunity to serve.

Research goes nowhere if no one's listening

A large part of my work at the American Vocational Association was creating events that would focus the nation's attention on vocational education. In 1967, we found a great opportunity to do that, and ran with it.

The Smith-Hughes Act of 1917 was the first Federal Act to provide support for vocational education. At the American Vocational Association (AVA), we recognized that 1967 would be the Act's 50th anniversary, and that a happy 50th anniversary is an event to be celebrated.

I believed we could get the attention of the nation if President Johnson would visit a vocational school and make a speech during his visit, which the national news would cover. I knew staff who had worked with Lyndon Johnson when he was a senator, and I was thoroughly

familiar with his voting record and his leadership in the Senate. I felt that deep down in his heart, the President related to the kind of people—the 8 out of 10 Americans—who would not be entering college, but who needed opportunities for education in skills that would make them job-ready when finishing high school. Based on all that I had observed about him, I felt sure that he would want to speak for our cause.

Fortunately, Douglas Cater, an Alabamian I knew well from my time in Carl Elliott's office, was then White House Education Advisor to the President. I called Doug and gave him my pitch about why vocational education would be something that President Johnson would want to support, and moreover, why it was so important for so many people in America. To my amazement, Cater said to me, "Why don't you put all of this in a letter to President Johnson, but mail the letter addressed to me at the White House. I promise you that I will get the President to read your letter."

I wrote the letter, which ended with an invitation to visit a vocational technical education center nearby in Prince Georges County, Maryland. Several weeks went by, and then a call came from Cater who reported that President Johnson had read the letter, and had asked him to make arrangements to accept the invitation! I was cautioned that NO ANNOUNCEMENT could be made, and that further planning must be held in strict confidence. We did, however, set a date with the officials of the school and proceeded to work with them, in secret, on a host of issues involved in the visit.

On Monday of the week that the Presidential visit was to occur, the Washington newspapers reported that the first chancellor of West Germany, Konrad Adenauer, had passed away and that President Johnson would attend his funeral, the timing of which had not been announced. My heart sank: I had no idea if the President could return in time for our long-anticipated event.

The anniversary was coming, but the President might not be able to attend

In the middle of the afternoon on Wednesday I had a call from Doug, who told me that *Air Force One* was on the way home and the President would come to Prince Georges County the next day at l0:00 a.m. as planned. In the meantime, he said, the Secret Service detail was on

the way to my office to get me to go with them to the site for the necessary security inspection and final arrangements. By the time I hung up the phone, a huge limousine had pulled up in front of my office building, and I knew that it had come for me.

The two agents opened the back door for me, and as we drove off, they proceeded to outline how I could help. They began to ask for names of people involved, and wanted to know exactly where the President would enter the building, and what he was expected to do when inside. Fortunately, I was in position to answer their questions, but I confess that part of me was feeling like that young girl from Ward, Alabama, and wondering how she had wound up being chauffeured in a White House limousine to a school where she would be directing an event graced by the President of the United States!

After about an hour at the school we had settled all the issues and proceeded to return to Washington. The radio in the Secret Service limousine was connected to *Air Force One*, and it was exciting to hear the conversations taking place as it approached the airport. It was then I felt certain that the President would actually be at our event the next day! Familiar names came over the communications system, calling their offices to catch up on what needed to be done once they were on the ground; some were calling their wives to pick them up at the White House for a ride home.

The President spoke and the people listened

The 50th anniversary event turned out to be all that we hoped it would be. National publicity[17] gave us an opening to educate the public through the President's speech and his visit; and it did not hurt our standing among education groups in Washington that we had been able to make this event happen. Of course, our next edition of the *AVA Journal*, which went to all of our thousands of members, carried the story with a picture on the front cover. Finally, we had our day in the sun!

Paying attention is a powerful skill: when you listen to what people say and observe what they do, you can see who your natural allies are likely to be in any effort. On whatever level you are working for change, from the neighborhood to the international, having a respected leader speak for your cause can help draw attention to the needs you are looking to address.

Learning from Life's Delightful Surprises

The educators represented by AVA's Division of Home Economics were very active at state and national levels, and I frequently spoke to these groups about our legislative agenda and how they could be involved. In early September of 1971, I spoke to the Louisiana Home Economics Association in Lafayette. The meeting planners commandeered Dr. Margaret Jolley to get me to the airport in time to catch my flight back to Washington. We had not met before, and as we chatted on the drive, I had no idea what a life-changing conversation we were having!

Margaret Jolley told me that her brother Richard had been in Washington, D.C. for a few months working with the Medicaid program and that she thought he would enjoy knowing me. She continued on to say that he was a Jesuit priest who had been President of Loyola University of New Orleans. She wasn't promoting anything romantic, she explained, since he was a priest, but she hoped that we would get to know each other. I allowed as how I would love to meet him, and then we moved on to other topics.

Two or three weeks later, Dr. Richard Jolley's secretary, Anita McIntyre, called to see if she might set up a time for Dr. Jolley to take me to lunch. We set a date, and Anita said that he would get a cab to my office and together we could walk the half-block to the restaurant.

A wait that was worth it

At noon on the appointed day, I was standing at my window to see if I could spot the cab when he arrived. Instead, I had a telephone call from Anita saying that Dr. Jolley was in an emergency meeting with the Secretary of Health, Education, and Welfare, and that he would be a few minutes late. After thirty minutes, she called again saying the meeting was still in progress, and perhaps we should postpone the luncheon until another time. I assured Anita that I would wait. Actually, after waiting for an hour I was insistent because I intended to have lunch and decided it was only fair that he pay for it since I had waited so patiently!

And so he came. From my window I saw him when he stepped out of the cab. I am sure I must have smiled because I remember thinking immediately, *I'm going to like this man.* Much later on, I often teased Dick that when I first laid eyes on him I decided I was going to marry him!

Our lunch was lengthy and pleasant. He told me about his job at the Medicaid agency and what he hoped to achieve in providing health care for the poor. He also told me about Loyola and some of his experiences in coming to Washington to lobby to preserve Loyola's tax exemption for the radio-television station WWL. Since I had worked in the House of Representatives I was very interested in his description of how he had worked with Representative Hale Boggs and Senator Russell Long. For the record, he was successful in retaining Loyola's tax exemption, thus preserving Loyola's endowment.

I can't remember all that we talked about, but we spent at least an hour and a half having lunch. We parted with the thought that we might see each other again.

A new kind of relationship

After that first meeting, I was surprised to realize that I felt this friendship might develop into something that I had not experienced before. In the rural community where I grew up, young people got to know each other primarily through school and church. During my high school years I never had a serious boyfriend. The attention I received from my peers came from playing the piano—while they sang and danced, I was providing the music. To be candid, none of the boys I knew really interested me. Somehow, I sensed that my future would lie beyond the borders of Sumter County, Alabama. With my mother as a role model, I did not want to "grow up, finish high school, and get married" which was the template for most young women of my community.

When I arrived in college, there were some different choices that I could make. I developed a strong interest in one particular young man who was Mr. Big Man On Campus. We did everything together —edited the newspaper and the school's annual; participated in student elections; sang in the College Chorus (where I played the piano); created events (where I played the piano instead of dancing!). On one occasion he told me he wanted to have a serious talk; he then

told me how much I meant to him and how much he relied on me and trusted me; and then he said: "My favorite teacher in high school was named Mary—we all called her 'Miss Mary.' She was just the best friend I ever had, and I think you are just like her. I am so glad we are good friends." I had nothing to say to him, but I thought "Men! Who do they think they are?!!"

Growing up, I had always thought I would marry someday—after all, my mother married for the first and only time when she was 35 years old. But my college days were traumatic with the death of my father, and I had precious little time to spend on cultivating friendships because I had to earn money to make my way through school. I had not anticipated that I would develop tuberculosis, and the aftermath of that life-changing event left me with the belief that I would never marry. And so, I put the notion of marrying and having a family to the side and concentrated on making a life for myself in the world of work. Fortunately for me, I still had my mother, who loved me unconditionally, and I knew that she would continue to be family for me as long as she lived. I wanted very much to be present for her throughout her life, and I saw myself as the one to help her in the life changes that she would endure.

Seeing new possibilities in life

Several days after our first lunch, Dick called and asked me to go to dinner. I suggested that I would be glad to prepare dinner at my home and invited him to visit and meet my mother. He said, well, that would be nice, and accepted. And after that evening, we never looked back.

We would have dinner together two or three nights a week unless one or the other of us had to travel out of town. He had a major project under way in four western states to measure the benefits of early periodic screening, diagnosis, and treatment of health problems of poor children, and he made frequent trips to California. He was also invested with the City of Newark, New Jersey in working on healthcare issues for the poor. He mounted a major effort to leverage Federal Medicaid funds to structure managed care options for the poor.

We had many interesting conversations as we learned about each other. We shared stories about our families and our educational experiences. We shared a mutual interest in our respective jobs, and

what we were trying to achieve. He told me of his experiences as a Jesuit, always with gratitude for the educational opportunities that the Society of Jesus had provided him – which included thirteen years of higher education (he had degrees from Gonzaga University, St. Louis University, Fordham University, and Princeton). For many years he had taught chemistry; engaged in research in the summers at Oak Ridge National Laboratory; chaired the Chemistry Department at Loyola N.O., before moving into administrative positions. We discovered that our political views were harmonious, and I began to say to myself, "What's not to like about this man?"

Making two life-shaping decisions, joyfully

So our relationship continued to develop. We went places together: to the Kennedy Center for concerts, for picnics in the Blue Ridge Mountains, on visits with family and friends. We just did the usual things I guess that people do, but he was 55 and I was 45 and neither one of us had been married. We were both walking on new ground, so we tried to take our time and learn what we could about each other and about our hopes and dreams and our vision for how we wanted life to be.

Dick introduced me to his best friends with whom we had dinner at least once a month. I met his Jesuit friends at Georgetown University, and friends in Tennessee from his research years at Oak Ridge National Laboratory. Dick came to Alabama with Mama and me where he met my family and saw the very modest places I lived and attended school. We were guests at the University of Alabama graduation where Carl Elliott received an honorary degree. Afterward we attended a dinner of 30 or so friends, all of whom thought I was bringing Dick to Alabama for their inspection and approval!

I don't remember the specific occasion we first talked about marriage, but naturally we did have many conversations about that possibility as our relationship grew. We recognized our ages as mature adults living reasonably good lives; we had no major personal issues that would impair our potential for developing a life together—in fact, we decided we would very much enjoy being a family—one that could include my mother.

Not last among our discussions was our future church affiliation. The more I learned and attended Mass I concluded I would be happy to continue my spiritual journey in the Catholic Church along with

my husband-to-be. Shortly after we met, Dick and I attended Mass together at a suburban church in Arlington, Virginia. We had many conversations about our faith. As I learned more about the Church, I recognized that my Protestant beliefs were not dissimilar to much of what the Catholic Church has taught throughout the ages. The liturgy was structured to reveal the whole of what the church teaches, and I felt my faith was strengthened through participating in the Mass and observing the traditions of the Catholic Church. And so I made two major decisions at the same time: I agreed to marry a wonderful companion and joined a new community of faith, becoming part of what Vatican II labels as "the people of God."

Joining our lives with God's blessing—one way or another

Dick was concerned about getting a papal dispensation from his priestly vows before entering into marriage. He was not at odds with the Church; in fact, he very much approved of the massive changes that occurred in the Church as a result of Vatican II. But because of those changes, he no longer felt that he wanted to remain as a priest, and believed that he would be granted a dispensation from his vows. He had resigned from the Jesuit Order and applied for a dispensation but was frustrated by the Vatican bureaucracy's failure to respond.

The saga of the dispensation became a cliff-hanger! We had privately set a tentative date for our marriage, but as that date approached, we re-set it for several months later in order to give Rome time to respond to Dick's petition. We went ahead with our premarital counseling session with the Pastor of Holy Trinity Catholic Church, the Jesuit church in Georgetown. Fr. Thomas Gavigan was a friend of Dick's and when we explained our circumstances, he suggested that we have Plan A and Plan B.

Plan A depended on the dispensation arriving in time for us to be married by Fr. Gavigan at Holy Trinity Church on October 7, 1972, at 11:00 a.m. He explained that he had recently been controversial with the Bishop of Washington and that he would truly be seen as a "radical" if he married us in the church without a dispensation. However, he said, there were young Jesuits around the Georgetown campus who would be glad to perform the wedding ceremony and that it would be permitted on the campus. If the dispensation didn't arrive, Plan B would have us married at the same time, but in Georgetown University's Dahlgren Chapel. With that settled, and with a hope and

a prayer for the dispensation, we announced our wedding date to our families and the world.

Happily, we were able to proceed with Plan A, which we much preferred. Dick's dispensation came from the Pope just days before our planned wedding date. We had determined from the start that our wedding would be a very small one, inviting our families and a few very close friends. The clergy almost outnumbered the wedding party: five priests who were Dick's friends concelebrated the Mass.

In the late afternoon, we held a wedding reception in the spacious party room of Mama's and my apartment complex, the Crystal City Plaza. A very large contingent of friends came to wish us well—it was a joyful occasion. We left the next day driving to the Smoky Mountains in Tennessee where we had rented a cottage at English Mountain. Our honeymoon was a time of rest, relaxation, and planning for the adjustments we would make as we began our new life together.

Shortly after we married, we moved with my mother into a larger apartment at Crystal City Plaza. We never considered that our marriage would change the reality that Mama's home was with me; we married with the intention that she was to be OUR family. We enjoyed our meals and family time with her, and were always stimulated by stories of her life experiences—many and varied as they were. In our domestic life we enjoyed many friendships and visits from our families.

Celebrating as a way of life

Being married to Dick also brought me into a new world of friends and celebrations—some purely for fun, and some with larger purposes. The annual Louisiana /Washington Mardi Gras was one of the most memorable fun events. It was a huge affair every year, lasting three days and ending with the Mardi Gras Ball. Loads of people came from Louisiana, and many top government officials and military officers of Washington were frequent guests. Tons of seafood was shipped in for events—we once ate Louisiana shrimp served from a pirogue!

We were also active with a former Jesuits' organization that came together around the idea that their attachment to the Jesuit community through their education, training, and various ministries should not be lost to the Jesuit Order. It created an opportunity for those who

had left the Order to continue to be supportive and in touch with a community that had a great impact on their lives. Dick was already acquainted with some members, but we also made new friends among the group. These associations remained strong as we later joined the Jesuit Companions of the New Orleans Province, and each year attended the Jubilee celebration in New Orleans.

Early in our marriage we determined that we wanted to spend time with our extended families, something Dick had not been able to do as a young man. When he was twelve, the family's priest told his parents that Dick "was brilliant and had the intellectual capacity to become a Jesuit." They gave their permission for Fr. Souby to recommend their son for a scholarship, and that year Dick left home in Morgan City, Louisiana, to attend high school at Spring Hill College in Mobile. Altogether, Dick spent thirteen years after high school in Jesuit formation, and during that time could only spend short visits with his family.

Our first Jolley family gathering was an entire week that we all spent at a rental house in Gatlinburg, Tennessee. We enjoyed good food, good conversation, and discussions long into the night. From that point on, we took every possible opportunity to visit with one another.

We made celebrations, big and little, a part of our life together, and I encourage you to do the same. Affirming the importance of friends and family, and taking the time to enjoy one another's company, by whatever means, is crucial to keeping relationships strong and growing. And healthy relationships enable us to be our best selves and to "do the work that God has given us to do."

Learning from Pioneers of the Past—and Responding to Life's Changes

Soon after Dick and I married, I was invited to leave the AVA and establish the first Office of Public Affairs for the American Home Economics Association (AHEA). Through the AVA, I'd provided training on policy issues and advocacy to a number of home economics groups, and many of their members wanted a stronger voice at the policy table. I enthusiastically accepted the position and set about building the foundation of a solid public affairs program for the Association.

My eight years of working closely with home economists through the AVA had led me to appreciate the contributions they made to family life through public school programs and in a broad variety of fields. Home economics (now more often called human environmental sciences) is an interdisciplinary curriculum in human development and environmental sciences.

Learning all you possibly can about an organization or cause with which you are working is crucial to success. You must know it in order to represent it and advocate for it, to be able to assess what its strengths and challenges are. Once at AHEA, I learned in more detail about the scope of their work. Our members taught in high schools and colleges, worked in business settings; served as financial counselors and consumer advocates; were employed as nutritionists in institutional settings; managed day care programs; and worked as family counselors and therapists. Each of the fifty states had a home economics association affiliated with the AHEA. I immersed myself in the work, and once again was traveling extensively, working with college and university departments and state associations.

The history of our founder was inspiring. The discipline of home economics was founded in 1899 by Ellen Swallow Richards, the first woman admitted to the Massachusetts Institute of Technology, and, later, the first woman to serve on the MIT faculty.

Richards' research on water pollution led to Massachusetts's creation

of the first water quality standards in the United States. Her interdisciplinary work focused on sustaining families and improving the quality of their lives, and from the beginning stressed the importance and necessity of communicating with the general public about the impact of public policies on the lives of families.

Dr. Richards had chaired an inaugural conference on "home science" in Lake Placid, New York, in 1899, and became the founding president of the AHEA in 1909. One of the highlights of my time at AHEA was the 1974 Lake Placid Conference, at which home economists from across the nation came together to consider Richards' legacy and to assess new directions for the future. My assignment was to review Dr. Richards' involvement in public policy and suggest how we might go forward in that arena.

National politics and home economics

Our work led us to actively support an idea for legislation suggested by Senator Walter "Fritz" Mondale (D-Minnesota). Senator Mondale said that if our nation was serious about supporting families, we should look at existing policies, and new proposals, from the standpoint of how they might affect families. The Senator observed that our national government currently assessed the impact of policies on our environment, and we could do likewise with policies affecting families. Tax policy, education policy, health policy, and a whole host of other areas all affected families and the Senator had formulated legislation to require family impact statements. AHEA supported the legislation, but before it could enter the process toward becoming law, Senator Mondale was nominated for the Vice Presidency and was elected along with President Carter in 1976. With no one else in the Senate choosing to champion it, the legislation died. But the value of the policy ideas it contained stayed with me.

With Senator Mondale on the Democratic ticket with former Governor Jimmy Carter of Georgia, I believed it was important to work for their election. I knew I could not do so as an employee of the American Home Economics Association since it was a non-partisan tax exempt organization. Nevertheless, I raised the issue with my colleagues, and it was agreed that I could take a two-week leave of absence, without pay, to go to Alabama to work for the election of the Democratic ticket. My own rationale included the assumption that the election of Carter-Mondale would give us an opening to do

significant policy work for families. And so I joined the campaign in Alabama under the specified conditions. I have always treasured that experience in helping to elect a Southerner as President of the United States. The voters of Alabama gave their support to the Carter-Mondale campaign.

Restlessness stirs, and a new opportunity knocks

But after 20 years in Washington, I began to wonder where my career was headed and what might be in store for the future. It seemed to me that my work life just kept repeating itself, year after year, with not much change occurring. The receptions, symposiums, strategy sessions, workshops, Congressional hearings, and traveling all seemed more and more routine. I began to question whether I was treading water instead of doing work that was going to help very much to change the world. And I was concerned about finding a way to care for my mother as health problems began to surface as she entered her eighties. Both Dick and I traveled extensively in our jobs, and had been secure in the knowledge that Mama was safe on her own in the place where we lived and could get help immediately if a problem arose while we were away. But as her health declined, I felt strongly that it was time for my work to be set in one location.

Once again, the opportunity for meaningful change came from a connection made in the course of my professional life. At a meeting of the North Carolina State Vocational Association, I met a young leader, Dr. Richard Waldroup, the Dean of Industrial Education at Guildford Technical College in Greensboro. He asked me many questions about my work and I, in turn, asked him about his college. He painted an interesting picture and I concluded that he was a progressive leader clearly in charge; committed to high standards; with a good understanding of the role of his institution in the economic progress of North Carolina.

Shortly afterward, Dr. Waldroup was in Washington and stopped by my office for a visit. He asked if I would be interested in visiting community colleges in North Carolina. He piloted his own airplane, and I boarded the plane with him for a one-day visit to community colleges. At that time, North Carolina was clearly a national leader in developing a first-rate community college system. We made stops in Wilmington, Greensboro, Charlotte, Ashville, and ended the day at the small town of Andrews in western North Carolina where Dr.

Waldroup's career began as an apprentice in a manufacturing facility near his home. We debriefed our various visits of the day…assessing strengths; identifying new opportunities; envisioning what could happen at each place we had visited, including some "armchair" assessments of the qualities of leadership that we met.

The recruiter is recruited

A few weeks later, Dr. Waldroup called me to say that he had accepted a position as President of Trident Technical College in Charleston, South Carolina. Within the next year, he invited Dick and me to come to Charleston to speak at the graduation ceremony. We accepted and the weekend ended with a job offer for me to become Vice President for Development at Trident Technical College. My response was positive, but I said it was impossible for me to make such a move without my husband. Dr. Waldroup solved that by introducing Dick to the president of the Medical University of South Carolina, also located in Charleston. It took about a year, but both Dick and I were ready to leave Washington for new frontiers; he would become Associate Academic Vice President of the Medical University, and I would become Vice President for Development at Trident Technical College.

The timing for this change was a Godsend for me. While on an extended visit to family in Alabama, Mama had been diagnosed with cancer. She was successfully treated without surgery, but while recovering from radium treatments, fell at my brother's home and broke her hip. I made many trips to Alabama during her illness, especially after she had to go to a nursing home for recuperation and rehabilitation following surgery on the broken hip.

Mama did not make a quick adjustment at the nursing home, and I am quite certain there was not a day during her three-months stay that was pleasant and happy for her, although she made the best of the situation. Knowing how unhappy she was in the nursing home in Tuscaloosa, Dick and I wanted very much to be able to care for Mama in our home.

In early November 1976, we went to Charleston to make final decisions and work out the details of entering this new phase of our lives. We were able to find a house that would meet our needs and accommodate my mother when she was able to leave the nursing home in Tuscaloosa. Just before Christmas, we said our goodbyes to friends and colleagues

in Washington and moved our household to a new home.

Embracing a new way of living

After life in an apartment, Dick and I loved being in a house with a lawn, a garage, and space for our collective "stuff." We found our house in suburban Charleston, actually in Berkeley County, in Otranto, a relatively new subdivision. Early on we learned the "blessings" of home ownership: buying a new heating/cooling system; mowing the large lawn; getting rid of termites; and surviving Charleston's major ice storm of the century with friends and their small children who needed the warmth of our fireplace. We turned part of the garage into a wood workshop where we spent a lot of time working together on pieces of furniture that are still in use in my Tuscaloosa apartment. In anticipation of my mother's arrival in Charleston, friends from Trident Tech helped us build a ramp to accommodate my mother's wheelchair for entry and exit to our home.

Mama joined us by the end of January. We chartered a plane to fly her from Tuscaloosa. She had been very unhappy in the nursing home and when my brother was wheeling her down the hallway to leave for the Tuscaloosa airport, she said to him: "Stop this wheelchair and give me my walker. I said I was going to walk out of this place, and I intend to do so." With that, she walked the last ten steps to the door of the car that carried her to the airplane for her journey to Charleston.

Ensconced in her room, Mama readily adapted to being home again, and we were happy to be reunited with her. We immediately began the process of finding a way for her to have physical therapy, and to identify and engage appropriate medical providers. She responded well to physical therapy and was able to walk a few steps using a walker. However, as the weeks wore on, she began to have pain where the broken hip was mended. The only way to ease the pain was through surgery, which she survived, but after which she was never again able to walk.

Facing reality and staying supple 'til the end

In October 1977, near midnight, Mama passed away at our home. We had round-the-clock help for her, but she always preferred that I put her to bed in the evening. That night she asked that I raise the hospital bed to a sitting position, and kept asking that it be raised higher so she could breathe more easily. When I told her that it had reached its

limits, she said: "Well, you might as well put on the coffee pot. There'll be no sleeping around here tonight!" Her mind, and her sense of humor, were fully intact even as she transitioned into death.

We brought Mama's body home to Alabama and buried her next to my father's grave at the Cokes Chapel Cemetery in Ward. Her grandson, Joe Robin Baskin, gave the eulogy at her funeral. He said, "She was the person in our community who helped us see the world beyond the borders of where we grew up."

My mother had a powerful capacity to face reality and deal with it without delay. Life is change, especially as you age. It's important to stay supple by embracing change throughout your life—and not to let your path become a rut.

Learning To Work through Opposition

When my friends back in Jasper learned that I was making a move to South Carolina, they gave me some advice, especially Sally Petrie. A native of South Carolina, she had moved to Jasper with her husband Jim, who was a partner in the law firm with Carl Elliott. She wrote: "When I read you were moving to Charleston I collapsed with laughter! When you get off the plane, be sure to set your watch back 50 years. If you think I'm conservative, just wait. Your impact there is bound to create some stories worth a long night's listening session—I look forward to our next meeting!"

Sally's comments were prescient, especially regarding stories that I would collect over the eight years we lived in Charleston. Whatever pain and angst occurred (and there was ample), Dick and I made new lifelong friends. I loved living in Charleston—it had the feel of a small town. On Saturdays you could stop at the bookstore, and before you realized it, you would have met up with friends and had lunch together. I loved my work and always felt I learned a lot and enjoyed most of what happened.

But I had been most excited to take the job because of the good ideas and visionary leadership of Richard Waldroup—and he died in an airplane crash just over a year after we arrived in Charleston.

Dr. Waldroup was flying through a snowstorm and crashed while trying to land in Lexington, Kentucky. He was followed as president by a succession of two interims and two others appointed to the permanent position. So I worked with a total of five presidents over a period of eight years, each transition bringing its own challenges.

As a result of leadership changes in the college, some of the Waldroup plans were kept in place, but poorly executed. At times I would make decisions and take actions as Vice President for Development despite the apathy or opposition of the other three VPs. More often than not my decisions worked out for the best. But in plain language, the men who were my peers as vice presidents were not always supportive of what needed to happen for the college to progress, and most of the time they tried to make sure that I was not the one allowed to solve the

problem at hand—or at least not to be acknowledged for having done it. For the first time in my life I experienced gender discrimination that was real and unadorned.

But I remained determined to do what seemed best for the College and most especially for the students that we were tasked with preparing for a changing world of work. We shared as well in the task of supporting the growth of the economy of South Carolina. I have often said that much of what I accomplished throughout my work life I could not talk about because I had to make it appear to be someone else's idea. I developed that skill in working for elected representatives. In that situation I was part of the Congressman's team, working under his direction, and since his name would appear on the ballot, it made sense to me that his name should be attached to every good idea and accomplishment we made. But to have to play that game within a group of supposed peers just to satisfy their egos was sometimes galling. **But I did play the game because I was focused on the goal of creating positive change and opportunity for the people we served.**

Accepting the challenge no one else wanted

The most daunting task I ever undertook at Trident Technical College was managing the installation and operation of a new mainframe computer for the college's financial records, including the monthly payroll system. The specifications for bids for the hardware had been prepared under the guidance of President Waldroup, but he died in the crash before the bids were finalized. Under the South Carolina purchasing system, if a bid met all the specifications, the College was obligated to accept the lowest bid. In our case, the lowest bid was made by the NCR Corporation, a company that primarily served the banking industry.

When information was revealed concerning the results of the hardware bid, the Director of the College's Computer Division immediately resigned. The Vice President for Financial Affairs, in whose domain this should have resided, complained that the system was not going to work, and he was not up to the challenge of taking charge. I knew someone had to negotiate through the thicket that surrounded the problem of implementation, so in a moment of frustration, I said to the three men who were my fellow vice presidents, "Well, I'll take it on."

There were major issues to be resolved: the foremost was the fact there was no known software in the marketplace that met the needs of an educational system that had to be compatible with the specifications of

the State accounting and payroll procedures. In short, there was nothing available to tell our new computer what to do. I knew immediately that I had to hire someone who could work us through our problems. I knew I didn't know anything about computers, but fortunately for me Dick had led the team in New Orleans that installed Loyola University's mainframe. He was able to help me understand the scope of the project and to teach me the language with which to describe it and discuss it with candidates. Armed with that knowledge and the confidence that I was a pretty good judge of character, I set myself to work to find the person who could make the system work.

Fortunately, we did find that person: Harvey Byrd. He had worked in one of Charleston's major banks and was familiar with NCR hardware.

We did the impossible and made the payroll transition on time

When Harvey Byrd came to the College, he not only had to solve the software issue, but also train existing staff. Many times in the eight-month period required to get the system up and running, I would drive by the office at 10:00 or 11:00 o'clock at night and see the lights on in the computer lab. I would stop by to get a progress report and ask Harvey what I could do to help. Sometimes he offered up something that he needed me to do, but if he could find nothing I could do to help, I would empty the wastebaskets; sharpen pencils; replenish supplies—anything to let the staff know that I would do anything in my power to help, but in the end, everything depended on them.

With their persistence and hard work and Harvey's guidance, we met all the deadlines. I still treasure a note sent to me by one of the staff when I left Charleston. Joan Groves wrote, "I will always be especially grateful for the celebration party you gave for the staff that worked so hard during payroll conversion. I will miss your friendly smile and support." Many years later I visited the College and talked with Harvey in his bright new computer lab with row upon row of desktop computers! No mainframes in sight!

All these years later, I am still amazed and impressed by the accomplishment of Harvey and his team. The experience confirmed for me the importance of, first, recognizing one's own limitations in the face of a daunting task; then, gathering sufficient information to be able to assemble the team to solve the problem. Once the team is assembled, the manager's job is to stay in touch with and sup-

port the team and its leader in every way possible, while staying out of their way and letting them do the work you brought them together to do. And when the challenge is met, to celebrate the people who did it!

Creating a space to broaden women's career horizons

The need to broaden the aspirations of women to succeed at work in non-traditional jobs became ever clearer to me as I worked in a community college. Many women were sole breadwinners for their families, and they needed to earn more than they could from the traditional pink-collar job of secretary or from jobs paying minimum wage. We established the FACET (Female Access to Careers in Engineering Technology) summer program at Trident for rising high school senior girls, bringing them on campus to experience activities in the technical labs and explore career options in engineering technology, which previously had enrolled only male students. The result was a major increase of women enrolling in technical areas at our college.

When Charleston's Levi-Strauss sewing plant closed in 1983 and moved its operations to China, the majority of the 400-plus workers were older women, many of whom had been employed at the plant for twenty years or more. They were left feeling lost and depressed: they had lost their jobs through no fault of their own and didn't have the skills to work in other settings.

I had to lay it on the line with the men who were "running" the college to convince them we needed to create a space for these women to find a new way to make a living. I knew they could find a future for themselves in the workforce through Trident Technical College, and that it was part of our mission to make that possible. I commandeered some space; had a telephone installed; found a coffee pot and some rocking chairs, and said to the women: "Welcome to Trident Technical College."

This gave them a place to come and be with their former co-workers as together they worked through the massive changes occurring in their lives. With counseling and encouragement, many of them felt at home, gained confidence, and became students at the college. There they discovered that they could do well in welding, machine tooling, and other industrial training programs. Most of all they learned that Trident Technical College existed for people who needed a second opportunity in life.

"I'm just one man away from welfare."

Networking became an important aspect of our work in advancing women's opportunities in jobs and careers. We knew our students were motivated by the desire to have good jobs to provide for themselves and, if they had them, their children. As one of the young women said, "I'm just one man away from welfare." And so we "networked" within the college by forming bonds among women faculty and staff to make certain that our optimistic women students not only graduated but were successful in finding jobs. We also reached into the community, and to other colleges in Charleston, and asked women to join our network.

We were an informal group—no officers elected, no committees, no dues, no by-laws. We simply announced that we would hold twice-monthly meetings, after work, to have drinks and conversation. Attendance grew rapidly and we often had 50-75 women participate. If anyone wanted to speak, they could do so by informing the Chairperson for the day. Working together, we identified career opportunities for our students; found mentors to encourage them; increased enrollments; and solved problems one by one as we found the resources within ourselves to respond. We did anything we could to help these students succeed: when I learned that one woman was no longer attending class because her car had broken down and she didn't yet have the resources for repair or alternate transportation, I drove her to and from class until she could pay for the repairs. It was important to me that she succeed; it was also important to me that everyone see that, while we couldn't meet every need, we were sincere in caring about our students and would help however we could.

The act of convening is powerful. Bringing together people who don't usually talk to one another, but who have common concerns and related expertise, opens the door to new connections, understanding, and change for the better. The power to convene is inherent in institutions such as colleges and universities, and I learned to use it as a tool of community development. But you don't have to be part of a big institution to bring people together.

Learning To Leverage Partnerships for Mutual Benefit

Trident Technical College had been established within the South Carolina Technical College System when Charleston, Berkeley, and Dorchester counties came together to take advantage of state financial incentives that would help local governments to cooperate and share resources to establish two-year colleges. The law also required formation of a local Area Commission to set policy for hiring the college president and for approving policies for operations. Responsibility for land acquisition and physical structures resided with the local community. Trident's first new buildings were located on the "North Campus" (in the City of North Charleston). Palmer College, a junior college located in Charleston's Historic District, merged with Trident, giving the new institution a presence in historic Charleston.

When I arrived at Trident, there was a sense of urgency to proceed with a new downtown campus to replace the antiquated building that had housed Palmer College. The existing building was totally inadequate to function efficiently, and parking was a disaster. A new downtown location had been acquired and plans completed before President Waldroup's death. Under the first interim president, Trident's Area Commission determined to continue the priority development of the downtown campus.

Plans were approved; bids let and approved; construction started. A large sign was erected at the site announcing, "Future Home of Trident Technical College." The location provided a spectacular view of the Ashley River and was accessed by one of the City's major crosstown streets. The first building was a large two-story brick structure. Construction went along satisfactorily and on schedule. Once the exterior of the building was virtually completed, the building inspectors discovered that the facility was not vented to take into account the methane gas that arose from the landfill on which it sat. This finding began a long and involved court case to determine which party, or parties, were liable for the mistake: the college, the architect, or the construction company.

As the months passed, then a year, weeds grew around the sign and the unfinished building. As expected, the court case moved very slowly. The "future home" was becoming a failure, and I felt it was going to continue to be a major problem for the college. The existing campus was not adequate nor was it possible to expand. We were missing so many opportunities for the people who lived in the peninsula city area!

Quietly exploring an obvious solution

One day, on my own and without discussion with anyone, I picked up the telephone and called Esther Tecklenberg, the first woman to be elected to the Charleston City Council. I said, "Esther, I need to have a private conversation with you. When can I see you?" She replied, "I'm making a ham sandwich for lunch, and I'll make one for you, too. Come to my house and we'll have that conversation at the kitchen table."

Within 20 minutes I arrived at Esther's kitchen and told her the situation: the problems with construction at the downtown campus, the possibility of an even more protracted process in the courts, and all the missed opportunities for service those were causing. Then, I suggested a solution.

In the process of negotiations to integrate public schools in Charleston, C.A. Brown High School, located in the Eastside community on the peninsula, was being vacated. It was a large up-to-date structure and well suited to become a downtown campus for Trident Technical College. It could attract many students who lived in the area and who needed the services we could offer. It was reasonable to assume that very few changes needed to be made in the building and we could have an early start-up. I also pointed out that the site of the unfinished, uninhabitable building could be returned to tax rolls of the City and add potential to its land use plan. Swapping buildings could be a win-win for the City and for Trident and the people it would serve.

Esther reacted by picking up the phone to call Mayor Joe Riley and asking when we might see him. He invited us to come to his office immediately, and so we left our lunch to explore our idea with him. When we walked in, I said, "Mayor, you don't see me here today, because I would be run out of town before sundown if the officials of

our College knew that I had come to see you." He smiled, and when he heard our story, he called his staff to ask for some details about his land use plan. When he hung up the phone, he said, "I'll take it from here. Thanks so much for coming."

Several days later, I met one of my staff in the hallway at the office who said: "Someone just saw the Mayor and the Area Commissioners walking through the C.A. Brown School. Do you know anything about what they might be doing there?"

My wide-eyed reply: "I have no idea."

Today that converted high school building is a bright spot for downtown Charleston and for Trident Technical College. Enrollment has grown from the very beginning, and many new programs developed on the campus. Until this day I never spoke about it again with Mayor Riley. **By thinking outside the box and not seeking any credit, I survived without anyone identifying my involvement. I was just thrilled that the move was, and continues to be, successful.**

Equipping leaders in the non-profit sector to better serve

Trident Technical College's mission was clearly defined: to provide education and training to prepare the workforce for a changing world of work, fueled by innovations in technology. Trident was authorized to award associate degrees; support industry-specific training for start-up companies attracted to South Carolina; and to provide continuing education in a variety of forms and settings. I very much supported this mission, but also felt that community development was important in establishing the College's role as an integral part of the community.

To that end, I convinced Trident's president to compete for a Kellogg Foundation grant funding a national pilot project of training programs for non-profit boards of directors. Trident Tech was one of five colleges in the nation chosen to participate, and we led implementation of the project in South Carolina. Through "Building Better Boards," we reached a new audience of leaders of non-profits with information and skills training to help them better manage their programs and improve community awareness of and respect for their services. This project attracted the attention of Governor Richard Riley, who requested our participation in training various boards and commissions that served the State of South Carolina. It also propelled us onto the national scene through the American Association of Community and Junior Colleges

as one of the regional demonstration colleges for the national grant.

Joining with other community groups to do something none of us could do alone

The creation of the Business and Technology Center on Charleston's Eastside was one of the most exciting projects I participated in during my time at Trident. Focused on addressing the poverty and blight in the area by supporting economic growth, the Business and Technology Center was an incubator, developed in partnership with the Control Data Corporation, for nurturing new businesses. Control Data, based in Minnesota, had successfully invested in blighted urban areas in Minneapolis, and was seeking to implement its prototype in other areas of the country.

Before developing a partnership with Charleston, Control Data wanted to gauge the support for the project, since cooperation would be needed from the entire city. To that end, Mayor Joe Riley appointed an Advisory Board consisting of business leaders; educators; clergy; legal, medical, housing, and financial professionals; and ordinary citizens. I was asked to represent Trident Technical College.

In the beginning, the Advisory Board met monthly to learn about the Control Data system for establishing the business incubator. As each member of the Board described their respective roles in the community and how their organizations could support implementation of the incubator, we all learned a lot about our city and began to really see how we could work together to bring change to East Charleston. The East Side Neighborhood Association accepted responsibility for integrating this new development into the community, providing a resource for activities to improve housing, and engaging in general community clean-ups. Its president served on the Advisory Board and thus was able to provide continuing feedback to the Eastside community as something new and different was about to begin in their neighborhood. I committed Trident to participate in education and training and to provide leadership training for the East Side Neighborhood Association. Other entities stepped forward to take on other responsibilities, and soon the Business and Technology Center was up and running—and successful.

The way people listened in those Advisory Council meetings—respectfully, with genuine interest—was the foundation of the success of the project. **If you want to make change in a community, you can't stand outside of it. You have to explore and know it, and let**

yourself be known by the people in it. You have to be a participant, and not just an observer.

Success opens a path home

The success of the incubator drew community leaders from across the nation, wanting to learn more and wondering whether they might develop such centers in their areas. I was a strong proponent of the concept and loved taking people to visit and experience what was occurring. One of those visitors was Julian Butler, my lifelong friend and coworker from Carl Elliott's Congressional office and Alabama political campaigns. Julian was then County Attorney for Madison County, Alabama, and had been tasked with recommending appropriate voting machines for purchase by the county. When he came to Charleston for a voting machine trade show, I insisted that he visit the Business and Technology Center. I knew that my home state's economy had suffered in the recession of the early 1980s, and I told Julian that Alabama needed to undertake such a development. At the end of our visit, he looked thoughtful and said that the University of Alabama, under the leadership of President Joab Thomas, might be interested.

Shortly thereafter, I had a call from UA Vice President Dr. Malcolm (Mack) Portera asking if and when a Tuscaloosa delegation might visit Charleston's Business and Technology Center. I happily made the arrangements for the visit and to meet and accompany the group. The University plane arrived with Dr. Portera and representatives from the Chamber of Commerce, the *Tuscaloosa News*, and other important individuals involved in industrial growth and development. At the end of the tour, Dr. Portera asked if it might be possible for the BTC staff to make a visit to Tuscaloosa to brief Dr. Thomas. Once again, I volunteered to make that happen. At the end of that visit, Dr. Portera asked Julian, "Do you think we can get Mary Jolley to come home to her Alma Mater and help us with our strategic plan for economic development?"

I didn't need much convincing—I was impressed with the leadership and goals of Joab Thomas and Mack Portera, and felt that working with them and their team was an opportunity to do good and necessary work in a place dear to my heart. And at the end of 8 years in Charleston, I felt the time to move on had come. Dick had retired at the end of four years at the Medical University, so when this opportunity presented itself, we were both ready to come home.

Coming Home to Alabama and Joining a Progressive Team

The recession of the early 1980's indeed had left its mark on the State of Alabama. The manufacturing sector alone lost almost 40,000 jobs. Unemployment in Tuscaloosa County was the highest in the State. The University and the State of Alabama had experienced several years of prorated budgets. It was clear to Dr. Thomas that the University could not sustain positive growth by merely negotiating for a piece of the state education allocations pie: new sources of funding had to be secured. In 1981 Dr. Thomas made a commitment to assist in building a strong economic base in Alabama, establishing three priorities for UA:

- to enhance the quality of all its academic programs;
- to become a major research enterprise;
- to relate its research program to the economic development of the state.

"The University that saved a factory"

In 1983, two years before I came to work at the University, a troubled factory in Tuscaloosa provided an unusual opportunity for faculty and staff to implement these plans. The Rochester Products Division of General Motors employed 200 people in manufacturing automotive components. The plant was scheduled to close if the employees could not find $2 million savings in operating costs. In the end, they lacked $470,000 finding the required reductions. The company turned to the Tuscaloosa Industrial Board and offered to sell the plant to the University as a research facility.

The discussions culminated in a partnership of the General Motors Corporation, the United Auto Workers, and the University of Alabama. The UA Board of Trustees agreed to use the building as a research facility for three years and to pay General Motors each year the $470,000 needed to keep the plant operating. However, if faculty, staff, and students, working with UAW members, could identify the additional savings, the University's payment would be reduced

dollar for dollar. UAW members voted to establish a Trust Fund with monthly deductions from their paychecks deposited to the Fund. As savings were identified, the monthly employee contributions were reduced accordingly, and ultimately the contributions were returned in full. The parties agreed on a three-year time frame, and a Management Committee of representatives from General Motors, UAW, and the University proceeded to implement the plan.

Within eight months the $470,000 had been identified. Encouraged by the success of the project, General Motors decided in 1984 to invest $14 million to turn the assembly plant into a highly automated, vertically integrated unit to fabricate carburetors as well as assemble them.

The University received nationwide recognition, including a front-page article in *The New York Times*[18] and in other major newspapers, as well as professional journals. All three major television networks (ABC, NBC, and CBS) filmed stories from Tuscaloosa.

When this success became known, the pleas for assistance from communities throughout Alabama began to grow. The University responded with a plan to assist counties and communities to organize for economic development. This strategic plan included four major goals:

- build world-class programs in manufacturing technology, transferable to industry;
- prevent job loss and attract new firms;
- assist the state and selected communities in creating effective economic development programs;
- assist Alabama to grow more of its own industry.

This is the plan I was hired to help implement and further develop.

A newspaper headline I thought would get me fired

My work was centered in the Division of External Affairs under the leadership of Vice President Malcolm Portera. I had an office next door to Dr. Harry Knopke, the Special Assistant to the President; we had a literal "back door" connection to the President's office. The view from my office was magnificent. I looked out on the President's

Mansion and its beautifully manicured lawn, every spring filled with tulips and azaleas. It was a thrill to be back home in Tuscaloosa, filled with expectations for helping my sweet home Alabama move forward on a realistic economic agenda. I couldn't wait to get started!

After one week of becoming acclimated to my new job, I was told that I was scheduled to be interviewed by a local reporter for *The Tuscaloosa News*. The interview occurred on a Friday afternoon, and would be in the Sunday newspaper. I got the shock of my life when I picked up my Sunday paper and read the headline, "She did more for education than anyone at the University of Alabama."

I knew I did not make that statement, and my first thought was, "I'll be fired before I even work here for one month!" Much of the article was about my work in Washington with Congressman Carl Elliott on the NDEA. By the time I came to work at the University in 1985, literally millions of loans had been made and significant aid had been targeted to help improve the teaching of math and science in local public schools of the nation. So the headline was created by the writer, based on statistics I had provided, but the words were his, not mine.

I didn't know what to expect when I returned to work on Monday; fortunately, the only thing said about the story was "Good article yesterday!" That response was a further sign to me that I had come to work at the right place, with the right people, where we were focused on getting the job done and not on protecting egos.

Setting up the Center for Economic Development

Shortly after arriving at the University I was able to get grant funding from U.S. Department of Commerce to establish a UA Center for Economic Development. With this new resource we were able to work with more local governments and agencies in strategic planning. We also provided assistance for the University's International Trade Center, which provided free counseling to help small businesses export their products; and funding to help support the Alabama Productivity Center within the College of Business. In addition, we were able to engage individual faculty in projects requiring special expertise. We were able to deploy all these resources to assist local communities. Some of these projects are still generating activities and have continued to make changes over time to improve Alabama's economy.

To help with our agenda it was apparent that we had to have someone who could keep track of all the details we had to manage. I was fortunate to find Renee Kirby Taylor who became the person we counted on to make the wheels turn for us as we were deployed around the State. Later on, Martha Walls Whitson also joined our staff, and the two worked in tandem to help achieve our ambitious goals.

Realizing that I was working in a talent bank

Early on, I had an experience that gave me a very important insight into the University, and universities in general. I was assigned to organize a briefing for President Thomas, who was scheduled to receive a delegation from Japan that was being wooed by the State of Alabama to establish a manufacturing plant in the state. As was generally the case, choosing a site for a new industry was highly competitive, and the Tuscaloosa County Industrial Development Authority (now the Tuscaloosa County Economic Development Authority) frequently used the University of Alabama as a major asset in its recruitment toolbox.

The only information we were given about the Japanese visitors was the code name under which they were traveling: The Azalea Group. The group consisted of five industrialists, none of whom were fluent in English. We also were told that the process had been very competitive and that Azalea had already visited many important sites. The unspoken theme was that Tuscaloosa was counting on the University to seal the deal that would bring the company to choose a site in Tuscaloosa.

After receiving that information, I closed my door and sat for five minutes taking deep breaths. I knew how to find Japan on the map, but I desperately needed help to set up a persuasive agenda for Azalea. I ventured next door to find Harry Knopke, who quickly assured me that I could find within the University the resources I needed for a pertinent lesson in Japanese culture and helpful suggestions in how to interact with the delegation. I learned that the College of Arts and Sciences had a Japanese Committee, who immediately agreed to help.

Getting good advice and taking it

The committee members gave us concrete advice on how to structure the meeting to best communicate our interest and respect to the delegation. At their suggestion, President Thomas invited the Japanese visitors to the President's Mansion, rather than holding the briefing

session in his office. He walked down the curving front staircase and greeted them as they arrived. Inside, we served green tea and presented each member of the delegation with a gift representative of Alabama. Marley Thomas, the president's wife, provided a completely unexpected and perfect touch for the meeting by cutting native azaleas from the local woods to decorate the entrance and dining area of the Mansion.

We won the competition! To celebrate the coming of the JVC manufacturing plant, the University greenhouse provided azalea plantings to landscape the entrance. Following our strategic plan of relating University research programs to industry in the state, faculty developed new research programs to support innovations and improvement in materials for information technology.

We also helped prepare the community and the incoming factory leadership to understand and interact with one another. To help Japanese families adjust to the cultural changes of living in Alabama, we formed a Committee on Community Change to "adopt" Japanese families and introduce them to local customs and resources. The University provided a Japanese Saturday School for the children who came to America with their parents. Together with some of the families, we began a community-wide Sakura celebration, a festival celebrated in Japan and in several locations in the U.S. These festivals encourage everyone to appreciate moments of beauty, symbolized by the blossoming of cherry trees—some of which were given to the community by JVC. Tuscaloosa also developed a Sister City relationship with Narashino City, including exchange visits and partnerships with Chiba University.

The most important lesson I learned from this experience was to recognize the magnificent scope and depth of knowledge that universities pursue. For the remainder of my time at the University of Alabama, I knew I worked at a talent bank—a place to go when I, and the communities for which I worked, needed knowledge on almost any subject one could imagine. **Public service is part of the mission of public—and some private—colleges and universities (including community colleges), so I encourage you to reach out to your state and local institutions when you need information and guidance. They may not be able to help you, but they can never help if you don't ask.**

Setting our sights on a new industry for Alabama

Learning from the successes of the Rochester Products experiment and the recruitment of the JVC plant, the University decided to lead the effort to attract a new General Motors plant to Tuscaloosa. GM had announced a new automobile—the Saturn—to be made in a completely new kind of plant with the latest developments in manufacturing technology. They were seeking a site along with a local commitment to train the new workforce. GM communicated its vision of the influx of people who would be hired to work at the plant along with people already living in the area. How could thousands of new people be absorbed into the existing community? We responded to GM with a comprehensive effort, not just offering land and outlining the logistics of transportation, but also citing the broader aspects of the community including schools and cultural resources, and our capacity to develop training programs for the workers.

As we went through the process, all the indications were that GM would choose our proposal, but in the end, we lost out to Spring Hill, Tennessee. The morning after the announcement, Mack Portera was on a plane to Michigan to find out why our proposal was not accepted. Why, after all, didn't we win the competition?

Learning From Failure, and Going for the Win

Mack learned that a small group from GM had paid an unannounced visit to Tuscaloosa and had driven around the community for a day. They saw school after school with temporary buildings housing our elementary and high school students. Their reply was simple: We didn't know how you could possibly accommodate the children of thousands of workers who would be employed by Saturn when you apparently cannot accommodate your existing population. Simple as that.

But a few years later, we were prepared. We learned from our mistakes. With the same location and a broad agenda of other supports in place, and recognizing all the pros and cons that had to be addressed as we made our proposal, Alabama landed the first Mercedes-Benz plant to be built outside Germany. The plant continues to expand and employs thousands of workers. With this development, the auto industry at large has continued to expand throughout the state, with Honda, Hyundai, and Toyota establishing plants here. Many other industries that supply automakers have also found a home in Alabama. As I am writing this, Alabama is among the top U.S. states in the manufacture of automobiles.

Learn from your failures. Investigate why you didn't get the outcome you wanted. See what you can change, and where you need to change course. And try not to make the same mistake twice.

My job description: connect and assist

Helping communities with economic development was a core part of my work at the University. That meant connecting the resources of the University of Alabama and other universities and community colleges to leaders in communities throughout the state. During my tenure we had assisted in establishing ten local economic development agencies with strategic agendas in place. They were located all across the State, from Dothan to the Shoals, from Gadsden to Eufaula to Phenix City.

I also had major responsibility in developing, in partnership with

community colleges and local towns, Centers of Excellence to focus on workforce training. These centers formed the basis for what is currently the Alabama Technology Network, which supports on-going training for industry. The Network has helped workers to be re-trained in high tech programs that helped industry convert to new needs while helping workers to retain their jobs.

Working with communities to develop their resources

Rural communities in Alabama suffer from ever-dwindling populations and resources. Community development projects in these areas have the best chance of success—indeed the only chance of success —if they involve all stakeholders in planning and implementation, and if they truly build on the strengths and particularities of the area.

The Alabama Rural Heritage Center in Thomaston, in Marengo County, was an excellent example of such a project. Working with a broadly representative group of concerned citizens and town government, we developed the idea of a rural heritage center to promote arts and crafts, a festival celebrating rural culture and foods (good old Thomaston barbecue), and small business operations to bring economic activity to rural Alabama.

We partnered with Auburn University's Rural Studio, a learning laboratory for architectural students located in Newbern (Hale County). Students there learn not just to design, but to build or repair structures to complement their locations and to be fit for their purposes and to suit the people using them. With these creative, dedicated students, major repairs were made to the abandoned former Marengo County High School home economics building, and the striking and functional redesigned building opened in 1986. It housed a gift shop featuring local arts and crafts and a commercial kitchen housing a local restaurant which made and sold pepper jelly, a commercially viable product that gave the Heritage Center an identity and helped provide financial support. After decades of tenacious success, however, the Alabama Rural Heritage Center was unable to survive the Covid pandemic and closed in January 2022.

Which points to one of the most difficult lessons you must accept in working for change and economic strength in communities: not every success will last forever. The outlook will sometimes be bleak, and sometimes there will be nothing you can do to change

it. Even the most vibrant enterprise may come to an end.

The JVC plant is a perfect example. It operated in Tuscaloosa for almost thirty years and at its peak employed 600 people, first manufacturing videotape, and when that technology became outdated, making CDs. It operated until 2015 at which point the industry moved to streaming services and cloud storage. This reduced the demand for its products, and the final 100 employees of the plant were let go as it closed.

But the economic and community changes that JVC began in Tuscaloosa and beyond still contribute to the vitality of the area. Today many international companies provide jobs in Alabama. The Narashino relationship still flourishes, and in 2022 the 36th Annual Sakura Festival drew crowds to the Tuscaloosa River Market.

Whatever good gets done goes on in some way.

One thing my experience has taught me that I want to impress on anyone reading my story is this: rarely is any diligent and heartfelt effort wasted. Sometimes a project that doesn't succeed in its initial objective goes on to do good in unanticipated ways. This was the case with our strategic planning effort for Greensboro (Hale County) in the early 1990s.

Our vision for the planning initiative was to develop a project that would receive grant funding from the U.S. Department of Agriculture. I stipulated in the beginning that the planning group must be integrated—that it must include African-Americans who in those days were frequently not on the radar of city and county planners in Alabama.

We gathered a team at the University to help and began by holding meetings at African-American churches in order to engage leadership of African-American communities. We also identified leaders from all segments of the economy, including public officials, educational leaders, public health, retail, and business leaders. Altogether we had a planning group of almost 100 citizens. We asked this large group to participate in creating a vision for Hale County, and then to develop the goals and objectives to help attain the vision. That became the action plan for HERO (Hale Empowerment and Revitalization Organization).

We did not receive the USDA grant, but the group wanted to con-

tinue working on the issues they had identified. So HERO became a not-for-profit tax exempt agency and developed business enterprises and affordable housing among other ventures. HERO also sponsored workforce training for out-of-school youth, before it ceased operations during the pandemic. Our work in Thomaston led me to a project in Beloit, Alabama. That project exemplifies both the difficulty of sustaining community development efforts in rural communities with ever-dwindling populations and resources, and the good that can come even when the initial objective can't be fully realized.

A proud and painful history

Mrs. Rosa Whitt, a retired school teacher who had helped with the Rural Heritage Center in Thomaston, asked me if I could help Beloit with a recycling business. I could not imagine how such a project could emanate in a rural area, so I immediately asked if I could come and observe her project so I could better understand what was needed. Mrs. Whitt and two other retired teachers met me at a brick school building that had become a community center and housed the recycling enterprise.

Beloit is located in Dallas County, a few miles west of Selma, and has a proud and painful history. Shortly after the Civil War, a Presbyterian missionary from New England, Dr. Charles Curtis, journeyed to Alabama to fulfill his call to mission: he envisioned helping the newly freed slaves of the South learn the skills that would be needed for the industrial work predicted for the future.

Upon seeing conditions in Dallas County, Dr. Curtis soon realized that the industrial revolution would not come South for many years, so he went back to New England and raised money to buy land in Alabama. He acquired 2,000 acres of good farmland; he sectioned the land into 40 acre parcels, leaving one section to develop a town. He made the land available to African-American families who were ready to do what they already knew how to do—to make a living on their own farms. He then built a school, and he named the community for his Alma Mater, Beloit College, in Wisconsin.

The community thrived. Its school educated both youth and adults. Small business ventures were developed to support and meet the needs of local citizens' purchasing power. High school graduates were admitted to college, and educational levels were improved throughout

the community. Vocational agriculture and home economics programs at the school supported farming and family life.

And then, in the 1960s, Alabama schools that had been ignoring the *1954 Brown v. Board of Education* ruling were desegregated by federal court order, and ultimately the Beloit School was closed and all its students transported to Orville, an existing all-white school. The school building changed hands repeatedly, until the group of retired teachers including Mrs. Whitt raised enough money to purchase the building and the property in the name of the Beloit Community Organization.

On my visit, I saw the part of the old school that housed the recycling program, which took in paper (primarily newspapers), tin cans, and glass. They gathered these materials by cultivating sources and then transporting the materials to the school for processing. They were having the most success with newspapers, which were bundled and sorted by volunteers from the community. The portion of the building where this work occurred was in serious need of repairs.

In addition, the group sponsored a feeding program for Senior Citizens and expressed the hope that they could find a way to provide educational/recreation programs for the young people of the community. They felt the future of the community was at stake in terms of finding ways to develop the young people.

Reaching out to Beloit's namesake

Over a few months of visits and conversations back and forth, two young graduate students at the University of Alabama— both African-American—were recommended to me as persons who might be interested in helping with a Beloit project. After one visit, Kenneth Crawford and Darion Petty were on board. I then asked University of Alabama President, Roger Sayers, if he would send a letter we drafted to the President of Beloit College, inviting him to offer his students an opportunity to re-invest in Beloit, Alabama. The letter told the story of Dr. Curtis' achievements, and stated that the community was in need of help once more. Dr. Sayers received an enthusiastic "Yes!" in reply, so with the support of Beloit College students we had some much-needed help to carry out the plans we made with the community.

With Mrs. Whitt and the Beloit Community Organization, we began

to work toward a Homecoming Event for people who had graduated from Beloit High School before its closing in 1963. We wrote letters; we started repairs on the building; we invited young people for recreational activities; we wrote small grants; we placed Beloit on Alabama's Register of Historic Sites and planted a marker at the school; we helped to organize the recycling operations; and we cleaned up and painted.

The first group of students from Beloit College came in two vans from the school; families in the community opened their homes to host them. There was such great interest in the project that the college had to hold a lottery to determine who could come for a two-week work period. We also recruited students from UA and adults in the area.

The good accomplished endures and sprouts

The Homecoming Event occurred in the second year of the project.[19] It was amazing to see, hear, and visit with so many of the men and women who had graduated from Beloit High School. They told stories of their youthful days, always with great appreciation for their families, friends, and neighbors who lived in Beloit. While the community center continued to struggle, two outcomes of the project had results carrying on into the future. Beloit College students raised money to endow a scholarship for an outstanding student from Dallas County, and Kenneth Crawford was hired as the Assistant to the President of Beloit College in 1994.

I am still in touch with Kenneth and with Darion Petty. Both are very accomplished— and both tell me that their "Beloit experience" had a lasting impact in their lives.

Sometimes seeds of work done will spring to unexpected life years after the event. In the summer of 2021 I received a telephone call giving me the encouraging news of one such late-blooming result: a retiring Beloit College staff member was doing preliminary work to explore the potential of a film festival in Dallas County.

Honoring a Legacy of Service: The Profile in Courage Award

Early one Sunday morning in 1990 as I read the Sunday newspaper, I glanced at an article featuring Caroline Kennedy and John Kennedy, Jr. They were telling how and why they had established the Profile In Courage Award. The $25,000 award was to be given annually to a person who had demonstrated the courage to take principled stands for their beliefs, and had been willing to pay the price—to endure the loss—that came as a result of their courage. The award was named after President Kennedy's best-selling book in which he described the political courage demonstrated by five famous leaders in America's history—leaders he deemed to be extraordinary because they made unpopular but principled decisions that resulted in political defeat.

When I showed the article to Dick his first comment was, "Don't you think you should nominate Carl?" It was clear to him as well as me that there was no worthier candidate for this award than Carl Elliott. (By this time in our lives and after decades of friendship, I did finally address him as "Carl" and not "Mr. Elliott.")

Julian Butler and I collaborated on the nomination. From the very beginning I felt we were going to win because Carl's entire life had been one of struggle to become a public servant, and he was willing to sacrifice it all to maintain his integrity and be true to his conscience. He had endured the loss of his wife and his son Carl Jr., his own health had declined, and by the time of the award he was in a wheelchair. Diabetes had taken its toll on his heart and impaired his vision to the point that it was difficult, if not impossible, for him to enjoy his lifelong passion of reading books.

A few months before we submitted the nomination, Wil Haygood of *The Boston Globe* asked Carl if he could interview him for a book he was writing about one of his former colleagues in Congress. Haygood got his interview about Congressman Adam Clayton Powell, but discovered an even larger story about Carl Elliott. He called back to Boston and asked the newspaper to send a photographer to accompany the story he had decided to write about Mr. Elliott. The article

revealed in poignant detail Carl's story and how he had faced the pain of losing almost everything save for his dignity and clear conscience. Even so, he blamed no one, expressed no bitterness for the hand that life had dealt. He continued to believe in the goodness of America while enduring his own life's hardships. He was at peace with himself and the smaller world in which he now lived.

The full-page *Globe* article[20] was reprinted in its entirety by the *Chicago Tribune* and other newspapers. In response to those articles, people from across the country who had received their education with assistance from the National Defense Education Act wrote to Carl to thank him. The letters were like a shot of adrenaline for Carl. He had always said that in time, history would determine whether or not his life's work had any significance. Having lived through the storms of history, he was finding validation.

We included Haygood's article in our nomination of Carl for the Profile in Courage Award. I believe that its clear evocation of what Carl had accomplished for the good of others, and what he lost for his refusal to abandon his principles, was compelling.

Carl Elliott receives the first Profile in Courage Award

Three days before the public announcement of the Award, we received word that Carl would be the recipient. We had three days to prepare, and I was able to go to Jasper to be on site to field questions, schedule interviews, and help him cope with the storm of publicity that was about to occur from quarters around the country and beyond.[21]

Erica Stern of the Kennedy Library Foundation was wonderfully helpful to Julian and me in working out the logistics of Carl coming to Boston for the official ceremony and surrounding events. The day before the presentation, Erica and I walked through the entire event to make sure that Carl could remain comfortably in his wheelchair.

Julian, Dick, and I were among the more than thirty friends and family who made their way to Boston to witness the award ceremony on May 29, 1990 [21] and participate in the allied events. Many of the Alabama friends and family were invited to the Kennedy family suite at the Library for coffee and croissants before the program. The Kennedys knew not strangers! Within minutes we were made to feel at home. When Jacqueline Kennedy Onassis noticed Carl in his

wheelchair trying to balance a glass of orange juice and a pastry, she walked across the room, picked up a small table and placed it beside him so he could comfortably shake hands and have conversations. The graciousness, consideration, and attention to detail of the whole family and the staff extended through all the events and beyond.

During the time in Boston, Mrs. Kennedy Onassis told Carl that she thought Doubleday (for whom she worked) would be interested in publishing a book about his life and all he had experienced. She asked permission to speak with them on his behalf. She said she would also assist him in finding a good writer to help and volunteered to recommend a book agent. This was a dream come true for Carl, his family, and his many friends.

The Cost of Courage: the book that changed Carl's life and insured his legacy

When Carl arrived home in Jasper, the telephone was ringing. It was Mrs. Kennedy Onassis informing him that the project was on "go" and that she would be in touch very soon to discuss details. She was as good as her word. Mike D'Orso was selected to be the writer; and she would be the editor. With that information, the agent was engaged and told to move forward on a contract. Carl's daughter, Lenora Elliott Cannon, summed up what this partnership meant for her father: "He could not have found a better editor or friend. With the generous advance on the book, Papa was able to pay his bills and maintain his dignity. It not only changed his life, but it insured his legacy."

Mike D'Orso was the best possible writing partner for Carl. He lived in Carl's house in Jasper, Alabama, and the two of them worked together for almost a year exploring every aspect of Carl's life. (Today, Mike is the author of 16 books, on many different topics and exotic places. After Carl's book, Mike worked with Congressman John Lewis in writing *Walking With The Wind* which won the Robert F Kennedy Book Award.)

Doubleday released *The Cost of Courage* in January 1992, with a book-signing in Washington, D.C. hosted by Senator Ted Kennedy. Once again I accompanied Carl on this journey to assist him with the details. The event was held at a historic site featuring a long flight of stairs at the front entrance. That seemed to be the only way to get

inside, and I quickly reminded the Senator's staff that Carl was bound to a wheelchair and there was no way he could manage the stairs. "No problem," was the reply. "Senator Kennedy has told his six male interns to be present and they will lift Mr. Elliott all the way up with him seated in his chair." I was holding my breath and praying they would make it all the way, remembering that Carl was six feet four inches tall!

The attendees included members of the House and Senate along with staff, long-time friends, and a sprinkling of lobbyists, Capitol Hill police officers, and Alabamians who had migrated to Washington over the years, including one naval officer whom Carl had appointed to the U.S. Naval Academy. Altogether, it brought Carl back to the scene of his work in Congress and gave him memories he savored throughout the remainder of his days on earth.

This event was followed by many book-signings in Alabama. The book was very successful in the marketplace and has been reprinted many times by the University of Alabama Press. After Carl passed away in 1999, it was my privilege and pleasure to work with Bevill State Community College in the creation of the Carl Elliott Museum in Carl and Jane's home in Jasper. He was a man worthy of remembrance: the example of his integrity and perseverance can inspire us all. In the darkest times, Carl said that history would judge his choices, and it is doing so.

Almost 60 years after Carl was defeated by the forces of racism and hate, and 25 years after his death, his legacy of inspiration is growing. He stands tall as an example of what an elected official—a politician—can and should be: a true public servant, dedicated to the good of the people he represents and to the nation as a whole, free of obligations to special interests and dark money.

Establishing Family Resource Centers

From the beginning of my time with the University of Alabama, we discussed possible strategies to address rural poverty, especially in Alabama's Black Belt. That region included—and still includes—some of the poorest counties in America. Many of the local governments had participated in the State Development Board's "Prepared Towns and Cities" program, in which they each created an Industrial Development Board. These boards were empowered to acquire land for an industrial park, and encouraged to provide road improvements, water, and sewer so that availability of good industrial sites would attract industry to locate and flourish. Some larger municipalities had been successful, but many industrial parks were still empty in the early 1980's.

In trying to think of ways to assist in creating jobs and alleviating poverty, I looked at the statistical picture of our human capital with the idea that the best way to create employment opportunities was to develop an educated and skilled workforce. We were aware of generational poverty, and the number of children who were living in poverty. From well-documented studies, from my own experience in post-secondary education, and even from my observations in the U.S. Congress, I knew we had never, at any level of government, made sufficient investments in people to prevent the conditions that result in high unemployment. Thus, generational poverty continued unabated. America spent literally billions of dollars trying to remediate deficits and eliminate barriers, but very little in the early investments needed to make a difference in the core problem.

Finding a practical solution for generational poverty

So this became my question: What can the Office of Economic and Community Affairs do to move the needle toward solutions? What can we do to make an impact on generational poverty? How can communities take advantage of the massive research revealing the importance of interventions that have positive effects for very young children? If we start early, can we make a difference in Alabama? What would a "start" look like?

I called on help from the talented faculty members at the University of Alabama, especially those in the College of Human Environmental Sciences who focused on families and human development. I asked my questions, and Sally Edwards (Director of Child Development Resources and Services) said: "I think I know where you might start to find answers. I will go with you to Gainesville, Florida. We can visit a family resource center and learn about their approach."

Which points to an important truth to know: almost always, people who are working in the public interest to create opportunities for people to improve their lives will be glad to communicate with you about what they are doing and to share what they have learned to help develop a body of best practices.

In Gainesville, we met Mary (Bebe) Fearnside. As a Head Start teacher, she observed that her students transitioning from her program into first grade were doing good work, but by the time they were in third grade they began to fall behind academically. She asked permission from the School Superintendent to make a survey during the summer to determine if there might be a way to keep the children from failure.

She conducted the survey herself by knocking on doors and interviewing parents with only one open-ended question: "What can the SCHOOL do to help you help your child learn?" Based on what she knew of her students and their lives, she wasn't surprised to hear many answers that stemmed from their reasons for being unable to help their children, such as "I can't help my child because I can't read"; "I can't help my child because I'm still looking for work so I can keep food on the table." The answers revealed how the family was existing at the margins, not knowing how they would survive beyond tomorrow. Many of the families were headed by single mothers with more than one child. If the mother was employed, it was always at minimum wage pay. The parents always wanted their children to succeed, but had so many issues it was all they could do merely to get their children to school.

Fearnside returned to her superintendent with the information she needed to convince him that the parents needed a community-based support system in order for them to help their children succeed in school. She asked that the superintendent give her one employee and let her use the empty, unused trailers parked on school property. With that foundation in place, she proposed to find in the community the comprehensive support needed to provide services for the parents. The

superintendent agreed, and Bebe created the first comprehensive family services center in Gainesville, Florida. Several years later there was a new permanent Center serving the Gainesville community named The Fearnside Family Resource Center.

Visiting the original Family Resource Center in Florida

On our visit to Gainesville, we saw a complex of 11 trailers connected by gravel walkways, located near an elementary school, and convenient to public transportation. The Center was open to all at no cost and presented as a pathway for helping "your child succeed in school." Most importantly, it was accepted by parents as a place where they could find success and encouragement. Each trailer was equipped to provide convenient access to an available service, including GED preparation, career counseling and job placement, mandatory review for WIC and TANF programs, classes in parenting skills, early intervention programs for children, baby-sitting for the children of adults who came to the Center for various classes and services, and more. Residents from the University of Florida Medical School occupied one trailer, providing medical services and education. Almost all of these services were provided by existing agencies who were quite willing to occupy the offered space, expanding the scope of their programs at no cost by simply transferring existing staff to the site.

This brief description does not detail all the programs, but Fearnside was able to measure success by following up with her Head Start students. She also reported that after two years the number of parents participating in "Parent's Night" grew from almost none to over 400!

The center was created as a not-for profit agency, and was operated under an Advisory Board consisting of community leaders and private sector business leaders. Church groups also provided support as well as volunteers who helped staff the center. During our visit we saw a list of forty-two agencies in the community that provided resources, including financial contributions. Center staff also were successful in securing grants from private foundations. National television found its way to Gainesville and televised the story throughout America.

Planting the seed in Alabama

Sally and I returned to the University determined that we would bring this concept to Alabama. President Roger Sayers and Academic Vice President Judy Bonner supported our plan and encouraged us to

proceed. We used the convening power of the University to organize a symposium in May 1992 at which we promised participants would learn about an interesting idea for implementation in their community. We offered the additional incentive of free parking and a free lunch. We invited Bebe Fearnside to Tuscaloosa for a day to teach five communities how to create a family resource center. Marsha Folsom, at that time the First Lady of Alabama, agreed to be our keynote speaker and to encourage more support for children.

Based on knowledge of communities where I was familiar with the leadership, we chose five where we thought we could expect success. We stipulated that each community should identify participants for a one-day symposium and suggested the leadership should consist of a mixture of public officials, church and business leaders, as well as representatives of social services agencies.

We applied the principles I've used throughout my lifetime and used everything I knew about community and economic development to give the seed of the family resource center concept the best possible chance to take root in Alabama. At the end of the day we asked the teams to engage in assessing community needs, holding town meetings and doing their best to establish family resource centers designed by their communities and operated as not-for-profit agencies. We promised to keep in touch, and without any additional staff or resources bravely declared, "Give us a call if you need help." With the support and professional expertise of Sally Edwards, and the encouragement of Academic Affairs leadership of the University, I believed we could develop five centers over the next three years.

Within the three-year period Alabama met our goal by having five centers up and going. Some centers began with nothing more than a five-thousand-dollar planning grant. From that early beginning, the centers created The Alabama Network of Family Resource Centers (www.anfrc.org) to develop quality standards with criteria for membership. Currently the Network has twenty-three members, with two more in the process of applying to join.

From the beginning, the key to organizing a community-based center has been to start with community leaders who catch the vision and commit to making progress. Community support is built over time by the clients who come for services. Word-of-mouth has proven to be a powerful generator for organizing community support. Community members are involved in all aspects, including needs assessment, advi-

sory boards, service delivery and program evaluation.

Family Resource Centers are about working in the present to improve the future

Of all the work of my lifetime, I believe Family Resource Centers may be the most creative venture in which I have been involved. I certainly do not claim credit for the excellent work of the center's staff and community leaders—we just created an opportunity for them to learn about the Florida development, and they are responsible for sustaining and growing the effort in the past three decades.

I actually retired from the University in 1994, but I have continued to work with the development of the Family Resource Centers. I still serve, as a volunteer, on the board of the ANFRC and as its Executive Director Emeritus.

Family Resource Centers are clearly about the future. Much of the social service safety net is about remediating the past. Centers are non-judgmental; they do not sanction for failure or wrong-doing. They focus on ways and means for solving problems and making progress. I have often said that I view the Centers as entrepreneurial ventures in development of human capital. As such the staff and volunteers strive to let no one slip through a strong web of community support.

The crucial outcome: hope

At the end of fifteen years of growth and development, we asked Center Directors to ask several of their clients to write short notes about the services they received and how they felt the about their experience at the center. In reading their responses, there was one word found in every note: HOPE. Time after time they wrote, "This center made me feel welcomed and gave me hope."

It has been a privilege for me from time to time to visit the different centers, and I have come away with gratitude for the way in which they have been able to create good and productive citizens and build good communities. Many clients are now giving back by helping as volunteers.

As I write this, the Network's centers provide services to people in 45 of Alabama's 67 counties. Our goal is to have centers covering every county in the state.

Retirement and Learning To Cope with a Loss Like No Other

Almost 30 years ago I started a "new life" of retirement years. While I had always thought that I would retire when I turned 65, as that time approached, I felt I needed to complete some of the projects I had helped to develop. I finally made the move and retired from the University at age 66, in 1994.

Dick's and my first order of post-retirement business was to complete building our dream home on land my brother had given us in Moundville, a few miles south of Tuscaloosa. We had each taken a couple of falls in our multi-level home in Tuscaloosa, and we wanted a home that would be suited to our needs as we grew older, with easy entries and wide hallways, plus space for entertaining and all of our books and interests. It took the better part of a year, but once we were moved and settled in we were ready to do those things we had planned to do in retirement.

As I mentioned, Dick was already retired when we moved to Tuscaloosa for me to begin work at UA. Immediately after we arrived, he found ways to be of service, especially with Holy Spirit Catholic Church. He served as cantor and lector, and sang in the choir. He also donated a computer for the church office, set up the financial records, and taught the staff how to use the system. He visited people in the congregation who were ill, and drove a Meals on Wheels route, delivering food and some moments of cheerfulness, often with our beloved dog Moriah. Dick said he sometimes thought the people were happier to see Moriah than him or the food!

After I retired, I continued working with the Alabama Network of Family Resource Centers, mostly as a volunteer. Dick and I had looked forward for time to travel and for me to engage more fully in community and church activities. While we were involved in the community and church, even while building the house, we found that travel didn't hold the appeal for us that we thought it would.

I had always wanted our first trip to be to Independence, Missouri. I wanted to go through the Truman Presidential Library and see what

Harry Truman displayed from his years in the White House. We set the date and, looking at the map to plan our driving route, decided to go through the Ozark Mountains in Arkansas and visit the Ozark Folk Center State Park established by Bessie Moore, for whom I had worked on the Advisory Commission on Libraries, and to enjoy the natural beauty of that area. Neither of us had been there, and that was on our bucket list. So we did that, and had a marvelous three days. But at the end of those three days when we were sitting at breakfast, thinking about going on to Independence, we looked at each other and said, "You know, I'm ready to go home."

And that's what we did: we turned around and went back home. We made other trips over the years, mainly visiting family and friends, but we just didn't spend a lot of time traveling, and we were happy with that.

The lesson I learned from this is that staying flexible in your mind is key to using your energies well and charting your most rewarding course. If you discover that something you had thought you would enjoy or that would help to achieve a goal turns out to be not what you anticipated, then change course. St. Ignatius taught the Jesuits to always make a plan, then implement it, but if a better idea comes along, change the plan. Let it go, and find a new way to achieve your ultimate goal of living a good and satisfying life.

Thriving beyond expectations

Every life contains some pivotal moments after which one's reality is changed. One such moment came for me in 1998, when I was entering a building to attend a meeting with some colleagues and realized that I couldn't continue walking. Fortunately, I quickly received medical help. It turned out I was having cardiomyopathy and had cardiac arrest in the emergency room. Friends later asked me if I had an out-of-body experience, seeing my body from the perspective of my ascending spirit, or being welcomed into a great white light by my already deceased loved ones. I had to answer that I had not. Instead, I heard a voice urgently asking, "Where are the scissors?" I remembered thinking, before I lost consciousness entirely, "Oh, dear. They are going to cut my new dress off me, and I haven't even paid for it yet."

I was mostly unconscious for a day and a half, and was in intensive

care for several days. I woke up one day to see someone I didn't know there in the room, looking over my medical chart. When Dr. William Hill saw I was awake, he introduced himself and said, "You've had a rough several days here, but you are going to get better and be able to go home. We've got one more procedure to do, and then I believe you will be able to enjoy a good quality of life for another five or six years." Now, 25 years later, with the installation of a pacemaker and the ongoing medical artistry of Dr. Hill, I have lived all these years able to continue with the work I want to do and with enjoyment of life, despite the mobility issues that have been increasing as I have aged.

Enduring my most painful loss

In 2001, my life took a heartbreaking turn. Dick died early one morning as we were preparing for a routine visit to our doctor. We had our usual breakfast and coffee while reading the morning newspaper. Moments later I called out to Dick who was nearby in the bathroom. When he didn't answer I discovered him unconscious and unable to respond to me. As I looked for signs of life, I called 9-1-1 and held him while trying to think of what I might do, although it was obvious to me that he was dying. In our living wills we had both said that we did not wish to have unusual and extraordinary measures taken to save our lives when that could result in leaving us in a vegetative state. EMS arrived very quickly, but there was nothing left to do. I realized that Dick was gone.

I grieved my loss deeply, and for a time I felt abandoned, not just by Dick, but by my friends and family as well. Finally I reached the stage that I could see that my other loved ones truly were concerned for me and present in my life, and could remember and cherish so many happy times Dick and I had together. Our commitment to each other let us share our hopes and dreams and our joy in helping others around us. We were blessed with reasonably good health, loving families, and sufficient resources for a comfortable life.

I take comfort in remembering the warm companionship we shared; Dick's strengths as a mentor and teacher; his enjoyment of friends and family, and in sharing our Catholic faith. I was especially touched by a letter he wrote to Fr. Warren Martin, a Jesuit who was Dick's Latin teacher at Spring Hill High School in 1928:

"Mary and I will celebrate our 25th wedding anniversary in October

of this year. When I left the Order in 1970 I could not really explain, even to myself, why I did so. But then I met Mary in Washington and I believe it must have been a benign Providence that brought us together, as she is the best thing that ever happened to me."

At the celebration of Dick's life at Holy Spirit Catholic Church in Tuscaloosa, my nephew, Dr. Loyd Allen, gave the eulogy. His words have echoed through the years and still have the power to influence the lives of others. In part, this is what Loyd said:

> *"In heaven religions do not exist, not even the Christian religion. Our fine distinctions between religion and irreligion, or between false religion and true religion, are rendered moot in heaven by the reality that there God is All in All and the blest are all in God. Infinitely loved children of God, whom the angels have welcomed home, have no further need for religious labeling.*
>
> *"Once in a great while someone appears down here, among us, who makes our universal kinship with God and with each other visible on this side of heaven. A Jew named Jesus of Nazareth is the clearest example of this graceful gift of God. In the words of the Anglican hymn writer Brian Wren 'Where generation, class or race divide us to our shame, Jesus sees not labels but a face, a person, and a name.' In Jesus we see in the past and the present the glorious future of all the children of God.*
>
> *"There are others, followers of Jesus, who also point to the promise of this divine future, though imperfectly. James Fowler has made his mark categorizing stages of faith. He calls the faith of such rare persons universalizing faith. Glenn Hinson, a Baptist holy man, calls them "horizonal persons." Fowler says their universalizing faith goes beyond religion's boundaries without ever abandoning their particular traditions. Hinson says they are persons who catch our eyes on the horizons of faith that stretch far ahead of our petty differences and distinctions. I say they are so full of God's unlimited, impartial love that they make us forget their religious affiliations in the way that we forget Jesus was a Jew. Or, put more positively, they raise their particular brand of faith to such intensity that it is transformed, and for the brief space of a human lifetime we glimpse the Truth beyond all our many truths. We see in them a reflection of the Truth, the Way, the Life revealed in John 14:6.*

> "My Uncle Dick was such a horizonal Christian. He lived a faith among us that rose above our ability to categorize, that broke the mold. He had sufficient honors, justly gained, on which to rest his reputation. A member of the distinguished Jesuit order, Fulbright Scholar to the University of Nottingham, holder of a doctorate in chemistry, President of a Christian university, advocate for the poor in the Nation's Capital, this complicated and educated man had plenty to brag about, but he never did ... Having this Jesuit husband, uncle, and in-law of our Allen family changed for the better our family's Christian faith. Uncle Dick's horizonal Christianity, never less than fully Roman but always more than that as well, called us to be better Baptists or Methodists, by being more fully Christian."

We buried Dick's cremains at the Morgan City Cemetery in Louisiana. Although a long way from where we lived, his family roots are deep there and it was always home to him. Eventually, my cremains will rest there beside his: the double tombstone is already erected, and I take comfort in the serenity of that place and prospect.

While these years have held the deep sorrow of the death of loved ones and, increasingly, the challenge and frustration of health and mobility issues, they still have been glorious years.

I'm convinced that continuing to stay active and involved in community and with a variety of people is a vital part of a good life. I'm grateful that I've had sufficient good health in my post-retirement years to continue working with some projects and causes that I think are important. I'm also grateful that I've been able to continue to have some fun. (Which are not mutually exclusive endeavors!)

Getting to know more of my extended family and of my family history has led me to both serious reflection and action—about which I'll say more in the next chapter—and amusement. Thanks to the genealogical research of my cousin, Gail Parker Williams, in North Carolina, I learned that the late Elvis Presley and I are sixth cousins: his great-great-grandmother was my great-great-great aunt! I wonder if Susanah Parker Preslar [later "Presley"] enjoyed music as well?

Choosing a new home and staying involved

A few years after Dick died, I decided that it would be best for me to move into a smaller home requiring less maintenance and located

closer to the activities in which I was involved. It was hard for me to leave the home we had built together, but I remembered how my mother had remained flexible throughout her life, adapting to new homes as her needs and capabilities changed.

I found an apartment in Capstone Village, on the University of Alabama campus. Living in town has made it easier for me to stay connected with students and other young people, as well as community organizations, colleagues, and friends. I have stayed so connected that some friends have teased me that I seem not to have grasped the meaning of the word "retirement."

Through the years, I've guest-lectured to undergraduate and graduate classes and mentored several students referred to me because of their interest in economic and community development. **Seeing what the upcoming generations are accomplishing gives me hope that the future can be—eventually—brighter than the past.**

The students in Auburn University's Rural Studio in Newbern, Alabama (ruralstudio.org), and of course their professors, have collaborated with neighbors in the Black Belt to create architectural solutions to over 200 challenges and projects. They design and create structures that are accessible and affordable. At the same time, the buildings are striking and dignified, respectful of their environments, and integrally connected to their communities. I met with these students to share my stories of life in Alabama's Black Belt, and encouraged and supported their work at the Safe House Museum in Greensboro.

The students' work with Mrs. Theresa Burroughs and planners from the University of Alabama led to the opening in 2002 of the Safe House Black History Museum in Greensboro, Alabama.[22] The museum repurposed a home that Dr. Martin Luther King, Jr., stayed in two weeks before he was assassinated; it honors the importance of the "Foot Soldiers" who marched for civil rights. **It is important that we preserve our history—all of it—to help us understand who we are and how our past influences present-day issues.**

Another project dear to my heart came to fruition in 2001 when the Carl Elliott Museum opened in his home-place in Jasper.[23] Bevill State Community College acquired the house after Carl passed away in 1999. Dr. Betsy Lavanna—who as a child in 1961 had been a Kennedy volunteer with us—led the grant application effort that won

funds from the National Endowment for the Humanities to develop the theme of the museum. We received grants from other agencies to repair and preserve the house and to fund exhibits. In addition to documenting the life of Carl and his family, the museum details the economic and political history of the area. Important artifacts include the famous "Rules Committee Chair" given to the Congressman by his constituents that I described earlier in this book. A timeline reveals his accomplishments as a legislator. The Red Bay Museum in Red Bay, Alabama, also includes exhibits about Congressman Elliott. It seems appropriate that his memory and legacy are honored, including the Federal building in Jasper and the Walker-Winston Regional Library being named for him.

The working partnerships developed in creating the Elliott Museum led to the opening of the Jasper Family Resource Center. I invited representatives from Bevill State and the Mayor's Office to visit the Dothan FRC with me, and the success they saw there, in a city similar to their own, convinced them to gather the community to create and to use their own FRC. Family Court Judge Jimmy Brotherton was a moving force in support of the development of the center.

Helping deploy the Anniston Civil Justice Fund

Helping engage a community to decide how to most effectively use money made available in the aftermath of a great injustice was one of the most challenging and most fulfilling projects of my lifetime. In Anniston, Alabama, PBCs (chemicals used in electrical equipment) had been manufactured, beginning in the 1920s, at a factory in proximity to Snow Creek. The factory was surrounded by a residential community of families and churches. In true Southern style, people had vegetable gardens and pecan trees in their yards and ate fish they caught from the creek. But over the years, patterns of illness among the people in the area led to the discovery that toxins from the factory had been allowed to pollute the soil and water and were present in almost everything that grew from or lived in them. In 2003, the settlement of *Tolbert v. Solutia, Inc.* led to individual payments to 18,000 plaintiffs represented in the suit, and establishment of a medical clinic to serve the area. The four law firms that negotiated the settlement each contributed $250,000 to establish the $1 million Anniston Fund administered by the Alabama Civil Justice Foundation (ACJF). The donors asked that the fund "be deliberately and strategically dis-

bursed in order to have the greatest effect on educational opportunities available in impacted areas of the community."

I was serving on the ACFJ board at the time. Sue H. McInnish, the executive director, asked me to partner with her in assessing the situation and seeking out the individuals and programs already working in the community that might be strengthened with proceeds from the Anniston Fund. We visited facilities, conducted interviews, convened community meetings, and listened to public officials, parents, and educational leaders. We developed relationships within the community, acknowledging the understandable distrust of many, but finding through engagement ways to carry on the work.

Ultimately, the Anniston Fund worked to leverage its investments in programs to attract additional funding from other sources, and concentrated on programs fostering early intervention for young children, providing a gateway to college, placing computers in community centers, and creating and implementing a plan for developing technology across the school system. The final disbursements from the Anniston Fund were made in 2010. The final report is available on the Internet.[24] **I recommend it as truly inspirational reading: the details on the synergy and outcomes of these investments, and the comments of children, parents, and other involved community members will underscore the value of doing the work of community development.**

Beauty and value out of destruction

The opportunity to do something constructive sometimes arises naturally from the most bleak circumstances, whether man-made or natural disaster. On April 27, 2011, an EF-4 tornado ripped through Tuscaloosa and surrounding cities, causing massive destruction and the deaths of 268 people in the state. Dr. Sue Parker, a UA professor in the College of Human Environmental Sciences, had a fabric shop on 15th Street that the tornado tore apart. After the storm, thousands of yards of fabric were found up in trees, wrapped around cars, and buried in the mud. Volunteers appeared almost immediately and helped Sue gather the cloth, which she washed or had dry-cleaned and stored in her garage.

Pondering what to do with the material, Sue called me. We thought immediately of Black Belt Designs at the Coleman Center in

York, Alabama. In 1985, I had worked with my old friend and co-high-school-valedictorian Tut Altman Riddick and her husband Harry in their philanthropic creation of the Coleman Center. The Coleman Center is a comprehensive arts center, working from the beginning to invigorate York with various workshops and projects. Black Belt Designs, a non-profit micro-enterprise clothing company, grew out of a three-day sewing workshop sponsored by the Coleman Center. The purpose of the workshop was to prepare special dresses for women participating in the Center's first Rooster Festival, and to provide some employment for garment-workers who had lost their jobs when a local clothing factory closed.

As a professor, Sue had consulted with Black Belt Designs' principals, Marilyn Gordon and Lillie Mack, sharing her expertise in entrepreneurship, fashion merchandising, and apparel production. We called to tell them about the material, and that was the beginning of "Remnants of the Storm." Marilyn, Lillie, and Mary Jo Hare came up to see the material, and together we measured it and talked about what could be done with it. Sue donated the 4,000 yards of salvaged material to Black Belt Designs, who made it into suits, jackets, scarves, and vests, all sold with a "Remnants of the Storm" label that told the story of the material. With this project, Black Belt Designs was able to increase its production and market a new product of historical resonance. When I think of this project, I think of the biblical injunction to "strengthen the things that remain." **I can't stress this enough: in any community or economic development undertaking, always ask, "What is working here? What resources do we have? What can we do, or do better, with what we have?"**

Young people with a plan and exemplary elders

One of the most striking and encouraging examples I've seen of young people choosing to take action to help others in the community came in 2013 when Josh Carpenter, 25, a native of Florence, Alabama, and his friend Dan Liss, 26, showed up on my doorstep having been sent by a mutual friend who told the two that I could help them with contacts in the State of Alabama.

Dan and Josh had become friends in London, where Dan—who described himself as a "recovering investment banker"—was working for Deutsche Bank and Josh was studying at Oxford on a Rhodes Scholarship. When they learned that the State of Alabama did not in-

tend to implement the provisions of the Affordable Care Act, they decided to do something about it. The two of them formed a non-profit organization, "BamaCovered," and came to Alabama to help citizens gain access to health insurance. They were planning to work in a three month's window to accomplish their goal. I was more than willing to share with them what I could tell them about the State and to put them in touch with others who could be helpful.

At the end of three months, BamaCovered had recruited and trained 600 student volunteers from college campuses across the State of Alabama. They deployed these students all around the State and they registered over 7,000 Alabamians, educating them about provisions of the Affordable Care Act and so empowering them to make informed choices about health insurance. As a result, many of these Alabamians, for the first time in their lives, had insurance that would enable them to see a doctor.[25]

The success of this project was wonderfully encouraging to me. Seeing these young people set an ambitious but realistic goal in service of others and then put their knowledge, skills, and talents to work achieving it was inspiring. **They saw a need, made a plan, communicated their vision to others, marshaled available resources, and made a real difference for the better in the lives of many people. That process can be a guide to others.**

As much as I am encouraged and inspired by many young people, I have also been greatly inspired by meeting two people who are even older than me—Jimmy and Rosalynn Carter. Although I had campaigned for President Carter and believed him to have been one of America's best and most honorable presidents, I had not met him or Mrs. Carter until my nephew Loyd invited me and Fr. Joe Tetlow to accompany him and his wife Libby to Plains, Georgia, in 2015. Loyd was a professor in the McAfee School of Theology at Mercer University in Atlanta and had been invited to preach at the revival services at Maranatha Baptist Church, where President Carter was teaching Sunday School.

We arrived in Plains in time to attend the opening service of the revival. Just as the service began, President and Mrs. Carter arrived and were followed into the church by twenty or more men and women who were visiting them, visitors whose skin was, as the old children's Sunday School song describes, red and yellow, black and

white. Their colorful dress and accessories showed that they came from all over the world. They were Hubert Humphrey Scholars (a program initiated by President Carter) who had been selected to come to America to study various aspects of American life with the goal of improving conditions of health, education, and the economies of their respective nations. Loyd did a good job of explaining to the group the traditions that characterize southern Protestant revivals. We sang some of the familiar hymns of my childhood. Fr. Tetlow commented later how much appreciation he felt for the theology expressed in song.

The next day we—Loyd and Libby, Rev. and Mrs. Jeramey Shoulta (Pastor of Maranatha Church), Fr. Tetlow and I— met the Carters at a restaurant in downtown Plains. The restaurant was what we in the South call a "meat and three," in which diners can choose from a varying list of one item of meat or poultry and three vegetables (of which macaroni and cheese is an option). Mrs. Carter carefully seated us all, and I was delighted to be on President Carter's right. I noticed that he ate black-eyed peas, squash, and rutabagas, with a piece of cornbread—and that not one crumb was left on his plate. It tickled me that I had chosen the same "three" to go with my "meat" of baked chicken.

Before we began eating, Mrs. Carter asked Fr. Tetlow to give the prayer of thanksgiving while we all held hands. Both of the Carters spoke of their friendship with Fr. Theodore Hesburgh, who for many years was President of Notre Dame University. Both attended the Memorial Service for Fr. Hesburgh and both had received honorary degrees from Notre Dame. Rosalynn remembered his work with her as First Lady when she led the effort to save thousands of Cambodians from starvation. President Carter had used him in many official capacities as an advisor. He said he once told Fr. Hesburgh to call on him if there was ever anything he could do for him. Hesburgh responded by saying that more than anything else he wanted to ride in the fastest airplane that our nation possessed. Although that airplane was a highly secret weapon, President Carter managed to grant his wish, and Hesburgh flew at 2,200 miles per hour! It was also revealed that a neighbor of the Tetlow family in New Orleans had married a nephew of the Carters. So, it was that kind of "family talk" and not much else about solving the problems of the world.

After lunch we drove to the Carters' home for dessert and coffee at their dining room table, which cozily seated the eight of us. Their house is not a showplace, but very much a family place and very much lived in. As we finished dessert, the President asked if we would like to see the rest of the house. And of course we wanted to!

You may imagine what his office was like, filled with memories from all over the world, with a comfortable chair and desk where he wrote for two hours every morning. The Carters had glassed in their former garage to make a spacious sun room. Beyond that, an attached room housed his woodworking shop. More kinds of woodworking tools than I knew existed were all neatly arranged and labeled. I asked if he could always find any tool that he wanted at any time. His reply: "You bet!"

He told us that he built a lot of furniture, most of which is taken to Atlanta for an auction at the Carter Center. One piece sold for $1 million. All the proceeds go to the work of the Carter Center which, by the way, he has endowed at $250 million.

Mrs. Carter was the caretaker of the patio on which hundreds of yellow finches eagerly enjoyed the feeders while squirrels scampered about picking up the seeds that fell to the ground. Mrs. Carter also works with a community group that promotes butterflies. She described in detail how they handle the butterflies to identify their patterns of migration.

As we left the house we stopped briefly for picture-taking at the front door. But that was not the last we saw of the Carters. At 6:00 p.m. we enjoyed a covered dish dinner at the Church's fellowship hall. The Carters joined us at our table, and we continued our visit. We walked into the church Sanctuary and sat together to hear the closing sermon for the day. As our visit ended we had a final opportunity to express our appreciation for our visit together, and to thank both of them for their work on behalf of all Americans.

Over the course of the visit we shared meals and visited in the Carters' home, and were made to feel as comfortable as if we were family members. I haven't attempted to recount all the humanitarian work that the Carters have done themselves and made possible through the Carter Center—it is astounding in amount and variety, and you can read about it on the Internet. What struck me most about them

was their friendly directness, the integrity with which they live out their Christian faith, and their obvious enjoyment of one another and of getting to know people. Their focus is not on themselves, but on the world around them, globally and locally, and what they can do to make that world a more just and healthy place. **Anyone, at any age, would do well to take them as examples of how to live lives that both make a difference for good and are full of enjoyment.**

I came away from the visit to Plains once again knowing how grateful I am to be an American. The Carters grew up pretty much like I did; they lived in Sumter County, Georgia, and I came from Sumter County, Alabama. His mother was a nurse and cared for the entire community; likewise for my own mother. He came out of that environment to become a great world leader. And he keeps on serving and leading. He has great intelligence and received education in the Nation's public schools. I believe history will treat him kindly, as perhaps one of the great leaders of his day. And in his post-presidency he and Rosalynn have worked in some of the poorest nations on earth to cure disease, feed the starving, and promote human rights. He is a man of peace and good will. All of this has reinforced for me the importance of each and every child in America, because you never know where our next great leader may be born and raised. We don't have any children to waste. We need their potential to grow and develop to the fullest extent possible. I hope that my life's work will in some small measure have helped a child be all that he/she can become.

During my retirement years, I've had the opportunity to continue to work in the areas that interest and concern me. Being a part, however small, of so many worthwhile endeavors has been both an honor and a pleasure. Beyond these individual projects, I have also been involved in other work that I know to be vital to the future of our country—the work of racial reconciliation.

Striving for Racial Reconciliation

If you've read the chapter in this book about my growing up, you know that I was a child of the Jim Crow South, in that long era before civil rights legislation was enacted and finally enforced. As a child, I saw the respect with which my parents treated everyone, and I remember my father's integrity in casting his unpopular vote on the school board to build a new high school for Black students. I didn't question "how things were," and didn't consider what it meant that my playmates and I didn't go to the same schools and couldn't use the same public facilities.

But as I grew, I began to question. After reading a magazine article about the discrimination against Black soldiers in World War II, I surprised my freshman college English teacher by writing a paper voicing my shock at the unfairness. As I wrote in an earlier chapter, I felt the same shock in my early days of working with Carl Elliott when I reported to him the findings of voter suppression in my home county, sure that he would vote for the pending civil rights legislation, only to hear from him that he could not vote for it. Not that he didn't believe it was right—but that if he did, he would not be reelected, and would not be able to do anything to pass other legislation that would benefit all citizens, Black and White alike. But not until I was working in economic development at The University of Alabama did I begin seriously to examine my own assumptions about the relationships I had as a child.

The situation that brought me to begin to face my own part in racial reconciliation began with an economic development project in York, separate from my work with the Coleman Center. The mayor asked me if I would come and help them do something to create new jobs for people there. The unemployment rate was about 15%, so of course I went. We met a few times with a limited group of local people and finally I said to him, "Look, two-thirds of the people who live in Sumter County are not represented by anybody in this room. All this talk is not going to go anywhere if the Black citizens in this county are not part of the discussion and part of the solution."

So we got together a broad group of citizens to participate in a strate-

gic planning effort. As part of the strategic planning work, I asked Dr. Rhoda Johnson from the University to talk to the group about racism. It was an eye-opening session for most of the people in the group, including me. As we were driving back to Tuscaloosa, I told her about my lifelong friend Mary Ella Williams Foster.

Mary Ella had lived in Chicago most of her adult life, and had moved back to Ward to take care of her elderly mother and her sister, who was partially paralyzed and on dialysis. Dick and I had visited with them the previous Christmas, and I had felt the same mutual affection I always had with Mary Ella. I said to Dr. Johnson, "After all these years I don't believe she had any bad feelings toward me—I just think she loved me and I loved her. But I've often wondered what she thought after she left Alabama, if seeing another way of life changed how she felt."

Rhoda looked at me and said, "Why don't you ask her?"

Well, how simple, I thought, abashed. "I will do that," I said.

So I went to see Mary Ella. I didn't know quite how to start, so I just came out and said, "I've come to talk with you, and this is what I want us to talk about."

We talked about the fact that we went to different schools, and that I rode a school bus while she had to walk. We talked about the fact that there were differences in the culture that kept us separated in other parts of life—there were Black churches and White churches, and those didn't mix at all, even though we played together every day as kids.

Mary Ella told me that when she moved to Chicago she understood what people meant when they talked about discrimination, because there the world opened up to her. She could go anywhere she wanted to go; she could vote with no question; she could go to school; she could do whatever she wanted to do. She saw that the way things had been were not the way things had to be—or the way they were supposed to be in the United States.

But then she closed our conversation by looking at me, giving me a big hug and saying, "But I've always loved you."

I knew that I had always loved her, too, and I told her as I hugged her back. But I wondered whether, if our positions had been reversed, I

would have been able to show the same grace and lack of bitterness that Mary Ella had shown me about the discriminatory behavior she'd had to endure and how that had affected her life. That conversation was a learning experience for me and my first one in racial reconciliation.

"We've still got a long way to go."

Through the remainder of my time on staff at the University of Alabama and continuing through the projects I've since been part of, I've worked to be sure all the stakeholders, Black and White, are represented. But the pace of change was and remains slow and frustrating.

In 2013, I attended an event marking the 50th anniversary of the desegregation of The University of Alabama. It included a serious discussion about the progress that had been made in the preceding 50 years in terms of Black university enrollments, graduates, and faculty members, and a general discussion of the events that had transpired during that time. I was walking out of the hall with Dr. Scott Bridges, a music professor who had been instrumental in establishing the series of UA "Realizing the Dream" concerts honoring Martin Luther King Jr., and Dr. Art Dunning, who was then Vice Chancellor for International Programs and Outreach for the UA System.

I didn't plan this, but as I was leaving with my friends I said, "I don't think I'll ever go to another meeting just to hear people say, 'We've come a long way but we've still got a long way to go.' In every meeting I go to, the subject of racism comes up and people say 'We've got some new laws in place, and a lot of things are different now than they were 50 years ago, but we've still got a long way to go.' But we never identify exactly what that way is. Well, as far as I'm concerned, it's called reconciliation. I don't know why we run from that word, but that's what's got to happen if we're going to ever make further progress with this issue."

I believe I spoke the thoughts we all were having. We set a time to meet and after a long conversation, decided we would do what we could to encourage the University to move further down that "way we still had to go."

Taking another personal step toward reconciliation

Around that time, I made up my mind to take a further personal step

in reconciliation. One of my cousins had taken an interest in our family history. In doing research, she found a will written back in North Carolina in which two people were included as property being left from one family member to his heir. I was shocked—I hadn't known that I was related to anyone who had owned slaves. That knowledge led me to a deeper sense of the history of which I was a part and which had formed me in ways that I couldn't fully realize. What I knew I could do, however, was to openly acknowledge that history and to say what I thought and felt about it. I could represent my family to the living generations of families that had been oppressed by the system of white privilege that had profited mine.

The opportunity to do that came at the annual service honoring the memory of Margaret Ann Knott at the Pleasant Hill Missionary Baptist Church in Yantley, Alabama, just a few miles from where I grew up. Ms. Knott, 19 years old, had been part of a sit-in on the street in front of the Choctaw County Courthouse on September 11, 1971, and was killed when a white man drove a vehicle through the intersection. A mixed-race grand jury had not indicted the driver, and Ms. Knott's mother had forgiven him.[26] A friend knew the organizers and asked permission for me to say something at that year's service.

The presider called on me, telling the congregation that I had asked to speak to them. I identified myself, told them that I had grown up in Ward, and I had only learned as an adult of advanced age that my forebears had owned slaves. I said that I had been taught by my parents to respect all people, and had tried throughout my career of economic and community development to make sure that all races were included. But learning that truth about my forebears had made me think about my personal responsibility in a different way. I said that I knew slavery and Jim Crow were immoral and wrong, and that I was sorry for the fact that White people, and my people, had perpetrated them and the ongoing discrimination that stemmed from them. From the bottom of my heart, I apologized. Then I asked for their forgiveness.

I think the people there were surprised, and I imagine some were skeptical. I'm sure if our situations were reversed, I would have been. But instead many of the participants lined up and hugged me and gave the grace of their forgiveness. I am more grateful for their kindness than I can ever say.

Racial reconciliation at The University of Alabama

Meanwhile, Scott had made contact with the William Winter Institute for Racial Reconciliation at The University of Mississippi. (The Center is now an independent non-profit named The Alluvial Collective.) He, Art, and I were scheduled to meet with them shortly before Christmas, but three days before we were to drive to Oxford, Art was named Interim President of Albany State University. All his energies had to go into moving and his new job, so we decided to regroup and go after the holidays. As it turned out, Dr. Jennifer Stollman, the academic director, was able to come to us before we could visit. As a result of her visit, and with the support and involvement of the University, over the next two years we had a series of small-group visits to the Center and two big workshops on campus with the aim of looking honestly and openly at what racism is, how it works, how it affects individuals and society—and what we can do about it as individuals and as citizens with the responsibility of holding our institutions accountable for embodying the values we claim in the Declaration of Independence. The small groups and the workshops all included faculty, staff, and students. Dr. Stollman led the first workshop, and the second was led by Dr. Damon Williams, who also did days of one-on-one interviews with faculty, staff, and students. This work provided the foundation for the University's continuing efforts to come to grips with the issues of diversity, equality, and inclusion.

As ever, we have come a long way—the university administration now includes a vice president for diversity, equity, and inclusion; frequent allied events and classes take place on campus; and in 2020 the UA Intercultural Diversity Center, first opened in 2016, moved into a new and central space in the student union building. And there is still a long way to go to a society in which everyone has an opportunity to succeed. Some stakeholders say the University's efforts go too far and have done too much; others say they haven't gone far enough and have done too little.

I'm almost 100 years old, so I've lived through a lot of ups and downs in civil rights. I've been aware of the absence of knowledge in the white community, including myself, of the history of Black people in this country. We know there was slavery, of course, and racial discrimination. Young—and not so young—white people tend to say, "I

had nothing to do with slavery. Don't blame me. I love everybody, and everyone's welcome with me," but that ignores the depth of culture of the Black community over time, the trials and tribulations they have faced, and the strength of character it has taken to do that.

There's a lot of history that doesn't get taught and doesn't get talked about, and as I am writing this, there's a great furor that any telling of American history that includes anything other than White men as heroes is false—is "critical race theory" rather than just simple history that includes all the people that were part of it. To me, such nonsense is part and parcel of the problem we have with healing the breach between Black and White. If you don't admit the facts, you can't face them and find a way to move forward together.

Bringing civil rights history to light in Tuscaloosa

A case in point of hidden history in Tuscaloosa were the events of Tuesday, June 9, 1964. At that time, a new county courthouse had opened in Tuscaloosa, and county leaders had promised that the water fountains and restrooms would be open to all. Instead, the opening was attended by then-Governor George Wallace and "Whites Only" signage was posted over the facilities. A group of concerned Black citizens gathered at the First African Baptist Church, planning to peacefully march to the courthouse to protest this situation. But just as they were leaving the church to begin walking, they were beaten and tear-gassed by the police. Thirty-three men, women, and children were hospitalized with injuries and 94 people were arrested.

This was a year before "Bloody Sunday" in Selma, and while that infamous day rightly made headlines around the world, there was not much press coverage of "Bloody Tuesday." I think it's fair to say that most White people in Tuscaloosa decades later didn't know it had happened. I thought about all those people who had been injured and unfairly arrested, and wondered if those arrests could be expunged from the record. I shared this thought with Scott Bridges, who volunteered to go to the Tuscaloosa County Courthouse and get copies of the records as a first step. Scott discovered there was no record of anything happening through the courts—not even a list of the names of everyone arrested—just as if the suffering they went through never happened. It turned out none of the "Bloody Tuesday" protesters, though arrested and held for hours at the Tuscaloosa County Jail, had ever been arraigned.

While Scott was at the courthouse, he ran into Judge John England and told him about our conversation and what he had found. Judge England advised Scott to get in touch with Tuscaloosa City Councilman Harrison Taylor, who had spoken about the need to preserve Tuscaloosa's civil rights history. The history wasn't written down, and even the youngest people who had been part of it were getting into their 70s. Councilman Taylor had been a 17-year-old protester on Bloody Tuesday. He recognized that the community was in danger of losing the knowledge of that experience.

Scott and I met with Mr. Taylor, and together we agreed that we should have a task force that would go about documenting that part of our history. We found more and more people who believed in the importance of this and were willing to work on it, so the momentum for the project grew and grew and grew. After about six months we were invited to a meeting of the Tuscaloosa City Council on October 16, 2016. The Council issued a proclamation recognizing the group as The Tuscaloosa Civil Rights History Task Force.

Scott served as the president of the task force, and over the next three years, twenty-some people worked on documenting the history of civil rights in Tuscaloosa, beginning when the first enslaved people were brought here. Faculty and staff from the University, clergy from local churches, community members, and foot soldiers from the Civil Rights Movement worked together to create the Tuscaloosa Civil Rights History Trail. The goal of the trail is to educate people through lifting up the facts of what has happened, making people aware of how our society has functioned and what that has meant over the years.

While some members of the task force were working on assembling the information to be included in the trail, others were focusing on bringing people together to begin the dedicated conversations that can lead to reconciliation. Dr. Ken Dunivant, then pastor of The First United Methodist Church in Tuscaloosa, offered the church as a meeting place for an initial training session with Dr. Jennifer Stollman, who led the participants through a program she designed to help people, both Black and White, realize what their hidden biases are. In subsequent workshops, she trained the participants to facilitate group discussions with the goal of extending racial reconciliation throughout the community.

Four interracial circles—small groups—were formed, committing to meet monthly and speak honestly and respectfully with one another. This work was coordinated by Nancy Callahan, who gave generously of her time and talent to help bring to completion the plans for projects identified by the four working groups.

Hunter Chapel AME Zion Church was the first Black Methodist church in Tuscaloosa, established in 1866 by freedman Shandy Jones. While the groups were carrying out their work, Hunter Chapel, under the leadership of The Rev. Dr. Thaddeus Steele, invited the group members and others in the community to come break bread and talk about their concerns and experiences. The dinner provided space for Black and White citizens to come together and explore reconciliation with each other as a necessary precursor of racial harmony and equal justice.

At the opening of the Trail in June 2019, the four circles each presented the projects they would be pursuing in the future. The task force became The Tuscaloosa Civil Rights History & Reconciliation Foundation, with its focus on educating people, continuing to document civil rights history, and bringing interracial groups together with the goal of reconciliation.[27]

And while that is simple, it isn't easy, especially not today in the polarized political dynamic of our country which makes me wonder if our democracy can survive. But as I write this, the work is going on. The City of Tuscaloosa has acquired the old Tuscaloosa County Jail as a site for a civil rights museum, and the Linton Barber Shop and its trove of artifacts of Tuscaloosa civil rights struggle as a historic site. So I don't give up hope, and whatever energy I have left in this lifetime, I am dedicating to working for the principles of fairness, and equality that I believe are the American dream, even though they haven't always been the American way. I hope you will do the same.

Finding What Sustains You: My Spiritual Journey

Throughout these chapters, I've told you stories from my life and the lessons I've learned that I believe can be valuable as you strive to bring about change and justice in the world. I want to finish this effort by sharing with you one final thing, and that is what has sustained me through all the decades of my life. That is my faith in the power beyond myself; and my determination to abide in that faith. Even in times when it has been difficult to believe in anything, I have continued to believe in and trust the teachings of the Christian tradition into which I was born. The spiritual aspect of my life is what makes every other aspect of it possible, and I believe that the practice of faith is essential for anyone who wants to bring about positive change in the world.

At this stage of my life I have been given the time to reflect on my spiritual journey. I originally was inspired to serious reflection at a retreat led by Fr. Joe Tetlow at Montserrat Jesuit Retreat House in Lake Dallas, Texas, in 2010. The retreat, themed "Advent: A Time For Waiting," closed with praying the scripture describing Pentecost. The scripture tells us that the apostles present when the Holy Spirit came upon them in "the upper room" asked each other, "What does this mean?" Fr. Tetlow asked us to think about some questions: Who am I? What am I to do? Who am I with?

In reflecting on my life's journey, I realized that the things I had experienced by age 26: the death of my father, life-threatening illness, victimization by prejudice for reasons over which I had no control—all gave me the strength to survive; to overcome adversity; to persist when the future was not clear; and to continue to be joyful and hopeful. Without these experiences, I can't imagine what my life might have been.

As a I spent time reflecting on my relationships and my formation as a Christian, I saw that I had been—and continue to be—blessed to know so many others who helped shape and influence my spiritual growth. I was raised a Christian from my birth, very much involved in the Baptist and Methodist churches that were the heart of the Alabama towns in which I grew up and worked as a young woman. I had

the tremendous good fortune to be taught Christianity by example as well as in words. My parents and family were my first and best teachers. I was exceedingly blessed by the love and support of my mother throughout her life. I recall with gratitude so many other people who have influenced my life and faith, first and foremost my husband Dick, who profoundly affected my spiritual growth by leading me into the Catholic faith. I am thankful that I have had life-long friends and colleagues who were inspirational, decent, kind, and lived lives of integrity, like Carl Elliott. They helped me to become a better person. Among them have been people who have shared with me their religious traditions that were different from mine. These friendships have enriched my life, broadened my perspective, and taught me to appreciate the diversity that exists in God's world.

Drew Christian, SJ, well described this kind of formative experience: "What is integrating and unifying for religious people is not some theological framework but their experience of holiness in others and the striving for holiness in their own lives, and through the prism of that holiness the overwhelming holiness of God."

In other words: God is in community.

I have also found God in music. Some of my earliest memories are of my father and mother singing hymns as we all were together in church, assuring me of the love of Jesus. Those memories gave me such comfort while I was in the sanitarium, and in every difficult time in my life since. I played for church services beginning as a child, and as a young woman played for all-night Gospel singings in rural Alabama, loving the sound of the congregation's voices raised in harmony, and in faith and devotion. Until my hands became too arthritic, I played hymns for myself at home just for the joy and comfort of it. I would sing hymns in the car as I drove from place to place in Alabama, and while my singing voice is not what it was, the words of hymns often come to my mind, comforting and encouraging me.

God is also found in quiet and solitude. The very practice of reflection is a way of realizing this presence. At my first Ignatian Retreat I drove to St. Charles College in Grand Coteau, Louisiana, where Dick had entered the Jesuit Order at age 16. On entering the gates I immediately sensed the peace and silence of the Spirituality Center. Huge pine trees lined the entrance driveway, and in the springtime azaleas provided pink blossoms all the way to the front entrance. Early in the

retreat we learned how important it was to observe silence. We were also encouraged to explore the grounds and walking trails and find a personal sacred in which space to spend time each day.

In another retreat, Hazelyn McComas of the Academy of Spiritual Formation asked, "Why are you here? Why did you come to this place of retreat?"

The answer is that we come because of our longing for God. St. Augustine wrote, "Our hearts are restless until they rest in Thee." We come because of the busyness and frustrations of life; we come seeking answers to tragedies we don't understand; perhaps we come because we have a loss of identity and recognize our limitations; or, we come because there is an absence of joy in our life or a sense of loneliness. And we come because we seek to live a holy life.

I have learned to slow myself down from time to time to realize that God is present to me here and now. He is present in what I do, the people I meet, and situations I find myself in each day. Each day, as I strive to overcome my tendencies toward being judgmental and impatient, I remember this advice from Pope John XXIII: "See everything—don't be blind. Overlook a great deal—you can't change everything. Improve a little—make progress."

In these latter decades of my life, I have been particularly sustained by the theology of St. Ignatius of Loyola, thanks in great part to the teaching of Dick's and my dear friend, Fr. Joe Tetlow. His series of talks about Ignatian spirituality entitled "Following Christ on His Way"[28] have been enormously helpful to me. I have learned that God is continuing to create me, day by day, and it is important for me to keep moving forward.

One of the practices recommended in Ignatian spirituality is a daily examination of conscience called the Examen. This consists of calming yourself at the end of the day and taking several steps of prayer and reflection. Here is the version I learned from Fr. Tetlow.

Knowing that God accepts me as I am and loves me as I am,
- I thank the Lord for this day, and express gratitude for the blessings of the day, giving thanks to God.
- I ask for light. I want to see myself and my actions the way my Lord sees them. So, I ask to be shown that.

- I take a closer look at what I did, and did not do, morning, noon, afternoon, evening. I think of habits I want to change and some virtues I want to practice.

- I admit I did things I meant not to do, and did not do things I meant to do. I want to feel not regret (that's about me) but sorrow (that's about me and God).

- Now, for tomorrow. I ask God to let me do better, saying exactly what I want to do better. Then I set myself to do or not do, as I have chosen…and I offer this choice to the Lord.

The Examen helps throughout the day in keeping me engaged, in thinking and examining what I do, say, and think. I have learned to slow myself down from time to time to realize that God is present to me, here and now. He is present in what I do, the people I meet and situations I find myself in each day. I have learned that I am called to imitate the life of Jesus of Nazareth. I have something to do, and I must do it or it won't be done.

You have something to do, too. Your community, your state, your country, and the world all need your particular contribution. You may feel that you can't do big things. The good news is, you don't have to. As you have read in this book, I didn't personally do big things. I did little things—made connections, brought people together, suggested possibilities, pointed to better outcomes, insisted on inclusion, thought outside the box—that helped big things happen. You can do the same.

If you already have faith, and a faithful community that sustains you in love and leads you to reach out to others in compassion to do that good work, embrace it. If you don't have this source of strength and refreshment in your life, seek it. I firmly believe that, as the Gospel of Matthew says, if you seek, you will find.

Your path may not be the same as mine, but you will find the work that is yours to do, and the strength to do it.

In the End, Gratitude

As I conclude my story, I have lived for almost 100 years. As I reflect on my life to this point, when the end is ever more clearly in sight, I can truthfully say that I have had a happy life and I do not obsess over what I wished I had done. In my life, as in everyone else's, there are disappointments as well as high spots, but at the end, there isn't very much that I would have changed.

If I had to choose only one word to express how I feel it would be "grateful."

I am truly grateful for my parents, my family, and so many others who have blessed my life in countless ways. I think often of two of my best-remembered teachers, Marietta Owings and Vermelle Jones. My sister and brothers, my nieces, nephews, cousins have all made me proud, and I love them all. My friends, Black and White, scattered from east to west, have been anchors in my life who supported and believed in me. I will always be enormously grateful to Carl Elliott who was my mentor and friend, and to his extended family who have accepted me as one of their own.

I am so grateful to be an American citizen. I have learned how much I truly love this land, and its beauty "from sea to shining sea." I come from a family of patriots going all the way back to the Jamestown Colony of Virginia where William Allen landed as an indentured servant. My mother volunteered as an Army Nurse in World War I; my Uncle Earl Allen was a doctor who volunteered to lead a medical team to rescue the Lost Battalion while serving in France in World War I; in World War II my father used his farm to support the war effort, and, to the extent he could, purchased bonds to invest in our government; my brothers all volunteered for the armed forces; we voted, and always participated in our local government to provide for the common good of ourselves and our neighbors. I had the great privilege of working in the United State Congress to craft education policy, and to gain a unique understanding of the people and the policies that have made our country great.

I am grateful that my upbringing led me to take the opportunity to

fight against religious bigotry and racism—to help elect John Kennedy as President of the United States when some Alabamians, including church leaders, openly opposed him on the basis of his Catholic faith—and to work for racial reconciliation, even with so much yet to be done.

I am grateful that I had the opportunity to work toward improving the lives of ordinary people…creating Federal legislation to open the doors of colleges and universities for talented students who needed financial support to enroll; to develop innovative programs offering new opportunities for women to enter careers with better paying jobs; to work with Alabama's Governor Jim Folsom, and First Lady Marsha Folsom, to jump start a network of Family Resource Centers across Alabama to provide a local support system for families; and to hold Board of Director's membership on the Alabama Civil Justice Foundation in its quest to bend the moral arc for economic justice toward programs to support families and children.

I am grateful for the opportunity to make changes in my life…to leave home to forge a career in Washington, D.C., then to Trident Technical College, a community college in Charleston, South Carolina, and back to Tuscaloosa and the University of Alabama. Who could have guessed that I would be happily married to Homer Richard Jolley at age 45, and get to know and love my new Jolley family!

I am grateful for the power of words and examples to inspire and encourage. This statement by Robert F. Kennedy is especially meaningful to me: "Few will have the greatness to bend history itself, but each of us can work to change a small portion of events, and in the total of these acts will be written the history of each generation. Each time you stand up for an ideal or act to improve the lot of others, or strike out against injustice, you send forth a tiny ripple of hope. Crossing each other from a million different centers of energy and daring, these ripples build a current that can sweep down the mightiest walls of oppression and resistance."[29]

In my retirement years I have had the time, and many opportunities, to give attention to my spiritual life. Through retreats, reading, and getting to know personally many of the men who make up the Jesuits of the New Orleans Province, I have been inspired to do more—to reach higher for the greater good. I have acquired spiritual tools to systematically examine my conscience; to study and reflect, and to

continue to make progress in recognizing how God is at work in my own life and in His World. I am especially grateful for the friendship I have enjoyed with Fr. Joe Tetlow, the Jesuit friend whom I first met when Dick brought him for dinner at our home in Washington, D.C. His work, his scholarship, teaching, and writing on Ignatian spirituality have been a special blessing in my life.

And, finally, I am grateful to you who have had the patience and perseverance to read to the end of my story.

Please accept my sincere thanks.

Notes

[1] https://www.al.com/opinion/2018/10/this-90-year-old-alabamian-changed-the-world.html Accessed January 3, 2024.

[2] Garrison Keillor. *Pontoon: A Novel of Lake Woebegon* (New York City: Viking Penguin, 2007) p.237.

[3] Last Lecture Series: "So People Won't Forget". 23 April 2012, The University of Alabama, Tuscaloosa, Alabama; 118 Graves Hall.

[4] Anne Lamott. *Traveling Mercies: Some Thoughts on Faith* (Anchor, 2000)

[5] https://encyclopediaofalabama.org/article/carl-elliott/ Accessed January 3, 2024.

[6] Associated Press, "Teenagers Ad Lib Advice to Congress." *The New York Times*, March 20, 1957, p. 1.

[7] About Mary Lasker: https://en.wikipedia.org/wiki/Mary_Lasker Accessed January 3, 2024.

[8] Scholarship and Loan Program, Volume 104, Part 14, Congressional Record, p. 16747, August 8, 1958.

[9] Wayne Urban. *More Than Science and Sputnik—The National Defense Education Act of 1958* (Tuscaloosa, Alabama: University of Alabama Press, 2010)p.192.

[10] Duke University, *Ways and Means Podcast*. https://waysandmeansshow.org/2018/02/25/s3e4-how-sputnik-sent-women-to-college/ Accessed January 3, 2024.

[11] Michael Bloomberg. "Why I'm Giving $1.8 Billion for College Financial Aid." https://www.nytimes.com/2018/11/18/opinion/bloomberg-college-donation-financial-aid.html?searchResultPosition=8 Accessed January 3, 2024.

[12] "Champions of Education." *The New York Times*, August 22, 1958, p. 9.

[13] United Press International, "Plush Chair Delivered to Rep. Elliott.", *Daily Mountain Eagle*, Jasper, Alabama, 14 February 1961, p. 1
and
James Free, "Washington Free-Ways." *The Birmingham News*, Birmingham, Alabama, 15 February 1961, p. 40.

[14] U.S. Department of Health, Education, and Welfare. "Education for a changing world of work : summary report of the Panel of Consultants on Vocational Education requested by the President of the United States." (1962) p. xvii.

[15] "Education for a changing world of work" *Illustrated brief summary.* New York Public Library https://drb-qa.nypl.org/read/2943041. Accessed January 3, 2024.

[16] John Siegenthaler, "Rep. Elliot Pays the Price in Alabama" *The Tennessean*, Nashville, Tennessee, 12 September 1964, p. 4. © John Siegenthaler – USA TODAY NETWORK

[17] Associated Press, "L.B.J. Scores GOP on Aid to Schools" *The Evening Sun*, Baltimore, Maryland, 27 April 1967, p.1.

[18] William E. Schmidt, "University Helps Save A Factory in Alabama" *The New York Times*, New York, New York, 26 September 1983, p. 1.

[19] https://www.hmdb.org/m.asp?m=83504 Accessed 7 January 2023.

[20] Wil Haygood, "Twilight of a Southern Liberal" *The Boston Globe*, Boston, Massachusetts, 28 February 1989, p.55.

[21] Ronald Smothers, "After 26 Years, a Lawmaker's Fight Is Recognized as a Profile in Courage" *The New York Times*, New York, New York, 28 May 1990, p.8.
and
Michael Blowen, "Alabamian Cited for Fighting Bigotry" *The Boston Globe*, Boston, Massachusetts, 30 May 1990, p.38.

[22] https://safehousemuseum.org/ Accessed January 3, 2024.

[23] Associated Press, "New museum pays tribute to ex-congressman's equal rights struggle" *The Montgomery Advertiser*, Montgomery, Alabama, 25 July 2001, p.21.

[24] https://www.acjf.org/wp-content/uploads/2020/04/Case-Specific-Projects.pdf Accessed January 3, 2024.

[25] Michael Winerip, "In Alabama, College Students Take On Challenge of Health Insurance Sign-Up" https://www.nytimes.com/2014/03/13/us/in-alabama-college-students-take-on-challenge-of-health-insurance-sign-up.html Accessed January 3, 2024.

[26] Associated Press, https://www.deseret.com/2014/5/11/20465838/learning-to-live-without-hate-civil-rights-protester-s-death-still-echoes-in-2-families Accessed January 3, 2024.

[27] https://civilrightstuscaloosa.org/ Accessed January 3, 2024.

[28] https://www.ignatianspirituality.com/ignatian-voices/21st-century-ignatian-voices/joseph-tetlow-sj/ Accessed January 3, 2024.
and
https://www.learn25.com/product-category/professors/fr-joseph-a-tetlow-s-j-ph-d/ Accessed January 3, 2024.

[29] Excerpt from Robert F. Kennedy's "Day Of Affirmation" speech given at The University of Cape Town, South Africa, 6 June 1966.

Photographs

Clockwise from top left—Mary in 6th grade; Charlie Neal Allen, father; Henrietta Pearson, mother, in NYC for post-graduate work; Mary, brother Walter, and the school bus they drove; Mary voted "Most Versatile Girl" by her classmates at Livingston State Teachers College; Mary with her father at the family home c. 1946; Mary with her mother at her University of Alabama graduation in May 1951; Aunt Emma Pearson, the Ward, Alabama, postmistress.

Clockwise from top left—Mary and Carl Elliott with Barton Parker; Elliott (center) and staff members; Carl Elliott portrait by Fabian Bachrach; Mary shakes hands with JFK in a presentation of Vocational Education report; Mary in November 1968 report of the American Vocational Association; Mary with Carl Elliott and campaign staffer Sally Petrie getting good news on Election Night 1962 about the returns for Mr. Elliott.

Clockwise from top left—Mary and Richard "Dick" Jolley on their wedding day; cutting the cake; Mary before the groundbreaking of the Berkeley Campus of Trident Technical College in Charleston, South Carolina, a project she helped bring to fruition as Vice President for Development at TTC.

*Clockwise from top left—
Julian Butler and Mary at the
installation of Carl Elliott's Profile
in Courage Award in the Gorgas
Library at The University of
Alabama, September 25, 2015;
Senator Ted Kennedy, Carl Elliott,
Mary, and Julian at the debut
book-signing for* The Cost of
Courage; *Mary and Julian with
Jacqueline Kennedy Onassis at
the Profile in Courage Award
ceremonies, May 29, 1990; Carl
Elliott's flag-draped casket at the
graveside in January 1999; Mary
with one-time "Kid for Kennedy"
Dr. Betsy Lavanna and Jasper
Mayor Don Goetz at the opening
of the Carl Elliott House Museum
in Jasper, Alabama, on July 12,
2001.*

Left—Beloit Homecoming Event, unveiling of historic marker, 1994. Darion Petty, left. and Rosa Whitt. Below—Mary with University of Alabama co-workers Renee Kirby Taylor and Martha Whitson.

Above from left, Dr. Milla Boschung, Dean of UA College of Human Environmental Sciences, Marian Loftin, Mary, with other directors at a meeting of the Board of Directors of the Alabama Network of Alabama Resource Centers; Mary with 90th birthday scrapbook given to her at the celebration referenced in this book's introduction.

THE MARY ALLEN JOLLEY
Center for Families

Sunday, August 15th, 2021

Tuscaloosa's One Place
810 27th Avenue
Tuscaloosa, AL 35401

On August 15, 2021, Tuscaloosa's One Place, one of Alabama's first Family Resource Centers, named its new building "The Mary Allen Jolley Center for Families" in recognition of her role in the creation of the network. Mary attended the celebration with family members and, in photo above, Janet and Lonnie Davis.

Mary is one of Alabama's legends. Her impact on our state's history and our country's history is rich with passionate change driven by her vision for justice and equality. As Board Member Emeritus of the Alabama Civil Justice Foundation, Mary continues to inspire us to enact change with the same grace, enthusiasm, and passion that she has lead with for so many years.

Nikki Tucker Davis, Executive Director
Alabama Civil Justice Foundation

Mary's vision and passion have been essential to the Alabama Network of Family Resource Centers from before it was founded until today. Mary has transitioned from traveling around the state extolling the virtues of Family Resource Centers to working from home to engage with her broad network of leaders, creating partnerships and connecting dots. Mary's passion for setting families up for success and for revitalizing entire communities is contagious, and her strategic thinking, optimism, and can-do attitude are inspiring.

Joan Witherspoon-Norris, Executive Director
Alabama Network of Family Resource Centers

From top—Visiting Plains, Georgia, in March 2015: from left, Rev. and Mrs. Jeramey Shoulta and their daughter, Rossalyn Carter, Fr. Joe Tetlow, Libby Allen, Jimmy Carter, Loyd Allen, and Mary; Senator John Lewis and Mary at lunch at Brown Chapel AME Zion Church in Selma, Alabama, during the 2015 observance of the 50th anniversary of Bloody Sunday; Mary with Bama Covered co-founder Dan Liss.

Clockwise from top—Alumni Director Pat Whetstone presents Mary with the 2008 UA Outstanding Alumna Award; Mary with UA President Roger Sayers receiving the Outstanding Commitment to Public Service Award, 1994; February 2022 UA College of Education Hall of Fame, Mary with (l-r, back) Marian Loftin, Marsha Folsom, Robyn Mackey, Margaret Morton, Melba Richardson.

Left and below—Mary receiving UA honorary doctorate, 2010; Mary with UA System Chancellor Malcolm Portera and UA President Robert Witt.

Top—"Realizing the Dream Through the Courage to Live a Life of Purpose." Mary with fellow award winners and the "Realizing the Dream" Committee at the 2020 Legacy Banquet, one of the annual events celebrating the life and legacy of Dr. Martin Luther King Jr., hosted by UA, Stillman College, Shelton State Community College and the Tuscaloosa branch of the Southern Christian Leadership Conference. Left—Mary received the Mountaintop Award; Representative Chris England, the Call to Conscience Award; Emma Mansberg, Horizon Award. Below—"The Power of Perseverance" 2023 Inaugural Tuscaloosa Civil Rights Foundation Uplift Awards. (l-r) Jasmine Rainey and Tim Lewis present the Founders Awards to Dr. Scott Bridges and Mary with Foundation board members Samyra Snoddy and Rebecca Minder.

174

Appendix 1

Honors and Awards

1982
Charleston Naval Base Woman's Emphasis Week, Keynote Speaker

1985
The Order of the Palmetto, State of South Carolina
Named A Palmetto Lady by Governor Richard Riley

1990
The Bevill Center (Center for Advanced Manufacturing Technology, Gadsden, Alabama
Award for Distinguished Service and Founding Member, presented by Board of Directors

1991
Tuscaloosa, Alabama, Mayor Alvin DuPont proclaims "Mary A. Jolley Day"
In appreciation for her work to establish the Tuscaloosa Convention and Visitors Bureau

1993
Tuscaloosa Convention and Visitor's Bureau Board of Directors Chair and The City of Tuscaloosa present Distinguished Service Award to Mary A. Jolley for her service as first President of the Board, 1990-1993

1993
The XXXI, Women's Honorary, The University of Alabama
Inducted for outstanding leadership and service

1993
Carl A. Elliott Society, The University of Alabama
Named Senior Member in recognition for creative advocacy for social justice

1994
The University of Alabama
Outstanding Commitment to Public Service Award

1994
Certificate of Appreciation from Alabama Governor James E. Folsom, Jr.
With gratitude for exceptional service
to the Governor's Office on Children and Families

1994
The Beloit Community (Beloit, Alabama)
For dedicated and outstanding worldwide community service

1994
The Southern Christian Leadership Conference
Recognition of Outstanding Achievement as a Leader
in the Spirit of the late Dr. Martin Luther King, Jr.

1996
The University of Alabama
New College—Senior Resource Program
Distinguished Professor Award

1996
Natural Helpers of Akron (Akron, Alabama)
In Appreciation for Dedicated Service

1996
State of Alabama Department of Human Resources
Recognition of Outstanding Service

1998
Hale County Farm City Program
Recognition for Community Support

2000
National Association of Social Workers, Alabama Chapter
West Alabama Unit
Public Citizen of the Year
In recognition of civic commitment and outstanding community service

2001
City of Jasper, Alabama
Proclaims July 12, 2001 as Mary Allen Jolley Day

2005
University of West Alabama
Honorary Doctorate of Humane Letters

2008
The University of Alabama
Distinguished Alumna Award

2009
The University of Alabama
Martin Luther King Realizing The Dream Founder's Award
For support and vision in establishing the Realizing the Dream Initiative

2009
The University of Alabama
Alabama Entrepreneurship Institute
Social Entrepreneur of the Year

2010
The University of Alabama
Center for Community-Based Partnerships
For Distinguished Achievement in Community Engagement

2010
The University of Alabama
Honorary Doctorate of Humane Letters

2010
Auburn University
Alabama Community Healthy Marriage Initiative
Marion Loftin Child-Champion Lifetime Achievement Award

2011
City of Anniston, Alabama
Citation for Service to Youth of the City of Anniston through the Civil Justice Fund
Dedicated Service to College Gateway and Good Choices Program

2012
Omicron Delta Kappa, The University of Alabama
Frances S. Summersell Award
For service to the University and the State of Alabama

2013
Alabama Civil Justice Foundation
Named Emeritus Member of the Board of Directors

2013
Alabama Network of Family Resource Centers
Named Emeritus Executive Director

2018
Hunter Chapel AME Zion Church, Tuscaloosa, Alabama
The Shandy Jones Award for Visionary Leadership

2020
The University of Alabama–Stillman College–Shelton State Community College
Mountain Top Award
In recognition of service for racial reconciliation

2021
Tuscaloosa One Place (Family Resource Center in Tuscaloosa, Alabama)
Building named "The Mary Allen Jolley Center for Families"

2023
Tuscaloosa Civil Rights History and Reconciliation Foundation Award
Founders Award
Recognizing outstanding service as co-founder

Appendix 2

Seven Life Lessons I Learned From Mary Allen Jolley
Comments of Marjorie Buckholtz
90th Birthday Celebration Of Mary Allen Jolley
August 26, 2018 – Tuscaloosa, Alabama

I am honored to be here today to pay tribute to my friend, my mentor, my colleague and my other mother, Mary Allen Jolley on her landmark birthday. Like many of you, I could write volumes about what she has meant to me throughout the past nearly half century. We were both a lot younger when we met, but I was not too young to recognize that there was much for me to learn from this remarkable southern lady.

Teach your children.
The battle for truth and justice begins at home. We were a young family when we met Mary and Dick Jolley in the early 1970's. Our son Charlie was a toddler and daughter Allison was around 4 years old. Our parents lived far away, and in no time, Dick and Mary became our surrogate grandparents. "You teach those children," she would often begin, and end with a parable of equality and social justice. We had two more children, and you can be sure they got the same lessons of love and coexistence. When Joshua and Hillary were born, Dick and Mary sat with my parents, the 'other' grandparents in the labor and delivery rooms as I was giving birth.

When there was a glaring injustice, or a wrong that needed righting in our community, eventually I would hear the words, "Now Marjorie, you've got to go home and teach your children about that. They need to make our world better."

Patience is the key.
"Just because you are smart, doesn't mean that you don't have to learn how to get along with people not as smart as you. There are way more of them than you and you might as well start right now learning how to bring others along to develop their talents and reach for their dreams. They want for their children what you want for yours. Patience is the key, Marjorie." Patience. Fffft!

Dr. Dick Jolley—of blessed memory—had an addendum: the deadliest combination in the world is ignorance and arrogance. How many times have I quoted him on that one.

Sex and money are at the heart of all scandals.
When Mary first told me this, I honestly didn't know what she was talking about. I was pretty naïve in the early 1970s. That was before Watergate and the myriad scandals that followed. There were a few minor kerfuffles at the technical college where we worked, and I was beginning to get the idea. By the time we moved to Washington, her words were prophetic.

Change is painful. People like things the way they are because they fear the unknown.
People don't like change, and they may not like you if you are the change agent. When you are a visionary like Mary, new ideas often create problems for the old guard. Sometimes people don't like you if you shake things up and come up with some different ideas and approaches.

Mary did this time and time again at the College where we worked. There was a group of retired military officers who found her particularly annoying. They tried to dismiss her, but she kept on smiling and while they may have slowed her down, they did not stop her. One example: New innovative programs for involving women in science and engineering technology programs in the 1970s drove the officers crazy but she broke down their objections one by one, and her pioneering program flourished and won accolades for at least a decade to follow. And that is but one example.

It's all about relationships.
As I've gotten to know Mary over the past 40 years, I was always amazed at the mountains she moved; the good she was able to accomplish; the laws she was instrumental in passing; and the commitment she had to righting wrongs and making the world a better place. She never boasted and didn't like to spend a lot of time looking backward. One thing I did learn, though, was that some measure of Mary's success came from her unique ability to develop, nurture and maintain relationships with those many partners in the projects she cared about. Those relationships lasted long after the particular project ended, and once she found her newest "soulmate" there was no limit to the dragons they would slay! Her ability to make and keep friends for life who share her values and goals is her "secret sauce" for getting things done.

Be loyal.
There is only one word to describe the kind of loyalty Mary practices and that is UNCONDITIONAL. She would never condone, enable, or cover up any wrong-doing, but when Mary is your friend, she does not abandon you.

She taught us the meaning of her commitment and her support. It is like a warm security blanket because you know that she will always be loyal to her friends and associates. Mary taught it by example without ever saying a word. If you are her friend, you are never alone. How rare is that in today's duplicitous political climate?

Leave a place better than you found it.
Wherever Mary lived and worked, from a small town in rural Alabama, to a Washington D.C. Congressional Office, to various Associations; to a community college in South Carolina; and back to Sweet Home Alabama and the University of Alabama, she left her mark. Each place was better for having had Mary first, and then the dynamite team of Dick and Mary Jolley in it.

In conclusion, when I think about Mary, and the wonderful contributions that she has made to the world of social and racial justice, I am reminded of something that another social activist, A. Philip Randolph* said, which captures both Mary and Dick's underlying philosophies:

"A community is democratic only when the humblest and weakest person can enjoy the highest civil, economic, and social rights that the biggest and most powerful possess.

"Equality is the heart and essence of democracy, freedom, and justice; equality of opportunity in industry, in labor unions, schools and colleges, government, politics, and before the law. There must be no dual standards of justice, no dual rights, privileges, duties, or responsibilities of citizenship. No dual forms of freedom."

Perhaps this is the greatest lesson I've learned from my beloved Mary Jolley.

*Philip Randolph (U.S. labor leader and social activist, 1889-1979)

Appendix 3

Tut Altman and I were co-valedictorians at Sumter County High School in York, Alabama. She was then and is now one of the most creative and expressive individuals I know, in media ranging from visual art to poetry to community activism. I treasure her friendship. Her poem below expresses in a way I never could the philosophy of life we share. —*Mary Jolley*

I STAND OUTSIDE

I stand outside closed circles.

Their rules smother the spirit

That searches higher and wider.

They constrain creativity . . . make limits.

I watch for crescent moons with promise,

new beginnings . . . adventures in darkness

that shine on possibilities.

I'm an outlaw on the edge

Learning from everybody,

Embracing all.

Tut Altman Riddick

February 2002

Acknowledgments

On December 1, 2023, peacefully but unexpectedly, Mary Allen Jolley died. Her death came just 16 days after she and I had delivered the manuscript of this book to Dr. Joe Taylor, Director of The University of West Alabama's Livingston Press.

When she passed, Mary had not prepared this page. There are dozens of people, not all known to me, who encouraged and challenged Mary in this endeavor. You know who you are, and I hope you also know with certainty that Mary loved you and appreciated your encouragement—and also your devil's advocacy.

There are three people without whom this book would not exist: Marjorie Buckholz, who was Mary's partner in its early conceptualization, organization, and development and outlined its ultimate shape, suggested the title of *Accidental Activist,* and was our closest counselor thoughout the process; Christin Loehr, who recommended the manuscript to Dr. Taylor; and Dr. Joe Taylor, who chose without hesitation to publish it.

It was my great pleasure to volunteer over several years with Mary as her editorial assistant in the creation of this book. From time to time Mary would insist that I change my volunteer status, and my response was always that the recompense I wanted was for her to say something really, really, *really* nice about me in the acknowledgments.

Sadly, that task now falls to me, so I will take the liberty of saying one of the best things I know about myself: Mary Jolley called me her friend.

—Jan Pruitt

Let's be like Mary!

Jan